Luxury and Visual Culture

Luxury and Visual Culture

John Armitage

BLOOMSBURY VISUAL ARTS
LONDON • NEW YORK • OXFORD • NEW DELHI • SYDNEY

BLOOMSBURY VISUAL ARTS
Bloomsbury Publishing Plc
50 Bedford Square, London, WC1B 3DP, UK
1385 Broadway, New York, NY 10018, USA

BLOOMSBURY, BLOOMSBURY VISUAL ARTS and the Diana logo are trademarks
of Bloomsbury Publishing Plc

First published in Great Britain 2020

Cover design by Adriana Brioso
Cover image: Dwayne Johnson and Bar Paly in *Pain & Gain*, 2013
(© Paramount Pictures/Collection Christophel/ArenaPAL www.arenapal.com).
Cover background: © natthanim/iStock

A catalogue record for this book is available from the British Library.

A catalog record for this book is available from the Library of Congress.

ISBN: HB: 978-1-4742-3953-0
PB: 978-1-4742-4603-3
ePDF: 978-1-4742-3956-1
eBook: 978-1-4742-3955-4

Typeset by Deanta Global Publishing Services, Chennai, India
Printed and bound in India

To find out more about our authors and books visit www.bloomsbury.com
and sign up for our newsletters.

Contents

Figures

Acknowledgments

I want to thank the following people for their valuable contributions to the writing of *Luxury and Visual Culture*: Frances Arnold, Hannah Crump, Pari Thomson, and Yvonne Thouroude at Bloomsbury, who have been consummate editors, offering reassurance and perceptive guidance throughout the writing process; my colleagues and students at Winchester School of Art at the University of Southampton, chiefly Ryan Bishop and Ed D'Souza, Jonathan Faiers, Lucy Hitchcock, Kate Langham, Sunil Manghani, Jussi Parikka, Debbie Pinder, and Yasmin Sekhon, who debated concepts of luxury and visual culture with me; and, as always, my life-partner and Director of the Winchester Luxury Research Group, Joanne Roberts, who discussed with me almost daily many of the ideas contained in this book and much else besides.

Introduction

This book is titled *Luxury and Visual Culture* because the important question I am addressing is this: *what appears as luxury in contemporary visual culture?* However, I do not want to imply that luxury within contemporary visual culture can be addressed and examined without any requirement for considering what contemporary visual culture, and linked concepts such as contemporary fashion and art, photography, cinema, television, and social media (Facebook, YouTube, etc.), is or can be. I think that we do need to contemplate what contemporary visual culture is or can be.

For me, contemporary visual culture means a specific art historical era with interconnective forces, active systems, and relationships of knowledge—which I will analyze in this book—and a discourse of pictorial representation. It means a way of exploring the visual domain and of performing cultural research. It also means a way of discussing the association between what we know and think about the visual and how we can articulate these things through culture.

Therefore, for me, examining luxury as profusion, sumptuous enjoyment, or indulgence in, and regarding, contemporary visual culture denotes more than merely analyzing luxury by itself. It also, unavoidably, requires engaging in the relationship *between* luxury and contemporary visual culture.

The book is organized along the following lines: I begin with an examination of the discourses of contemporary visual culture in Chapter 1. This will provide the reader with my selected viewpoint on those discourses. I then shift in Chapter 2 to an analysis of luxury in contemporary visual culture. However, as I understand it, the way luxury works, and the ways people utilize luxury, cannot be comprehended without positioning luxury within larger settings, routine practices, activities, and situations. It must be contextualized: luxury constitutes a specific realm—the abundant—with its own logic. But, while luxury does constitute a specific realm, it is nevertheless connected to other realms, to the realms of fashion and art, photography, cinema, television, and social media, for example, and these realms together form the contexts of contemporary visual culture. Likewise, luxury plays specific roles for people in everyday life;

nonetheless, to comprehend these roles, they must be positioned within a more wide-ranging context related to everyday life; they are most meaningfully examined by concentrating on how people react and make choices in everyday life and on how luxury plays a part in that configuration.

This means that before progressing to the details of luxury and art, luxury and photography, luxury and cinema, luxury and television, and luxury and social media, I will introduce and summarize some more general and methodological traits of contemporary visual culture in Chapters 2 and 3. I will examine the main visual representations in contemporary visual culture and I will evaluate how people as what I call "visual consumers"—cultured people who observe, detect, or glimpse, for instance, a contemporary Valentino advertising campaign not as an unconcerned viewer or spectator but as a probable or definite consumer, as cultured people who engage with Valentino advertising campaigns—understand everyday life in contemporary visual culture. I will give the context within which luxury operates, but I will also show how luxury in contemporary visual culture becomes more combined with other everyday life practices. Therefore, by way of contextualization, I will interrogate the customary borders between the luxurious and the non-luxurious. I begin with the concepts of cultural studies, visual representations, and contemporary visual culture studies in Chapter 2, dealing with what I name "luxury-branded visual representations" (e.g., Fendi, Bulgari, and Donna Karan) and with the notion of contemporary visual culture as the study of what I describe as "luxurious photographic, cinematic, and televisual selves," as the study of visual-cultural representations of shifting and unstable luxurious selves asking questions like "who am I?" In Chapter 3, I contend with the role of luxury fashion in contemporary visual culture. Chapter 3 explores the concepts of the visual consumer and the contemporary visual culture of luxury fashion according to Roland Barthes (1915–80), the French cultural critic who was an important figure in the development of semiotics—the theoretical study of visual representations as signs and languages, meanings, and communication—or the visual analysis of representations in everyday life and popular cultural narratives. Barthes's work not so much supplies the methodological foundation as the methodological inspiration of this book because it includes a huge range of visual subjects and representational themes. These themes incorporate the nature of visual consumption and visual codes, the work of reading, and the configuration and fragmentation of texts. Furthermore, in numerous places, Barthes's writings challenge us as visual consumers to consider the myths of luxury fashion and the ideology of luxurious contemporary visual culture and of spectacular luxury fashion as a sociocultural order, as sets of representations, as

conceptions, and as discourses of pleasure, and, finally, as luxury-branded visual representations that frequently appropriate the written word (Barthes 1972a, 1977a, 1981).

In Chapter 4 on luxury and art, I investigate the role of luxury-branded visual representations produced by contemporary artists such as Jeff Koons in contemporary visual culture. Chapter 4 is a conduit to later examinations of the function of luxury-branded visual representations produced by contemporary photographers and filmmakers, television, and social media producers in everyday life. In Chapters 5 and 6, I turn to the relationship between luxury and photography (e.g., the twentieth-century and contemporary luxurious photographic selves of Edward Steichen and Annie Leibovitz and visual representations of sensuality in contemporary luxury fashion photography) and luxury and cinema (e.g., the twentieth-century and contemporary luxurious cinematic selves of Sofia Coppola's [2003] *Lost in Translation* and Michael Bay's [2013] *Pain & Gain*, questions of lavish choice, the fragmentation of meaning, transformation, and sensuality evident in luxury lifestyles in contemporary cinematic cultures).

Examinations of the relationships between luxury, twentieth-century and contemporary television and between luxury and contemporary social media take up Chapters 7 and 8. I initially analyze the ways luxurious televisual values operate in terms of the meanings and significance I attribute to television series such as *Miami Vice* and *The Sopranos*, *Suits*, and *Harlots*, how they are employed in the everyday life of televisual selves' mental inclinations, critical dispositions, moral likings, and philosophical preferences, and how these are changing in contemporary television. A stress is here put on new televisual pleasures, rich experiences, and sensual behavior. I then turn to the problem of the relationship between luxury and social media, to physical and digital luxury, to the luster or sheen of physical luxury fashion houses such as the flagship and department stores of Louis Vuitton, and to the role and characteristics of what I describe as "the new digital luxury fashion house." A conclusion ends the book.

In this book, the reader will discover two arguments advocating the utilization of the concept of contemporary visual culture. The primary *theoretical* argument I have previously stated. However, there is also an *experiential* argument. I argue that contemporary advanced cultures may be examined as contemporary *visual* cultures. These cultures are to a sizable extent influenced by a collection of new luxury-branded visual representations that can only be labeled and explained as *forces* and powers, energies, and intensities. The diverse luxury-branded visual representations produced by contemporary artists and the production of

ever more luxurious photographic, cinematic, and televisual selves can thus be understood as "in becoming," as progressively significant, and contemporary capitalist cultures are becoming more and more multifaceted, luxurious, branded, and visually dominated by "*jetztzeit*" or "the time of the now" (Benjamin 1970: 263). This does not involve a total separation from modern visual culture. History comprises traditional, modern, and contemporary visual and cultural characteristics (Kromm and Bakewell 2010). Yet, the chaotic range, extraordinary pace, and sheer amount of increasingly technological forces, such as social media, have enlarged to the degree that, in place of modern visual culture and cultural studies, I prefer to write of contemporary visual culture and contemporary visual culture studies. These technological forces driving visual representations influence everyday life in new ways, and this establishes new visual prospects, chances, and new cultural difficulties, particularly as such technological forces are seemingly devoid of any visual source or cultural objective and never come to halt at a terminal or equilibrium state.

I argue that techno-structural transformations are producing the increasingly immaterial cultural conditions for new forms of visual production and consumption (although this book is largely focused on visual consumption rather than visual production or visual distribution), new ways of proceeding, and new types of awareness in contemporary visual culture. The most important concept that I introduce is the concept of *voluptuousness*, which relates to, originates from, rests in, or is typified by gratification of the senses, particularly in sophisticated or lavish behavior. I argue that this concept more than others encapsulates the general consciousness that symbolizes people's drives, visual consumers' goals, and luxurious photographic, cinematic, and televisual selves' desires in contemporary visual culture. Voluptuousness has developed in a multilayered interaction between structural forces, the visual and cultural production and consumption of representations, and luxurious conceptions of human agency. Everyday life is altering more swiftly than ever, with visual forces constantly interrelating and establishing a dynamic cultural world in flux. People's luxury lifestyles, along with their visual representation as luxurious photographic, cinematic, and televisual selves, are incessantly recreated and redesigned in new and original ways. In an epoch of what I identify as "pleasure dysphoria" (desire as a state of unease or generalized dissatisfaction with life), when outmoded customs, rituals, and practices of luxury lose their power over people's lives and their visual representation as luxurious photographic, cinematic, and televisual selves, they increasingly take responsibility themselves for their own pleasure-seeking worlds that are always in the throes of becoming

dysphoric, of becoming uneasy, of becoming dissatisfied, of becoming *something else*. This can be shocking and problematic because the eternal feature of their luxurious worlds of visual and cultural forces is difference from whatever self has gone before in their lives and from that which they will become. But for people and luxurious photographic, cinematic, and televisual selves who are safe, protected, and sheltered and who have the material, immaterial, and cerebral resources (through perceiving and, crucially, through *intuiting* the "correct" or "appropriate" cultural forces), contemporary visual cultures of luxury present openings for individual voluptuousness never offered earlier.

These structural alterations in everyday life parallel structural changes within luxury. People and luxurious photographic, cinematic, and televisual selves with voluptuous lifestyles understand luxury as a realm that is inevitably connected to their own individual existence. Luxury is not some distant object or obsession, point, or event, economically disconnected from their everyday lives; luxury is about individual voluptuousness and about grasping voluptuousness without reference to a non-indulgent understanding of existence. Luxury and its visual culture is thus increasingly linked, for example, to the new televisual value inclinations of television series such as *The Sopranos* and *Suits* rather than to the traditional luxurious televisual values of a television series like *The Crown*. The new televisual value inclinations of *The Sopranos* and *Suits* seem more "right" to contemporary visual consumers and to the visual culture of luxurious photographic, cinematic, and televisual selves than do the traditional luxurious televisual values of *The Crown*. In the same way as people as contemporary visual consumers and as luxurious photographic, cinematic, and televisual selves increasingly learn through intuiting the forces of different social media networks in everyday life, they also increasingly intuit the capacity of luxury to produce not only group level change but also new physical and digital luxury products and services. This establishes a fascinating situation for luxury fashion houses such as Louis Vuitton to cope with, as I will examine in Chapter 8.

This book uses numerous different academic and visual sources from many diverse subjects and confronts several different issues. That might make *Luxury and Visual Culture* difficult to read from time to time. However, there are few other ways to proceed to make examinations of the relationship between luxury and visual culture meaningful. *Luxury and Visual Culture*, then, is, to some degree, an invitation to its readers to consider different ways of proceeding and different kinds of analyses when envisaging the numerous meanings of the association between luxury and visual culture. Importantly, readers will observe in several chapters that I discuss various visual representations at some length but

do not offer them as illustrations. There are two significant points to make which explain the absence of these illustrations: first, some illustrations are extremely expensive to purchase for reproduction purposes, and, second, it is rare for authors of books on visual culture to be granted permission by the owners of luxury-branded visual representations to reproduce them as illustrations in their books. The book is intended for scholars and students originating from, for example, critical luxury studies and visual culture, fashion theory, contemporary art, photography, cinema, television, and social media studies. Certain readers may be more attracted to my examinations of fashion, and other readers to my analyses of art or photography, cinema, television, or social media. However, I hope that most readers will read the book from the first chapter to the last. There are topics that I wish to convey in as comprehensible a way as possible. In this regard, the nature of the book, its objective, and its narrative are the linear expression of its author. Yet, all books are a manifestation and consequence of the interactions between the forces of their nature, objective, and narrative, with each interaction between the forces of the writer and the reader revealing itself as a unique event.

Visual culture

The visual is a luxurious phenomenon. We have learned that the visual not only means attained by or belonging to human sight but also means that beams of light coming to, proceeding from, or directed by the human eye or sight are abundant and, on a sunny afternoon, extravagantly pleasurable (Bryson et al. 1994; Jenks 1995). However, we struggle to comprehend others' art and to implement our own meanings in using the term visual, culturally and historically. Meaning is relative to and dependent upon structures of the visual connected with forms of cultural life, such as making a painting or the indulgence of eyeing a Cartier watch. We have discovered that visual terms and discourses are never unbiased but are bound to cultural systems of understanding, practices, and routines. They are never of global application but forever dependent, attached to specific eras, places, circumstances, and disagreements.

We have realized that numerous terms, and particularly those associated with luxury, such as lasciviousness, lust, and debauchery, are disputed (Sombart 1967; Sekora 1977; Berry 1994; Armitage and Roberts 2016a; and De Laveleye 2016). This means that they are internally multifaceted; their qualitative usages or effects are many and continuously discussed. Hence, luxury is involved in the recognition of a usage of the visual, and perpetual and fierce arguments frequently occur over its cultural meaning. We may even deduce that each act of seeing or description of the eye, every categorization of its meaning, comprises a random collection of components bound together by phenomenal and powerful worlds of meaning and metaphors of sense-data, which are not inherently human.

Visual culture, I argue, corresponds to this interpretation of the essential and meaning-situated character of the visual. The visual is internally multilayered, negotiable, evaluative, and contested. The exercise below faces the dangers of being a discursive practice; of enforcing involvement in a humanist/meaning complex; of demanding the reader's agreement to a purely human and to a purely visual culture; and thus of guaranteeing future subjugation to the barring of other kinds

of animals and of other kinds of sense-data—for instance, through hearing, taste, touch, and smell. Nonetheless, it is vital to accept that not only is visual culture significant for the comprehension and direction of luxury; its own conceptions of the visual and its cultural vocabularies are caught up and inherent in today's luxury discourses and practices. Examining visual culture is itself a luxurious pursuit, a lavish fight for the powerful meanings of luxury besides understanding.

A genealogy of the visual, or the retroactive comprehension and disturbance of the visual past by the retrieval of excluded cultural usages, abstract taxonomies, and discursive senses and practices, is beyond the range of this chapter (Merleau-Ponty 1969; Foucault 2002; Jay 1994; and Berger 2008). Nevertheless, genealogies of the visual have appeared in contemporary literature and can offer a valuable medium for cultural organization and critical consideration of human experience linked to, or co-experienced with, the visual. One contemporary investigation is thoroughly researched and helpful—that edited by Jane Kromm and Susan Benforado Bakewell (2010)—and it will be used as the foundation of my own study.

Kromm and Bakewell's goal is a historical yet contemporary one: to bring lucidity into the discussion of the history of the term visual culture in Western civilization from the eighteenth to the twenty-first century (see also Mitchell 1996; Walker and Chaplin 1997; Mirzoeff 1999; and Heywood and Sandywell 2017). Lucidity may only be obtained at the expense of streamlining and abbreviation. Kromm and Bakewell attain this by delivering a historical and investigative summary of the most important or meaningful uses of the terms in question and a critical examination of the assumptions and contentions used with them in contemporary theories and uses (see also Evans and Hall 1999; Dikovitskaya 2006; Sturken and Cartwright 2007; and Mirzoeff 2012). As the disclosure of plural and background meanings through the concepts of the visual and of culture, the exercise is beneficial, but some may find flaws with the goal of bringing lucidity to a subject where disagreement and forceful contests over meaning rule. My purpose here is to demonstrate qualitative differences and of effect; to moderately divulge the variety and disputed and stylistic character of the visual and cultural discourses. Only then do I expound a visual lexicon and cultural usage to steer the reader of this book.

Culture and visual culture

Difficult terms with numerous usages invite conflation and misunderstanding. Much literature on visual culture and luxury has concentrated on these subjects.

The intricacies of visual culture are increased as we think about "visual" and "culture." "Visual" is occasionally used to mean a visible, recognizable thing and a quality or effect; or it could suggest all that can be observed by the human eye, and is adjacent in meaning to the phenomenal domain, except that this last object also comprises all other types of sense-data that human beings can appreciate—for instance, through hearing, taste, touch, and smell (Kromm and Bakewell 2010: 5–8). Visual also denotes "the visual" in an abstract meaning, seemingly indicating comprehensiveness but excluding a great deal of human experience generally linked to, or co-experienced with, the visual. In brief, the "visual" in visual culture is not conclusive, and it is up to authors to elucidate their usage and not to combine dissimilar meanings. The idea of the visual can, for example, be used regarding the quality or effect of something—where the idea of the visual is more moderate and related, for instance, not to visual culture as such but to customary art historical definitions, usages, meanings, and techniques of examination (D'Alleva 2005). If the recognized concept of style is a privileged distinguishing characteristic of visual culture's treatment of the visual, as I argue, then we should take note of the stylistic lessons of the "visual" used to mean a system of visual appearance or the nature of objects such as paintings (Bryson 1985; Elkins 1999). Used together with other terms, "visual" can denote "visual analysis" and the activity, for example, of explaining and contrasting styles in renaissance painting, with the aim of presenting categorizations of form (Nelson 2000; Fry 2017).

The concept of "visuality" functions as an idea and as a designation for the organization of the visible appearance of things in the world. In this meaning, it has connections to "commodity"—a productive notion in Marxist philosophy (Haug 1986). Visuality has had a complex intellectual history involved with the development of a variety of disciplines including semiotics (Barthes 1984) and phenomenology (Merleau-Ponty 1969). Concentrating on the idea of a changing visible arena, Merleau-Ponty (1964: 9–25), for instance, considers the biological–physical procedures of seeing encompassed within direct acts and ways of observing the world, and of Paul Cezanne's ways of expressing this activity within his paintings as creative "visual representations," with the latter defined for the purposes of this book as a set of processes by which signifying practices appear to depict or mirror symbolically other objects or practices in the "real" or independent world (Hall, Evans, and Nixon 2013). Visual representations are thus constitutive of the meaning of that which they stand in for and the creation of the representational effects of realism (Mitchell 1995).

In another route, writers and political militants have pointed out what Guy Debord (1967) named the "society of the spectacle" in contemporary capitalism and examined its visuality. The society of the spectacle incorporates the pervasiveness of visual mass media, for example, television and computer technologies (creating real and "hyperreal," or simulated, visual representations of global culture: Baudrillard 1983) and their interconnected surface forms (e.g., stunning television newscast experiences such as the hijacked aircraft crashing into the New York World Trade Center towers in 2001, repeatedly re-shown on television as an "instrumental image loop": Armitage 2012: 95–116). This kind of visuality—apocalyptic—"visionary"—"overexposed"—extreme—and on a huge scale—conjures up a threatening abnormal and cultural world tottering on the threshold of what Paul Virilio (2007) calls the "original accident."

The "culture" in visual culture is similarly vague, abstract, and interrelational (Williams 1986; Jenks 1995). Culture can mean a process, a creation, or the result of human shared life such as the development of luxury; it is the main indication of the patterns of human social and historical arrangement. Culture has three linked features: the traditions or forms of art thought to signify the uppermost attainments and values in a society; each of the objects, organizations, and practices comprising the "material culture" (Tilley et al. 2013) of a society; and the lived associations between individuals and groups in a society that is characterized by their interrelated economic, political, generational, and communication systems. In brief, the concepts of culture and society intersect. Conjoined to "history" as in "cultural history," culture is concerned with shifts in the meaning of society in the eighteenth and nineteenth centuries— when the industrial revolution and the urbanization that was associated with it in Britain were understood to be altering the character of life and social organization (Thompson 2013). While all three features of culture may be used concerning luxury, it is common for contemporary definitions of culture and society to be characterized as part of the reaction to the transformation and crisis in advanced societies caused by the growth of capitalism, the spread of democracy, the early stages of globalization, and cultural imperialism (Said 1994).

Culture, in the three meanings outlined above, forms a main part of the object of study of art history—discussed later in this section. In its conventional emphases, though, art historical attention has concentrated on the traditions and forms of art. Cultural studies—also discussed later in this section—conversely, has inclined to focus on the maximum variety of objects, organizations, and lived relationships. Disagreements between art history and cultural studies

are therefore often focused on disputes about questions of canonical selection. Which artworks and practices justify being examined, how values and rulings regarding the importance of objects are to be ascertained, and what and whose ideas of society are presumed to afford the appropriate framework within which individual objects and artists are to be considered are only a few of the areas of argument and issues in play concerning the concept of culture in the sometimes-conflictual relationship between art history and cultural studies.

Three terms connected to "culture" also must be expounded upon as their senses feature predominantly in the visuality and discourses of visual culture, specifically art history, cultural studies, and the idea of a cultured person.

Art history is used to denote the historical study of art and the practices of those engaged in curation, research, and teaching in universities and museums. Art history thus alludes chiefly to the post–World War II academic discipline of the same name—furnished with recognized curriculum and typical aims and objectives imparted at undergraduate and postgraduate levels; to the creation of authorities employed in numerous sites, including teaching the art and history of luxury in schools and universities; to the purchase and sale of luxuriant art and other superabundant objects in auction houses and dealing galleries; and to the curation and conservation of luxury objects in museums (Newall and Pooke 2007). Art history's disciplinary status resides in collections of ideas and theories, purposes and techniques of investigation—accompanied by foundational contentions and values that reinforce and direct the analysis (Hatt and Klonk 2006). Description of the discipline's growth in European universities in the twentieth century is disputed. However, in recent years, art history has advanced and increased practically beyond recognition, making it unlikely that any agreement endures over the important concerns of the subject. But art history can also signify its disciplinary emphases—for example, on the determination of the authorial source of artworks (who created what, when, why, and how). In this sense, art history represents the transformation and development of culture—contrasted with the customary interest in art as history; changes and advances that in turn include, for example, the cultural study of symbolism in artworks (iconography); social history of art examinations of the sociocultural conditions wherein art is created and consumed; feminist and ethnic attention to the position of women and minorities in the expansion of art, art organizations, and in culture and society; the psychoanalysis of art and artists; and semiotic philosophies of how artworks comprise and convey meanings through signs and communication systems (Hauser 1951; Clark 1982; Barthes 1984; Pollock 2003; Crow 2010; and Barbe-Gall 2011).

Arguments, for instance, over the choice of objects of study for art history, have continued and suggest how art historical and art critical interests, mainly in the age of modernism, intersect and divide (Harrison 1997). Disputes over the creation of a canon of artworks and artists—namely, those objects and creators thought valuable to consider as "the finest" consistent with exacting standards and values—reveal how the deceptively uncomplicated idea of an objective history of art differs from the actual selections and supplementary assertions expressed within art historical explanations. The study of the growth of the discipline—which is frequently argued to have begun with the Italian Giorgio Vasari's (2008) *Lives of the Artists*, initially printed in 1550—is named "art historiography." Art history thus matured not as a global but as a European and North American subject bound to the scholarly visual and representational interests and institutional values of a somewhat unworldly, yet urban, not to say urbane, largely white, mainly male, elite, centered in the European cities and North American cultures of the Western Hemisphere (Belting 1987; Fernie 1995).

Cultural studies refers to the interdisciplinary investigation of contemporary social life concerned with visual and other kinds of representations (During 1992; Grossberg and Nelson 1992; Barker 2011). Cultural studies alludes often to contemporary mechanical, broadcast, electronic, and digital media. It has more specific uses in numerous disciplines and theories related to types of human performance in, for instance, fashion and art, photography, cinema, television, social media, and other kinds of cultural conduct (see, for example, Hebdige 1979; Hall and Jefferson 2006; Durham and Kellner 2012; Longhurst et al. 2016). I shall use the term "cultural studies" *visually*. I will use it to denote an academic discipline that has been taught, studied, and reproduced as a subject in universities since the 1960s (Storey 1996; During 2005). Normally, cultural studies is used to designate an academic discipline that intersects with conventional art history, but it can also be characterized as an alternate academic discipline that sets itself against conventional art history (Anderson, Dunlop, and Smith 2014). This difference is presented in terms of an occasionally hostile collection of explicatory theories and ideas, techniques of examination, and sociopolitical and cultural viewpoints. Cultural studies is used throughout this book as a wide-ranging category for the study of the components that structure the customs of a people, or of separate groups of people, such as subcultures, within a society. Initially, cultural studies did not examine the luxurious desire for the routine use of, or immoderation in, what is superior or expensive whether food, dress, furniture, or other appliances, but instead examined youth cultures

in the 1950s and 1960s, chronicling their communication with music (such as soul) and varieties of clothing (e.g., the English "Mod" look: Rojek 2007). Emphasizing shared lively habits or lifestyle culture, cultural studies' advocates generally pay less attention to the analysis of separate objects (Candlin and Guins 2009). Although such objects are created and utilized by people within historical and social conditions, they are, in conventional art history's concern with, for instance, paintings, conferred isolated, even independent, prestige and value. Still, there are anthropological analyses in art history that understand luxury and other objects in terms of their social distribution and purpose (e.g., Kuldova 2016). Furthermore, art historians have occasionally left objects aside and considered the social institutions (e.g., art academies, galleries, and museums) associated with art production and consumption—thus anticipating cultural studies research on the interface between groups, beliefs, institutions, and social power.

The disparities between art history and cultural studies as modes of academic learning and teaching are political, organizational, and social, besides intellectual and investigative. Cultural studies progressed in Britain as a critique of the consumer–capitalist society developing in the 1960s. Cultural studies' non-academic origins are in workers' education—the discipline only transferred to the universities as an academic specialty during the 1970s. When this happened, several art historians entered or criticized cultural studies, for a combination of political, professional, and philosophical motives. Yet, today, while these arguments persist, art history and cultural studies tend to support each other more than they fight each other. There is no mandatory disagreement between them. However, cultural studies I believe to be a contested concept, and one often susceptible to commingling and misinterpretation. My usage will be enlarged in Chapter 2.

A cultured person is the most value-loaded term in my cluster of key concepts (Kennedy 2014). This evaluative meaning to the culture of the person as "the finest" remains a significant representative subject for all who examine culture. This attaches to the term "cultured" a person who has, most likely, studied art and history, music, literature, morality, and politics or who is a participant in a movement vigorously advancing cultured people, such as those whose ideas and ideals concerning human society are elitist or at least individualist, concerned with great artists, and the pursuit of excellence (Sandel 2006). There is a danger, though, in assigning to the idea of the cultured person too much of a philosophical and high culture emphasis. Instead, I consider the notion of the cultured person as one concerned with movements for genuine democratic

social transformation and with people seeking to understand art and history and to act imaginatively. Consequently, the myth of the unique artistic genius is one form of the cultured person, but other forms may be more concerned with the reality of the collective artwork. Cinema, which describes both moving films and the entire shared system of organizations and agents involved in film production, is one example, but there are countless others.

Tracing visual culture

One of Kromm and Bakewell's most noteworthy contributions to comprehending visual culture is their historical investigation of its usage. Put beside my concise lexicon of visual culture's terminology above, we have a guide to the concept of visual culture.

Condensing Kromm and Bakewell's history, we can map the original usage of visual culture to the art historian Michael Baxandall in his *Painting and Experience in Fifteenth-Century Italy: A Primer in the Social History of Pictorial Style* (1988), denoting by the expression the interrelated structures of knowledge and visual representation developed during the Florentine renaissance, molded as these were by new visual abilities and methods entailing measurement and classificatory rules employed in art and trade (Kromm and Bakewell 2010: 7–8). Intersecting this date span in the nineteenth century was the introduction of the modern and contemporary usage of visual culture by scholars in the advanced societies to convey the incorporation of objects of study beyond the variety of objects typically included within the customary categories of art and design. The concept of visual culture thus indicates an amended explanation of the concepts and techniques required to comprehend the advanced societies and the circumstances of cultural producers and consumers' pursuits and identities within them. Visual culture is therefore the designation for a multidisciplinary diagnostic fusion over and above a designation for the objects it examines (Kromm and Bakewell 2010: 8). This usage has developed into the broadest usage beyond art history in the subjects of visual analysis and cultural criticism.

Kromm and Bakewell's investigation, impressive and extensive as it is, does not include every conceivable usage of the term "visual culture." There are, I argue, two forms of visual culture: one "moderate," which I support, and the other "radical," which I do not support (see, for instance, October Editorial Collective 1996; Drucker 1999; Elkins 1999; and D'Alleva 2005: 82). This is because the radical form of visual culture contests art history with a view to absorbing it.

In its moderate form, however, visual culture combines and considers types of mass culture that have had negligible status in art history. These include fashion and contemporary art, photography, cinema, television, and social media—media, moreover, which have subsisted for years although experienced repeated economic, technological, and organizational alteration. Visual culture appreciated as a disciplinary field concerned with the above objects of study— together with advertising, graphic, and product design—developed out of cinema and cultural studies. In this moderate form, then, visual culture inhabits a field that art history does not.

In its radical form, though, visual culture rejects art history, refusing its originating philosophies and values. In this refusal, mass media becomes a vehicle for reconsidering important suppositions and ideas that govern traditional art historical discourse inclusive of the concept of luxury. These incorporate, for instance, conceptions of individual originality. The radical form of visual culture consequently refers not only to the collective and creative aspects of manual skills but also to the refusal of art historical suppositions of individual uniqueness and innovation. Objects, designs, and customs are doubted, as are changes at the formal aesthetic or thematic historical level and as is the conviction that Western canonical art is the touchstone and assurance of discrimination and artistic excellence.

Beyond fashion and contemporary art, photography, cinema, television, social media, and other digital imaging forms, equipment, and techno-structures, the radical form of visual culture endeavors to reclassify the sphere of the visual in contemporary global-capitalist societies. This usage builds upon the nature and meaning of, for example, global-capitalist culture's spectacular fashion photography such as that of luxury brand Marc Jacobs, its typically luxurious visual representations, emotional, experiential, and sociopolitical influence on viewers and societies—and all from fashion photography's vantage point of its enormous electronic billboards at major train stations and airports.

Understanding visual culture

How do we understand these diverse usages of visual culture? I do not argue for one, "accurate" usage of the term. That was never my aim. What I have done demonstrates the disputed character of the discourses encircling visual culture. From there, what I can do is to locate myself within the discourses and summarize how I propose to use the appropriate terms.

Concerning the terms "cultural studies," "art history," and "cultured person," I argue that these can be connected to each other as different modes of understanding culture. For me, cultural studies is an academic discipline that coexists with, rather than competes with, art history as a form of still-evolving inquiry, and cultured persons are people in dialogue with and movements of response to that inquiry. Likewise, I will refer to modern visual culture as visual culture produced from the 1860s to the 1970s and contemporary visual culture as visual culture produced since the 1970s (see, for example, Edwards and Wood 2013). By contemporary visual culture studies, I mean a contested concept that is currently and reciprocally reshaping and recharacterizing contemporary ideas of the visual and of culture. Hence, by contemporary visual culture studies, I mean pictorial, representational, sociocultural, and scholarly efforts to understand contemporary visual culture.

The above specified definitions will be expanded upon in later chapters in this book and then chiefly regarding luxury. Before so doing, it is valuable, though, to examine the theoretical status of the discourse of contemporary visual culture.

Contemporary visual culture is frequently used as a term of skepticism, designating a type of thinking that is at best all-encompassing and fundamentally disordered in its all-inclusiveness—and at worst mistaken and alarming. This usage is itself as varied as the objects of criticism are numerous. But the crux is that contemporary visual culture is openly sociological thinking; that the rejection of numerous aesthetic and historical standpoints is a surrender from the search by many art historians for the real examination of the visual and for the correct analysis of the cultural; that the renunciation of ideas of aesthetic value only frees theorists of contemporary visual culture from the problem of considering artists' intentions and the history of individual human agency; and that the supporters of contemporary visual culture misunderstand the diverse work that occurs within art history for an unvaried concentration on individual artistic creativity. Those usages are common in art history in addition to some academic circles concerned with visual and cultural, aesthetic, and historical values.

This critique is comprehensible to some degree. First, as I indicated briefly above, broadly, there are two rival forms of contemporary visual culture, and the fact that it cannot be precisely identified makes some cultured people—both inside and outside academic circles—anxious. Second, the conviction and fact that numerous supporters of contemporary visual culture, inclusive of those concerned with the configurations of luxury, are ex-mass media theorists and ex-art historians, disenchanted discourse theorists, or members of the creative

industries intimidated by or reordered in post-manual skills restructurings of culture strengthens their adversaries' convictions that contemporary theorists of visual culture are either unsophisticated wide-ranging idealist visionaries of inclusion or pessimists concerning human uniqueness and originality. Yet, there is a large difference between being an idealist visionary of inclusion and being a pessimist regarding human individuality and innovation. Moreover, as I suggested earlier, these two standpoints may be rearticulated more impartially and academically to describe two main kinds of contemporary visual culture theorists. I call these two groups "moderates" and "radicals."

This last is one helpful way to appreciate the difference between the fundamentally critical and confrontational attempts of the radicals and the more moderate beliefs in the ability of individuals concerned with the visual and groups concerned with the cultural to come together and study, in the work of those addressing the new luxurious mass cultures of fashion and art, photography, cinema, television, and social media.

Radicals are opponents of art history who support departure from the study of individual artistic objects, while moderates are inclusive and support involvement in the study of all sorts of mass cultural styles, inclusive of luxury. The former seek comfort in the nontraditional, while the latter support involvement in new artistic forms and new historical themes. Radicals contemplate various aesthetic and historical viewpoints, such as the belief in Western canonical art and taste, and of practices of measurement based upon them, to be contingent and uncertain. For them, aesthetic skepticism, doubt, and contingency regarding artistic quality are all. They are particularly condemning about art historians' declarations of the problematic nature of digital imaging forms and technological systems such as the internet. Moderates are more self-assured about the possibilities of examining such technological systems. They seek to consider the reflexive creation of new types of visual cultures and new visualities. For them, contemporary visual culture creates spaces where opportunities for experiments in rewriting the sphere of the visual and new, often luxurious, contemporary global-capitalist sociocultural configurations of meaning flourish.

The subsequent analyses will be conducted from the viewpoint of the moderate contemporary visual culture theorist. I will demonstrate what luxury "means" in an era of contemporary visual culture, considering techno-structural forces along with human agency, without overlooking the restraints put, and the chances presented, by the visual and the cultural in stating this meaningfully.

Adopting a moderate rather than a radical position may be branded a move founded in the idealist faith in human agency and its distinctiveness, ingenuity,

independence, and inventiveness. However, it is not a position embraced thoughtlessly, contrary to proof of the opposite. I will argue for my humanist beliefs, for ethical visual theories and cultural practices that highlight, though not to the exclusion of all else, the place of reason, technology, science, and modes of human fulfillment in the world of luxury. Thus, I will employ the language and philosophies related to a moderate analysis of contemporary visual culture. While I recognize the positions of other contemporary visual culture theorists, I will stand up for my argument for a contemporary visual culture without techno-structural determination: a contemporary visual culture which puts explicatory worth and importance on visual and cultural transformation and which is moderate in its understanding of luxury and visual culture, the theme of Chapter 2.

2

Luxury and visual culture

I argued in Chapter 1 that contemporary visual culture studies signifies the contested concept that is currently and reciprocally reshaping and recharacterizing contemporary ideas of the visual and of culture. In this chapter, I will outline the character of this concept concerning luxury-branded visual representations and luxurious photographic, cinematic, and televisual selves. This is not a simple undertaking, however. The inter-discipline or concept of contemporary visual culture studies, a visual consideration of cultural studies, has not often been used (Smith 2005a,b; Smith and Morra 2006; Walker and Chaplin 1997: 31–50). The chief exception is Smith's *Visual Culture Studies: Interviews with Key Thinkers* (2008). Otherwise the concept of visual culture studies is marginal within contemporary visual and cultural theory. Accordingly, within the arts, the humanities, and the social sciences today only a few books, book chapters, or articles have been published with "visual culture studies" in the title. Comparatively, in the present period, hundreds of books, book chapters, or articles have "cultural studies" in their titles, and hundreds more have "visual culture" in their titles. I will consequently initially utilize the discussions focused on the concept of cultural studies. But shifting into this discourse is something of a problem.

Employing the concept of cultural studies as a foundation for a discussion of contemporary visual culture studies should be straightforward. This would be the case if the concept had been used in an overtly "visual" way, if it had been utilized to delineate more explicitly the mass of frequently conflicting visual representations that typify our era. However, the difficulty with the concept of cultural studies is that the usual way of using the concept has not always been that visual. Quite the contrary. To a larger extent than the concepts of culture and the idea of a cultured person, from the 1960s onward the concept of cultural studies is bound to a multilinear and rather undetermined way of regarding sociocultural changes. It is bound to a view of understanding such changes

as often undetermined by visual development. Chris Barker's otherwise well-respected text, *Cultural Studies* (2011), for example, neither features a chapter on visual culture studies nor discusses visual culture. In this sense, the discourse on contemporary cultural sociology, with its stress on multilinear transformations, is a more logical connection to the discourse on cultural studies than is the discourse on contemporary visual culture studies (e.g., Back et al. 2012).

The now "traditional" cultural studies viewpoint is still buoyant within the arts, the humanities, and the social sciences. Analyses using the term "cultural studies" are still concentrated upon the interdisciplinary study of contemporary sociocultural life and types of human performance and self-exhibition in, for example, fashion, popular music, dance, and other types of subcultural behavior, while this is seldom the case when it comes to analyses using the term "culture." Therefore, to use the concept of cultural studies in a more productive way, it is essential to emphasize its visual connotations while avoiding what Mieke Bal (2003) calls "visual essentialism" or the assumption that the visual possesses an underlying essence that defines its "true nature." The visual in culture, as well as the representational in the visual, can never be reduced to developments within sociocultural life. It may be that at specific junctures and in specific contexts sociocultural issues are primary. This may be the case regularly. However, whether this is the case is an experiential issue, an issue for the examination to demonstrate experientially, not something to be decided upon beforehand. The basis for the examination must be to consider visual issues alongside other pertinent sociocultural issues. This is a way of advancing that is characteristic of contemporary examinations of culture and visual culture (studies that, also, increasingly are conducted with the use of the concept of cultural studies, if not contemporary visual culture studies, as in Longhurst et al.'s *Introducing Cultural Studies* [2016]). It is a common orientation point for examinations of culture and visual culture within critical theory (Held 1989), contemporary cultural theory (Bourdieu 1984; Featherstone 2007), and visual culture studies (Smith and Morra 2006), and it is within this area of thought that I locate myself.

I make a distinction between twentieth-century and contemporary mechanical, broadcast, electronic, and digitally mediated visual representations, and I argue that these together give contemporary visual cultures a distinctive form. Contemporary visual cultures are what I call *visual-cultural configurations*, visual cultures with a definite techno-structure and a precise set of visual and cultural relations.

In other words, for me, the concept of cultural studies refers to a collection of visual and cultural representations that are mediated forms of human

performance and self-exhibition; to the visual configurations of fashion and the cultural deployment of the resources of art and photography, cinema, television, and social media; to the development of the forces of visual and cultural representations of popular music, dance, and the upsurge in other types of subcultural behavior; to the founding of overlaps with traditional art history and the reconfiguration of explanatory visual principles and cultural concepts, methods of analysis, and sociocultural political perspectives; to the study of all the visual and cultural elements that make up the way of life of a people—or of distinct groups of people (subcultures) within a particular society; to the visual and cultural analysis of youth, music, and forms of dress; and so on.

The key visual representations associated with cultural studies, as observed in my account, include visual and cultural representations of fashion, youth, and ways of life. In my description, culture includes fashion, it is based on the reconfiguration of explanatory visual principles, it is analytical, and it is concerned with people. To this we may add that culture increasingly has become a luxury brand–dominated culture of visual representations produced by contemporary fashion designers and contemporary artists (e.g., Van Cleef & Arpels jewelry, Montblanc fountain pens, and Jaeger-LeCoultre watches). On another level, the way culture has changed, through discourses as well as through meaningful visual representations, is through an increasing cultural discourse and depiction of *pleasure* within these visual representations. This has coincided with an increasing level of *participation* on the part of "visual consumers"— cultured people who perceive, notice, or see, for example, a contemporary Dolce & Gabbana luxury-branded visual representation not as an indifferent viewer or spectator but as a likely or genuine consumer, as cultured people who involve themselves with Dolce & Gabbana luxury-branded visual representations. Cultural discourses and depictions of pleasure are fused with meaningful visual representations, and visual representations with participating visual consumers.

Visual representations and contemporary visual culture studies

The visual representations of modern culture formed modern visual culture. Likewise, I argue, the visual representations of contemporary culture form contemporary visual culture. What, therefore, do I mean by contemporary visual culture studies, as against modern cultural studies, visual representations, and what is contemporary visual culture as against modern visual culture?

In my estimation, it is more reasonable to describe contemporary advanced cultures as visual cultures than as cultures. By this I mean that advanced cultures throughout the previous decades have altered considerably. This does not mean that there is no continuity between the two types of cultures or that the changes are as powerful as those between traditional and modern cultures, but it does mean that the differences are significant enough to merit this distinction.

There are numerous ways to explain the dissimilarities between modern visual culture and contemporary visual culture. For example, in contrast with modern visual culture, I identify contemporary visual culture with a shift toward luxury-branded visual representations, with visual consumption (Schroeder 2005), with increasing cultural pace and continuous aesthetic modification, with an accent on surfaces and images, with luxury brands (from IWC Schaffhausen Swiss watches to Jo Malone fragrances, and Ray-Ban eyewear), with what I call below luxurious photographic, cinematic, and televisual selves, with *jetztzeit* (the presence of the now), with a reexamination of extant concepts, philosophies, and even with the end of cultural critique (Benjamin 1970: 262–64; Smith 2008).

It would be problematic to fit all the characteristics described above into one, rational structure, and that is not my purpose. The literature and debate on contemporary visual culture is huge, and with people coming to the debate from varied discourses and for disparate objectives, there will be no universally agreed upon structure.

I will not give a thorough discussion of the various standpoints taken in this debate; that has been conducted already (see, for example, Heywood and Sandywell 2017). It is vital to recall, though, that the viewpoints on contemporary visual culture are neither unavoidably optimistic nor pessimistic. My distinction between radical and moderate visual culture theorists, discussed in Chapter 1, is a helpful reminder of this. Contemporary visual culture comprises components that might make a delightful culture or an awful one. That is not given in advance. It is determined in historically specific locations. This means that Hal Foster's critique (2002: 90–91) of contemporary visual culture based on its intrinsic "ahistoricism" is justifiable only against one type of contemporary visual culture (Smith 2008: 9–10). Modern visual culture ends, I suggest, when terms such as process and product, human, collective life, patterns, society, history, organization, traditions, and forms of art held to represent the highest sociocultural achievements and values lose their appeal and their purpose as guides to sociocultural action. That may be correct concerning a radical visual culture theorist but not concerning a moderate one. I will not shift further into the radical/moderate debate here. Alternatively, I will emphasize several

characteristics that I see as critical in the visual and cultural configuration of contemporary visual culture, characteristics that, additionally, are interrelated.

I will concentrate on the *presence of the now* within contemporary visual cultures. Contemporary visual cultures are becoming increasingly temporally multifaceted, and they are altering quicker than ever before. This makes it hard to understand what the consequence of the consumption of different visual representations will be. Contemporary visual culture is still dominated by visual representations, but they are not the same visual representations that dominated modern visual culture. Contemporary visual culture's visual representations are increasingly *luxury branded* (Armitage and Roberts 2016a).

One reason behind the increasing presence of the now concerning visual and sociocultural change is that the world of luxury as a world of refined and intense enjoyment is expanding. *Luxurious photographic, cinematic, and televisual selves* are increasingly determining contemporary visual culture. We increasingly live in a world in which, for example, luxurious photographic representations appearing as luxury fashion photography can have a vast influence on our understanding of luxurious selves and their pleasures, sumptuous subjectivities, and exquisite identities. This is as true for luxurious cinematic representations appearing as luxury lifestyles as it is for luxurious televisual representations appearing as luxurious values. We increasingly live today in a luxurious visual culture predicated on the time of the now (Benjamin 1970: 253–64).

But we also increasingly live in a *luxury brand–dominated culture of visual representations produced by contemporary fashion designers and contemporary artists*, from Chanel and Yves Saint Laurent haute couture to Louis Vuitton bags and BMW cars. An increasing part of our everyday life experiences is luxury branded: "pro-logo" instead of "no logo" (Klein 2010; Kapferer and Bastien 2012). It is increasingly through the luxury brand that we are conscious of what is appearing in other parts of the cultural world of visual representations. Visually consuming the visual culture of luxury fashion and the luxury-branded visual representations produced by contemporary fashion designers and contemporary artists plays an increasingly significant role in everyday life. With the aid of such a visual culture, involving its semiotics, luxurious visual representations, and language, it is possible to understand luxury fashion and luxury-branded visual representations produced by contemporary fashion designers and contemporary artists in everyday life. Our cultural narratives are increasingly fused with our luxurious visual representations (Barthes 1977a: 79–124).

Consequently, in my assessment, contemporary visual culture is increasingly characterized by *luxury-branded visual representations,* by *luxurious*

photographic, cinematic, and televisual selves, and by a *luxury brand–dominated culture of visual representations produced by contemporary fashion designers and contemporary artists.* These are the techno-structures and visual representations that more than many others make contemporary advanced cultures into contemporary visual cultures. By this, I do not imply that contemporary visual culture involves a total rupture with modern visual culture. There are continuities. We still live in cultures formed by visual representations of necessity and need, for example. However, in my view, the differences are powerful enough to merit this distinction: the range, the rate, and the amount of luxury-branded visual representations, luxurious photographic, cinematic, and televisual selves, and luxury brand–dominated visual representations produced by contemporary fashion designers and contemporary artists have enlarged to the degree that, rather than modern visual culture and modern culture studies, I prefer to write of contemporary visual culture and contemporary visual culture studies, and the techno-structures and visual representations that more than others form contemporary advanced cultures are the ones asserted here. Of these, the first two I will attend to in this chapter. The luxury brand–dominated culture of visual representations produced by contemporary fashion designers and contemporary artists will be addressed in Chapters 3 and 4.

Luxury-branded visual representations

One main characteristic of modern visual culture, compared with traditional visual cultures, is that visual representations change at an ever-increasing speed (Virilio 2006, 2009). Culture becomes ever more visually multifaceted, and the only invariable is change itself: all that is culture melts into visual representations. This is true too for contemporary visual culture. It could also be argued that the speed continues to accelerate. This can be observed, for example, in changes happening in visual-cultural discourses, in addition to changes in lifestyle choices. The acceleration in speed may not be so new. But, the quicker contemporary cultures change and the more visually multifaceted they become, the more problematic it becomes to spatialize or historicize the consequences of diverse types of visual and cultural action. Contemporary visual culture is more *in thrall to time filled by the presence of the now* than modern visual culture was (Benjamin 1970: 253–64; Virilio 2011).

I argue that visual representations in the form of advertising and advertisements on their way to contemporary visual culture have gone through three phases. In

the first phase, as graphic representations amalgamating the usage of visual and textual data, throughout the eighteenth and nineteenth centuries, "printed visual representations"—mainly the then recently emerging newspaper and journal media forms—functioned on the level of local or regional "classified notices" (i.e., classed or boxed according to different categories) notifying readers that goods or services were obtainable for their acquisition. These concerned, for example, lodging and foodstuff, dining and transportation. In this first phase, "information" is a more precise word than "advertisement" for a plain if valuable sort of announcement. In the second phase, in the twentieth century, "branded visual representations" of lifestyle choices and identity functioned on the level of a changing national and increasingly international cultural development in modern cultures: a development that incorporated multifaceted and costly forms of newspaper, magazine, and television advertising, large-scale billboard photographic images, cinema, and the increasing usage of internet computer formats (see, for example, Barthes 1972a; Williams 1980; Williamson 1978). The visual representations of advertising in these twentieth-century instances denote a complex, repeated, and methodical attempt to persuade visual consumers that they would be happier if they sported branded clothing, ate branded food, or drove branded cars (Lury 2004, 2011; Schroeder 2005). Now, in contemporary visual culture, visual representations have become increasingly "luxury branded" (e.g., Bottega Veneta leather goods, Balenciaga fashion design, Omega watches). The flow of luxury-branded visual representations and textual elements occurs on a global level within, for example, luxury fashion magazines or, increasingly, within contemporary art, which, more and more, represent successful methods of branding intended to convince luxury fashion magazine and art, photography, cinema, television, and social media audiences (Baudrillard 1998; Sassatelli 2007; Featherstone 2016a; Deloitte 2017). There is an increasing *movement* of luxury-branded visual representations (e.g., as luxury fashion, as produced by contemporary artists in everyday life, and as social media advertising) and luxurious selves (e.g., in photography, cinema, and television aimed at target luxury audiences) across the world. These luxurious selves and often sexualized luxury-branded visual representations move increasing distances and with increasing pace, making it progressively difficult to "locate" their luxurious sexualities and identities, thus making their luxurious history, consequences, and actions within an increasingly celebrity-endorsement driven contemporary visual culture seemingly still more branded, immaterial, ahistorical, and temporally filled by the presence of the now (Cashmore 2014).

Pace and change are significant issues regarding visual representations. The accelerating production of visual representations as signs (which represent concepts and are apprehended as marks that create or transmit meaning through their association with other signs) underlying branded visual representations is often called mass production, specifically, the development and production of branded visual representations, textual, and linguistic materials on a huge scale as inexpensively as achievable for an enormous group of linguistic and communication conscious viewers and analytical readers as consumers (Nixon 2016). To do this, branded visual representations must be consistent, and their preparation must be unified if linguistic and communicative relationships between culture, society, and meaning are to be established, maintained, and reproduced. This mass-produced, almost assembly-line, yet simultaneously creative production of branded visual representations is based on linguistic principles of communication that are valid not only to produce branded visual representations as a field of knowledge. They might equally well be applied to sociocultural descriptions, to photography, cinema, art, sports, and culture to highlight that language and communication can be used as tools, techniques, and processes of critical interpretation.

In contemporary visual culture, these branded visual representations are changing. Today, visual consumers are increasingly unwilling to accept a dearth of choice between alternative branded visual representations, or between alternative forms of the same branded visual representation. They want to make luxuriously branded choices. Also, with the faster speed of everyday life, visual consumers want luxury-branded visual representations for briefer periods of time. This means that the creation of luxury-branded visual representations as signs must be concentrated upon condensed linguistic, communication, cultural, and narrative structures (i.e., recounted fictional or non-fictional stories) with a possibility for variable meaning for a sometimes obsessive yet heterogeneous visual consumer group versus lengthy linguistic, communication, cultural, and narrative structures and standardized branded visual representations or signs for a homogeneous group of visual consumers. Within the niche production of contemporary visual culture, variability of meaning is the key to luxury-branded visual representations, signs, and their formation of cultural narratives (Barthes 1975, 1977a).

Moreover, the equilibrium of the creation of visual representations as signs is changing from branded linguistic, cultural, and narrative structures to luxury-branded codes or the conventions by which an individual element is accepted as belonging to a luxurious linguistic, visual, or cultural network of symbolic or

ideological meanings in a narrative sequence. What is increasingly being created as visual representations—and viewed as signs—are luxury-branded codes containing the primary structures that make luxurious signs more meaningful than others. But the luxury-branded code value in linguistic, cultural, and narrative structures, the luxury-branded code value through which such signs and their meaning are read, while theoretically limited, is also increasing its potential. Linguistic, cultural, and narrative structures are deconstructed, by creators of luxury-branded visual representations as signs and by visual consumers. Producers of luxury-branded visual representations as signs spend mountains of money on luxury-branded advertising that requires "reading" to be basically informed and on written textual design that completes the luxury-branded visual representation, and visual consumers buy into luxury-branded visual representations as signs that collate the "right" fragments of luxurious meaning for cultured people. The deconstructed and cultural constituents of luxury-branded visual representations as signs increasingly decide their value, meaning, and significance (Barthes 1977a).

Concerning the luxury-branded visual representations of pleasure, both as a concept and as a discourse of desire and gratification, amusement and enjoyment, it could be argued, first of all, that the niche production of contemporary visual culture is no more or less concerned with pleasure than the mass production of modern visual culture. The logic of the niche production of contemporary visual culture is different from the logic of the mass production of modern visual culture, but it is still based on branded visual representations of pleasure, of trying to shape a cultural order of luxury-branded visual representations, and subsequently the place and importance of pleasure within it. But, the niche production of contemporary visual culture requires more of its practitioners in luxury fashion and contemporary art, for example. Determinations of the cultural order of luxury-branded visual representations must be made quicker and based on less reliable information regarding how luxury-branded visual representations and visual consumers, through a myriad of relations, construct and seek pleasure today. Visual consumer pleasurable behavior toward luxury-branded visual representations is becoming increasingly and immediately interactive through social media and so on, founded on technological recognition systems, and thus discontinuous (Kapferer and Bastien 2012).

Second, visual representations are becoming more culturally multifaceted. In modern visual culture, cultural life became ever more pleasurable through an engagement with different if predictable sets of recognized visual-cultural relations and branded code systems. Culturally specific discourses and

depictions of pleasure made branded visual representations meaningful. Through various positionalities produced by these cultural signifying systems, branded visual representations became a central thread in the sociocultural fabric. In contemporary visual culture, these branded visual representations seem to continue to be a dominant conception in the sociocultural structure, but, within the context of our increasingly discontinuous history, at least some branded visual representations now seem to be decentered fragments of a torn sociocultural fabric.

On the one hand, the niche production of contemporary visual culture designates that visual consumers form meaning within their own cultural fields; they cannot be regarded as one homogeneous receptive group. This means that through the reception of different luxury-branded visual representations and through their testimony, enjoyment, and history, visual consumers culturally "participate in the figures, the faces, the gestures, the settings, the actions" (Barthes 1981: 26). There is an increasing level of participation when it comes to visual consumers' readings and use of visual representations of luxury-branded lifestyles. There is, also, an increasing participation on the level of culturally produced visual consumers and their interpretations of luxury-branded visual representations. The amount of interpretations of luxury-branded visual representations is increasing. If in modern visual culture it was common to participate in submissive interpretations of branded visual representations, for example, in contemporary visual culture it is common to participate in aberrant interpretations of luxury-branded visual representations—to read and use luxury-branded visual representations not in their intended fashion but *otherwise*. An analogous argument can be made for interpretations of literary or historical representations.

But contemporary visual culture is not only about participation in a cultural order and sensibility. I also argue that today we are increasingly seeing luxury-branded visual representations that *disturb* the cultural base of extant luxury-branded visual representations, luxury-branded visual representations wherein the characteristic spectacles of modern visual culture are disrupted. This can be observed in the relationships between pleasure and *jouissance* (the bliss of unsettling experiences of enjoyment or elation: Barthes 1975) and between luxury-branded visual representations and the visual consumer: at the base of the cultural order of luxury-branded visual representations is how the visual consumer situates, or is situated by, his or her response to luxury-branded visual representations. But it is also noticeable concerning visual consumers' readings and use of luxury-branded visual representations. The relationships between a

disrupted culture and order and between luxury-branded visual representations and the visual consumers' position are becoming ever more individualized, and so is the relationship between each visual consumer and the increasingly disturbing practices and constant effects of contemporary luxury-branded visual representations. The question of visual consumers' "investment" in luxury-branded visual representations has become more problematic in contemporary visual culture. The entire cultural configuration within which luxury-branded visual representations belong is questioned; there is no principle of meaning according to which the configuration is culturally ordered (Barthes 1982b).

In this setting of everyday life, it is pertinent to refer to what I call the *luster* (the quality or condition of shining by reflected light) of, as against the participation in, a cultural order and sensibility (Beauloye 2016). I argue that participation in a visual-cultural order and sensibility only signifies the moments where luxury-branded visual representations form either a backdrop in visual culture or become the concentration of it. It does not encapsulate one of the most vital characteristics of contemporary luxury-branded visual representations, specifically, the fact that, in contemporary visual culture, visual-cultural relations are not only increasingly glossy and metallic, pearly and silky but also increasingly removed from physical luxury contexts; they lose their essential connection to physical luxury fashion houses such as Louis Vuitton flagship and department stores. Instead, their roles are substituted and annexed by social media or digital luxury networks, chiefly the new socially mediated digital networks of the luxury fashion house. Visual consumers, now become users, can endlessly view and, crucially, re-view or re-use socially mediated and digital luxury-branded visual representations without face-to-face encounters. And the new socially mediated digital networks of the luxury fashion house (networks comprising fashion designers, luxury brands, supermodels, etc.) can catch the gaze of the visual-user through their sometimes subversive, sometimes "natural" luxury-branded codes that attempt to construct a whole and composed luxury-branded visual representation. This is one aspect of the luxury-branded visual representations that I associate with contemporary luxurious photographic, cinematic, and televisual selves.

Luxurious photographic, cinematic, and televisual selves

As argued above, contemporary visual culture is partially formed by visual representations typical of modern visual culture. But those visual representations are not the only ones having an influence on contemporary visual culture.

One other set of visual representations has become increasingly significant in contemporary visual culture: *luxurious photographic, cinematic, and televisual selves.*

Luxurious selves can be traced back to at least Greek and Roman antiquity in Europe (Berry 1994; Featherstone 2016b). However, luxurious photographic, cinematic, and televisual selves are a twenty-first-century phenomenon that is making an impact in more and more parts of the world of visual culture—a phenomenon that is not at all complete. They are, then, visual representations that have gained my increasing academic attention. Yet, I argue, luxurious photographic, cinematic, and televisual selves remain unacknowledged contemporary conceptualizations because they are currently not thought of as an important topic within any academic discipline, except critical luxury studies (Armitage and Roberts 2016a,b).

For me, one of the main ways to theorize luxurious photographic, cinematic, and televisual selves as a concept is to connect them to luxurious visual representations of subjectivity and identity in a variety of discursive contexts. In other words, I see luxurious photographic, cinematic, and televisual selves as visual representations of selves asking questions such as "who am I?" and as visual representations of selves asking questions such as "what am I?" I see luxurious photographic, cinematic, and televisual selves primarily as visual representations of selves asking who they are, which necessarily also involves them considering what they are, as in the luxury brand–dominated culture of visual representations of minds and bodies produced by contemporary fashion designers and contemporary artists. These visual representations undoubtedly have an influence on everyday life, and visual consumers and users are conscious of their presence. However, that does not mean that the visual representations necessarily provide either visual consumers and users or luxurious photographic, cinematic, and televisual selves with the answers to their questions such as "who am I?" as their minds and bodies think and move about in the worlds of luxury and visual culture as material and immaterial beings. In my view, it is more sensible to regard the visual representations as selves asking questions such as"who am I?" and to examine the role they have on visual consumers and users or luxurious photographic, cinematic, and televisual selves' questions and answers concerning who they are.

Accordingly, by luxurious photographic, cinematic, and televisual selves I mean those visual representations of luxurious photographic, cinematic, and televisual selves asking who they are, which unavoidably also involves them considering what they are, that make the world of luxury more open to question,

problematized, and altogether larger. The world of luxurious photographic, cinematic, and televisual minds and bodies and that of how they are related to one another is expanding through visual representations that we might call visual representations of luxurious subjectivity. Because of novel considerations of the nature of the self and many new related questions, luxurious photographic, cinematic, and televisual minds and bodies are increasing their significance. It is today possible to ask: what is the relationship between luxurious photographic, cinematic, and televisual minds and bodies? For, through the luxury brand–dominated culture of visual representations produced by contemporary fashion designers and contemporary artists, luxurious photographic, cinematic, and televisual minds and bodies are increasingly encountered and experienced all over the world. The luxurious visual representations and language of luxury fashion, as stated above, are but two examples of how the world of luxury-branded visual representations continues to expand into contemporary art and everyday life.

Luxurious photographic, cinematic, and televisual selves are not only about questions concerning luxurious photographic, cinematic, and televisual minds and bodies, though. The visual representation of luxurious photographic, cinematic, and televisual selves also involves the rise of visual representations of voluptuousness, the increase in visual representations of luxurious existence, increasing visual representations of luxurious morality and luxurious sensuality. And they most definitely include increasing questions and problems concerning luxurious time and thought. Luxurious visual-cultural configurations of the past and the present produce an immediate, crystallized moment: the now. We all increasingly live in what might be termed a luxurious visual culture predicated on the time of the now. It is a luxurious visual culture wherein luxurious subjectivity is a series of moments that we can imagine as loaded with conflict and possibility, as a visual-cultural discourse that can enlighten our investigations into luxurious experiences of temporal salvation, material, immaterial, and contemporary revelation.

One of the chief questions for research is to do with *luxurious photographic selves*. It involves twentieth-century and contemporary luxurious photographic selves. I argue that numerous visual and cultural issues collectively are reconfiguring the twentieth-century role played by luxurious photographic selves: a rising number of photographic selves take the form of voluptuous photographic selves; the contemporary ties between luxury and fashion photography tend to become stronger; luxury fashion photographers such as Annie Leibovitz have a twenty-first-century global emphasis; and, perhaps

above all, contemporary luxurious photographic selves increasingly give up their selfhood to voluptuousness, to the voluptuous pursuit of lasciviousness and sinfulness, to lavish sensuality and opulent identity construction.

A second key question is to do with *luxurious cinematic selves*. It involves the relations between luxurious cinematic selves involved in luxury lifestyles in twentieth-century and contemporary cinematic cultures, from Walter Lang's (1940) *The Blue Bird* to Harmony Korine's (2012) *Spring Breakers* (Kohn 2016). The visual representation of luxurious cinematic selves has led to the increasing visual representation of luxurious cinematic selves facing questions of lavish choice. But these questions are associated with the fragmentation and transformation of luxury lifestyles in contemporary cinematic cultures. They are based on luxurious cinematic selves having to deal with lavish choices: lavish choices involving luxury lifestyles in some contemporary cinematic cultures and criminal or voluptuous lifestyles in others. These visual representations of lavish choices are leading to a visual and cultural reconfiguration of the role of luxury lifestyles in contemporary cinematic cultures.

Increasingly, however, my attention has been focused on *luxurious televisual selves*. Like luxurious cinematic selves, luxurious televisual selves I associate with the fragmentation and transformation of luxury lifestyles in contemporary televisual cultures, from television series such as *Dallas* to *Billions*. A few new luxurious televisual selves, with those who are portrayed in new luxurious lifestyles as the undisputable front-runners, flaunt their luxurious televisual values (e.g., concerning their aesthetics of fashion, their political and cultural aims, or the validation of their own actions) to the rest of the world. I argue that the global influence of new luxurious televisual selves may be as powerful as other, equally well-known, forms of luxurious photographic and cinematic selves. Cultured people everywhere are increasingly visual consumers of new luxurious televisual selves and their new luxurious lifestyles.

In my view, new luxurious televisual selves are truly representative of contemporary visual culture. New luxurious televisual selves portrayed in new luxurious lifestyles are increasingly exhibited around the world, and the world is becoming progressively visually represented as luxurious, according to televisual selves portrayed in new luxurious lifestyles. Different televisual cultures have always affected each other, but never have the visual representations been so representative of contemporary visual culture, I argue.

Thus, the display of new luxurious televisual selves I associate with the fragmentation and transformation of luxury lifestyles in contemporary televisual cultures, with the portrayal of new luxurious lifestyles, with the parading of new

luxurious and multifarious televisual value patterns and inclinations such selves produce and brandish and their new voluptuous televisual behaviors as selves.

However, I am not trying to give a sentimentalized picture of what, for example, televisual values looked like before new luxurious televisual selves inflicted their new luxurious televisual beliefs and lifestyles on them. Most televisual values were not "good" in the sense that they were uncontaminated by "bad" influences. Rather, the televisual values had already, pre-new luxurious televisual selves and their new luxurious lifestyles, been formed through such moral binary terms: binary terms wherein traditional practices concerning "right" and "wrong" set the map for moral behavior.

Nor do I argue that the visual representation of the luxurious at the individual and the group level on television is essentially a bad or wrong thing. Indeed, I argue that there are numerous luxurious televisual moral maps that many cultured people as visual consumers probably would like to find giving their behavior direction all over the world: moral maps such as visual representations of scorn or affection, wealth, patriarchy, and power.

Moreover, it is vital to differentiate between the vaunting of, for example, new luxurious televisual selves and their lifestyles and the real moral consequence of the rightness and wrongness of these lifestyles. The rightness and wrongness of a new luxurious lifestyle is always taking place in a certain televisual and cultural setting, and the meaning of such right or wrong actions cannot be interpreted straight off the lifestyle. Different cultured people as visual consumers interpret comparable lifestyles in different ways contingent upon, among other things, visual and cultural experience. I will revisit this subject in more detail in later chapters.

Additionally, my sole concentration on visual representations of the luxurious is not intended to give a dubious picture of contemporary visual representations of photographic, cinematic, and televisual selves. I argue that it is not a question of ignoring visual representations of the non-luxurious, but rather of emphasizing the ways in which visual representations of the luxurious have become increasingly prevalent in everyday life across much of the early-twenty-first-century world of visual culture.

My point is that the visual representations in contemporary and increasingly luxury-branded cultures are quite multifaceted. They cannot be reduced to a solitary visual representation of a luxurious photographic, cinematic, or televisual self. Expounding on this assertion, we can differentiate between six different aspects of the movement of the luxurious that the visual representations affect: fashion (the movement of luxurious visual consumers, users, and brands,

luxurious languages, narratives, codes, readings, texts, and fragments); art (the movement of luxury brands, contemporary art, everyday life); photography (the movement of luxurious selves and voluptuousness); cinema (the movement of luxury lifestyles, the luxurification of cinematic culture, notions of lavish choice and voluptuousness); television (the movement of luxurious televisual values, inclinations, and voluptuous behavior); and social media (the movement from physical to digital luxury).

These different aspects all have their own interior logic, and they are bound by different types of restraints. Yet the association between them is not only increasingly immaterial but also increasingly eventful. The ways that, for instance, a specific new luxurious televisual self is affected by the luxurious cinematic self may have little to do with the movement of contemporary art, or with the representations displayed through global television channels to that new luxurious televisual self. The immateriality of these contemporary movements is also increasing; certainly, the pace, level, and quantity of each of these movements is today so immense that the immateriality of the contemporary has become fundamental to the luxuriousness of televisual and particularly socially mediated selves. It is in keeping with this cumulative immateriality that contemporary ideas of the televisual and socially mediated representation of the luxurious become important and multidimensional, influential, eventful, and affecting.

Luxury and visual culture

In this chapter I have examined, among other things, visual representations of selves asking questions such as "who am I?" that partially influence contemporary advanced visual cultures. I have accomplished this by employing the discourse of cultural studies and contemporary visual culture studies. In concluding this chapter, there are several features of my examination that need to be emphasized.

First, in utilizing the concepts of cultural studies and contemporary visual culture studies, it was essential to explain that I employ these in what could be called a contemporary "visual" way. Namely, my standpoint on visual representations is one that is not opposed to as different from multilinear and undetermined ways of regarding visual and sociocultural changes. As I argued, the development of modern visual culture is the consequence of the complex interaction between many different visual representations. It is in this context that Barthes (1977a, 1984) alludes to the meanings, languages, and readings of

visual representations typical of modern visual culture as volatile. It does not mean that the visual representations are random, but it means that the result of the articulations between the visual representations are always historically, visually, and culturally specific. I concur with the above-labeled image of modern visual culture, but I would add that the trait is still more pertinent for contemporary visual culture. The surprise of contemporary visual culture and its study is that its course is unstable: the one stability is ongoing instability.

Second, in this situation, I concentrated chiefly on the significance of visual representations of luxurious photographic, cinematic, and televisual selves. The different movements of luxurious visual representations, as considered, reconfigure the twentieth-century roles played by visual representations and establish novel twenty-first-century associations between selves and visual representations. They have furthermore led to my rethinking of the role of luxurious visual representations of selves as visual representations of selves for the sense of visual-cultural voluptuosity. As I argued, visual representations of selves and contemporary visual culture are now open to question, to problematization, within a twenty-first-century luxurious environment. The luxurious visual representations of modern visual culture produced the luxury fashion photography of Edward Steichen (Ewing and Brandow 2008). The luxurious visual representations of contemporary visual culture are altering the nature of that luxury fashion photography under the influence contemporary luxury fashion photographers such as Annie Leibovitz.

The visual representations of luxurious photographic, cinematic, and televisual selves, moreover, have involved my significant rethinking of what modern visual culture was about; it has led me to retheorize, critique, and reconceptualize usually held viewpoints on modern visual culture as having one set of unified systems of knowledge and graphic representation expanded in Florentine renaissance society (Baxandall 1988). There were countless pathways to modern visual culture, not all of them to do with visual abilities and methods, computation, and ordering rules. And if we are to concentrate upon contemporary visual culture, perhaps our interest should be aimed toward luxury-branded visual representations and luxurious photographic, cinematic, and televisual selves, not fine art and anti-commercial visual cultures. These visual cultures and representations are luxurious, branded, and, crucially, produced by contemporary luxury fashion designers and contemporary artists from Karl Lagerfeld to Damien Hirst.

Lastly, it should have become obvious in reading this chapter that when debating the visual representations of contemporary visual culture, I did not

elucidate the implications of these visual representations in any detail. I did not say what effects these visual representations have had on cultured people as visual consumers and users in contemporary advanced visual cultures. There is a straightforward explanation for this. Visual representations of selves asking questions such as "who am I?" do not function that way on cultured people as visual consumers and users. We cannot reveal anything meaningful about the role of these visual representations until we relate them to luxurious photographic, cinematic, and televisual selves, until we relate them to how such selves in visual-cultural contexts act and react within these visual representations. That is the purpose of subsequent chapters.

3

Luxury and fashion

How are luxury-branded visual representations produced by contemporary fashion designers configured? What are their effects? How are luxury-branded visual representations read, and what kinds of luxury-branded visual representations are read by which visual consumers? One of the chief concerns of this chapter is to explore the concept of the visual consumer noted in the Introduction and broadly examined in Chapter 2. For, unlike the idea of the viewer, which might be used to describe a cultured person inspecting or examining representations, or the notion of the spectator, which could be employed to explain a cultured person who sees or looks on at representations of specific scenes or occurrences, a visual consumer, I argue, is more than a viewer or spectator. This is because the visual consumer is a cultured person who sees, observes, or catches sight of, for example, a contemporary Chanel luxury-branded visual representation not as a casual viewer or spectator but as a potential or actual consumer, as a cultured person who absorbs luxury-branded visual representations. In this sense, a visual consumer is a cultured person who looks at luxury-branded visual representations with, on the one hand, visual care and attention, but, on the other hand, a view to desiring, if not necessarily purchasing and using up, the luxury-branded commodities and services portrayed in their visual representations; a cultured person who closely observes their own and others' longings associated with the acquisition of luxury-branded goods and services or scrutinizes their visual representations as a possible or real customer; and a cultured person who sets out to view luxury-branded visual representations differently from their producers. A visual consumer is thus a cultured person who is attentive to the visual culture of luxury and its contemporary luxury-branded visual representations, its semiotics, narrative structures, language, codes, texts, voice, meaning, and sociocultural order, inclusive of the visual culture of luxury and its contemporary luxury-branded and other luxurious visual representations in art and photography,

cinema, television, and social media. This chapter therefore explores luxury-branded visual representations by concentrating on how they are read by visual consumers within the visual culture of luxury fashion—the prevailing luxury styles, customs, and manners in dress and behavior or luxury garments in the current mode—mainly, how luxury-branded visual representations constitute an essential ingredient and exemplification of the visual culture of luxury fashion and how such a configuration forms the visual culture of luxury fashion. A theoretical method is adopted, examining the role of visual consumers and their effect on luxury-branded visual representations of fashion. The interactions between visual consumers, culture, and luxury-branded visual representations of fashion will be discussed regarding the theoretical works of Roland Barthes (1972a,b, 1974, 1975, 1977a,b, 1979, 1980, 1981, 1982a,b, 1983, 1984, 1985a,b, 1986, 1987, 1988, 2002; Barthes, Stafford, and Carter 2006) to understand how they develop a foundation for analyzing the visual culture of luxury fashion. This chapter also delineates the semiotics of luxury-branded visual representations and how the visual consumers' individual and sociocultural collective act of reading is vital in the configuration of luxury-branded visual representations. Barthes's (1972a) semiotics is an interdisciplinary innovation that arises from linguistics and structuralism—the methodology that, among other things, suggests components of human visual culture should be comprehended through their relationships to an all-embracing structure (Sturrock 2003: 74–97). In Barthes's account, semiotics is an investigative procedure that explores the relations between culture, society, and meaning and their subsequent configuration as an area of knowledge. Barthes uses semiotics (as do I in this and the succeeding chapters of this book) in sociocultural fields such as fashion and art, photography, cinema, television, and other media to demonstrate that it can be employed as a tool or as a method during analytical interpretation. Thus, it is how luxury-branded visual representations are socioculturally shaped in luxury fashion in which we are involved, interrogating the creation and facility for signification of luxury-branded visual representations.

The subdiscipline of luxury and visual culture is engaged with studying luxury-branded visual representations as concepts functioning within and from a variety of media sources. The goal is to connect with all types of luxury-branded visual representations so that in contemplating the configuration and purpose of luxury-branded visual representations, new contemporary ideas of luxury-branded visual representations and critical methods of understanding can appear. This chapter therefore re-visualizes luxury-branded visual representations, exploring how they are shaped, read, and produce meaning in culture through

examining their techno-structures and then reconstructing them so that there is a different awareness of luxury-branded visual representations and their position in the visual culture of luxury fashion.

Visual consumers and the visual culture of luxury fashion according to Roland Barthes

In this re-visualization of luxury-branded visual representations, it is essential to look again at their individual components, to consider how, for example, images of luxury objects and their accompanying written text combine to produce the final luxury-branded visual representation. Every luxury-branded representation of fashion starts with a visual and semantic structure—with, for example, a color, a photograph, a logo, a written caption, a strapline, a statement. It is this visual and semantic structure that I am employing to explore Barthes's hypotheses concerning signification and how signs hold meaning, to aid us to configure luxury-branded visual representations in culture, and how the luxury-branded visual representation, as a network of signification, possesses meaning in sociocultural discourses concerning luxury fashion. The components of the luxury-branded visual representation I will discuss are concerned with the place of the luxury-branded visual representation, its effect, and how culture assimilates the luxury-branded visual representation and vice versa.

Chiefly, Barthes was absorbed in how a luxury-branded visual representation's potential for construction and ownership of meaning is fulfilled. He was attentive to how we understand luxury-branded visual representations, what it is about them that permits us to make cultural meaning of them. Employing literature as his model, Barthes concentrated on viewing a "text"—any meaningful structure, understood as being composed of signs that stand for, refer to, or represent something else—as a series of "codes" (a set of culturally recognized rules that guide how a text may be read) that literature created, and he investigated how these functioned as literary works and their significance in the discursive practice of culture. Relating Barthes's system of thought to luxury-branded visual representations is difficult because it is problematical to detach the subject of representation from the luxury-branded visual representation in view of the cultural codes and discourses through which we have been taught to understand them. Nevertheless, what Barthes's structuralist style of thinking concerning the luxury-branded visual representation does is focus our understanding on the codes that arrange the luxury-branded visual representation's meaning.

Hence, we can consider luxury-branded visual representations as systematic and massified, multifaceted, and complicated sociocultural relationships that are arranged in specific ways to create a diversity of meanings. To exemplify Barthes's method, I will turn to his visual and semantic structural exemplar of the color blue in luxury fashion.

In his essay "'Blue Is in Fashion This Year': A Note on Research into Signifying Units in Fashion Clothing," Barthes (Barthes, Stafford, and Carter 2006: 37–53; original italics) reads in a luxury fashion magazine that "*blue is in fashion this year.*" It is a visual (the color "blue") and semantic structure, one of many that Barthes calls "suggestions" (2006: 37). "I see," writes Barthes (2006: 37; original italics), "imposed upon me a link of equivalence between a concept (. . . *fashion this year*) and a form (. . . the color *blue*), between a signified and a signifier." On one level, blue as a visual and semantic structural representation of luxury-branded fashion seems to ask "what do you believe this sign represents?" or to inquire "what do you think this color of fashion clothing represents?" Its involvement with the visual consumer commences on the level of visual and semantic structural representation and introduces a potential discourse. In any case, are we not trained to "see" luxury fashion magazines or luxury-branded visual representations as representatives of meaning? To connect with "blue is in fashion this year" on this explanatory level, though, is to overlook its visual and semantic purpose and its structural sociocultural status. What "blue is in fashion this year" does is to "suggest" networks of visual and semantic structural relationships that can be "seen" by visual consumers when decoding luxury-branded visual representations and their written texts such as a logo. "Blue is in fashion this year" asks to be interpreted as a "suggestive" luxury-branded visual representation and written text, through its self-reflexive location, and seeks an uncritical understanding from its visual consumers. By only being a visual and semantic structure of "suggestion," such luxury-branded visual representations and their written texts do not query the random character of signification. It "suggestively" utters that "blue is in fashion this year" represents the contemporary sign of luxury clothing, but in fact represents a *visual and cultural imposition* (blue *is* in fashion this year), a visual and cultural idea of luxury-branded visual representations and their written texts that also dissuade visual consumers from re-visualizing and re-reading them, from becoming conscious of their dependence and silence on cultural codes concerning the interpretation of luxury-branded visual representations and their written texts. Imagery and its written textual use are left unquestioned—why can't "blue is in fashion this year" represent fashion clothing? Yet in seeing "blue is in fashion this

year" as a visual and cultural imposition (and later pointing out the utilization of color and its status within visual cultures) what Barthes highlights is the sociocultural configuration of luxury-branded visual representations and their written texts as replete with links of equivalence, as a mesh of concepts, cultural and temporal fashion codes, written forms, colors, and seemingly haphazard networks, socioculturally configured through such relationships. Barthes also seeks to make the visual consumer conscious of the link of equivalence between a signified and a signifier with a view to eliciting critical acts of reading such configurations. Consequently, Barthes's essay not only disputes and disturbs the network of, and sociocultural reaction to, luxury-branded visual representations and their written texts concerning the color blue but also exposes the randomness of color in fashion that has been arranged to create specific visual and written textual consumer locations and reactions to signs and to luxury fashion clothing.

From such visual and semantic structures, we can see how these relationships are shaped, arranged, and joined to create meaning. Contemplate Barthes's interrogative approach concerning relationships of signification. Barthes's methodology of investigating the "how" and "why" concerning visual and textual meaning is a novel style of philosophy and his influence here for the luxury-branded visual representation is that of querying its *ability* to culturally signify meaning in individual discourses. Barthes's articles on fashion and art, photography, cinema, television, cultural idols, and luxury-branded visual representations all ask the same question: how does the structure of a visual and/ or textual representation contribute to its meaning? In *Camera Lucida* (1981), Barthes writes of the photograph giving "a little truth, on condition that it parcels out the body. But this truth is not that of the individual, who remains irreducible; it is the truth of lineage" (1981: 103). Yet his understanding of the photograph is not the understanding of a written text: "Photography's Referent is not the same as the referent of other systems of representation. I call 'photographic referent' not the *optionally* real thing to which an image or sign refers but the *necessarily* real thing which has been placed before the lens" (1981: 76; original italics). Barthes's (1981: 107) examination is centered on the arrangements and cultural influence of the photograph, along with, for instance, his understanding of the photograph's evidence as "a matter of being." His remarks on the well-known American luxury fashion photographer Richard Avedon's (1923–2004) photograph of "A. Philip Randolph," the former leader of the American Labor Party, acknowledge this "truth" or "real thing" that is present in photographs. Barthes thus differentiates between the photograph as a technological medium with a cultural currency and as a discrete visual representation.

For Barthes, the photograph only exists in culture, and in *Camera Lucida* he interprets photographs in luxurious terms, in terms of his pleasure as a visual consumer and examines the character of the photograph through such pleasure. Barthes (1981: 107–10) is exploring photographs of his late mother. For him, these photographs offer a truth or real thing that is discovered in the network of relationships that shape the sociocultural discourse still in existence and identifiable between himself and his mother. We can merely read about Barthes as visual consumer in terms of these photographs of his mother. But, in so doing, we can view how they signify and are fashioned through this sociocultural discursive practice that exists between Barthes and his mother. Barthes (1981: 109) writes of "leafing through" photographs of his mother and of his sorrow at looking at them, showing that the configuration of the structure of a photograph happens through the act of reading.

What this examination of the photograph designates is how dominant the photograph and thus by extension the luxury-branded visual representation is in culture. It is imperative to appreciate that how we as visual consumers view the photograph as a luxury-branded visual representation is invested in the recognition of photographs in their series (in their siting in culture, in the sequence of relationships that situate them) over and above their evocation of other photographs as luxury-branded visual representations that signify identical meanings to the initially viewed photograph. In *Camera Lucida*, Barthes (1981: 110) introduces the photograph by Avedon called "A. Philip Randolph," in which Barthes reads "an air of goodness." Yet he has been debating the photographs of his deceased mother "according to an initiatic path" (1981: 109), which finally leads him to "that cry, the end of all language: 'There she is!'" This placing of Avedon's photograph of Randolph in Barthes's recollections exemplifies how a photograph signifies through a sociocultural configuration of a specific discursive practice. For the reader or visual consumer, it is unimportant that the photograph of Randolph, which, for Barthes, is a "luminous shadow" (1981: 110), is not Barthes's mother. This is because, alongside Barthes's (1981: 110) account, the visual consumer identifies the photograph of Randolph's air and goodness, of his luminous shadow, body, life, and "transparent soul" as germane to Barthes's book and to the photographs of his departed mother, entirely founded on its textual positioning.

The Avedon photograph of Randolph is underlined with a quote, "No impulse of power," along with the name and date (1976) of the photograph and the photographer (Barthes 1981: 108). The Randolph photograph is, much like Barthes's (1981: 110) mother's photographs for Barthes himself, a photograph

of an impulse, a "bright shadow," but also of a subject which will lose its power and perish forevermore. The discourse and structure of narratives illustrated by photographs is, of course, a common one. Here, Barthes is playing with the placement and creation of the photograph and the connection between written text and photograph by detecting the manner through which photographs signify. He employs culturally recognizable and comprehensible discursive practices for the visual consumer to acknowledge and participate in. These are the discourse of heartache—leafing through the timeworn photographs of his departed mother to memorialize her and remember her "individual expression," and the discourse of the structure of lineage, of "likeness," here Barthes (1981: 109) "rediscovering" his mother. This structure of sociocultural relationships and practices aids him in stressing that every photograph and its ensuing explanation is separate yet connected within a code. Additionally, he infers the pleasure or "sudden awakening" (1981: 109) that he, as a visual consumer himself, receives from connecting with photographs like this, a pleasure "in which words fail."

Avedon's photograph of Randolph is of an aged black man with gray balding hair, and it is appealing to read Randolph as further "evidence" of Barthes's mother's air, as somehow a further expression of her truth (1981: 109). This emphasizes how the photograph and thus the luxury-branded visual representation effortlessly slide from the particular (Barthes's mother's identity) to the general (human acts of kindness), which is part of the recognition of the photograph and how we can acknowledge its location concerning culture (the codes that acknowledge this is a convincing representation of an elderly black man—a likely subject of importance) and regarding other photographs of the same time and style. For Barthes, this photograph functions on the level of Randolph's air expressing "the subject, insofar as that subject assigns itself no importance" (1981: 109). In his text, the declaration "No impulse of power" appears under the photograph of Randolph (1981: 108). The representation of Randolph is clearly not one of a being that Barthes loved impulsively, but in discussing such a declaration Barthes calls to notice being and the power of love and the ongoing conflict between being, love, and the photograph. Barthes's declaration "No impulse of power" also exemplifies our impulsive investment of faith in familiar written words such as "mask" and "soul" over his powerful image of air as a way of seeing people's faces and lives, yet simultaneously too perhaps exemplifies the visual consumer's wish to contest Barthes's (1981: 110) own idea that Randolph's air in the photograph might be "moral" or contribute to his face the expression of a life of worth. With Avedon's photograph of Randolph, Barthes reads "an air of goodness (no impulse of power: *that is certain*)" (1981: 110;

original italics), but as visual consumers we may wish to interpret Randolph's air, goodness, impulse, and their power in the formation of this specific text's meaning differently.

In comprehending the nature of the visual and semantic structure of photographs, and thus of luxury-branded visual representations, we are interrogating their sociocultural composition—how photographs and luxury-branded visual representations play a part in culture and function structurally. Photographs and therefore luxury-branded visual representations are a network, a sociocultural construction of protocols, "laws," and codes, and Barthes is an important analyst of such networks. The visual consumer's critical task in examining photographs as luxury-branded visual representations is to undertake an active position and to understand luxury-branded visual representations as cultural creations, recognizing their important location in the network of luxurious visual production and meaning within visual culture. The visual consumer must engage with photographs from a critical viewpoint, uncover why luxury-branded visual representations signify what they do, and how they possess the ability to do so. From this perspective, the visual consumer can examine and understand luxury-branded visual representations as sociocultural creations that are configured through discursive structures.

On the semiotics of luxury-branded visual representations: The narrative structures and language of luxury fashion

Luxury-branded visual representations are repeatedly being situated as culturally configured structures of sociocultural discourse. To understand this ability and function of luxury-branded visual representations and their cultural significance, luxury-branded visual representations must be re-visualized. Viewed beyond their usual functioning, networks of luxury-branded visual representations interrupt inactive viewing locations and are detached from their planned intention, which is to remain undisputed, "unseen," or as a "natural" feature of culture. Barthes's influence arises from his structuralist philosophies, which considered sociocultural experiences as exchange commodities stemming from random networks such as language. Barthes argued that everything in culture is a creation: cultural pretenses and deceptions (luxury-branded visual representations, texts, lifestyles) are not natural; however, throughout the relationships that create their meaning, they can seem a natural constituent of culture.

To examine how such pretenses and deceptions make meaning, Barthes contended that it was essential to evaluate the networks that amalgamated to make the signification achievable. Barthes was involved in how these organized relationships interwove to configure meaning and how the structure of these relationships functioned in sociocultural discourses. To expose these random structures of signification, Barthes (1972b: 260) referred to linguistic and literary subjects to examine how literary structures were configured into a network. He examined narratives from literature (Balzac, Flaubert, Proust, and Robbe-Grillet) employing linguistic philosophy to separate and discern the structures of relationships that configured the "literariness" of these literary narratives.

It is difficult to utilize Barthes's linguistic examinations within the context of luxury-branded visual representations, particularly as written text, if present within the luxury-branded visual representation, is typically negligible or a component of seduction and vagueness. In decoding the luxury-branded visual representation, though, there is a type of interpretation. As visual consumers, we take part in the luxury-branded visual representation in comparable ways to how we take part in written text—we try to uncover its cultural meaning, and society has founded the discursive practice that "luxury fashion" means something, or that a luxury fashion designer is attempting to express an otherworldly "sensation" or idea. We ask: "what does a Chanel jacket mean?" or "what is it endeavoring to transmit?" Our awareness of meaning and Barthes's writings on narrative structures assist us to comprehend our visual consumer's mania with the meaning of a luxury-branded visual representation. What configures a narrative? What groupings create dissimilar narratives? Why is applying narrative structure to a luxury-branded visual representation such an attractive thing to do? Why are certain narratives such as those associated with luxury selected over others as having elevated cultural importance? Barthes strove to answer such questions through studying narratives.

In several essays gathered in *The Language of Fashion* (Barthes, Stafford, and Carter 2006; see, also, Barthes 1977a: 79–124), Barthes performs structural investigations of narrative. He expounds a semiotic methodology to expose how structure produces meaning. This permits him to critically explain discourses as networks and components of greater discourses, as networks of relationships that are joined to configure meanings. In interrogating narrative and its purpose, he claims that a chief concern of structuralism must be to ascertain the fragments that comprise a text and to define the language through which they are interpreted. The intention was to elaborate a method for examining narrative networks and structures that would help discover a general structure

that gathered these networks and discourses together within a text to create a narrative. He recognized that narrative structures were varied in their consumption and their production, and he understood that narratives must be examined separately to unearth their distinctive structures. Nevertheless, Barthes argued against a preordained author that could answer any queries of meaning from the narrative. He examined the influence of such methods through narrative structures, sometimes employing examples from French luxury fashion culture.

In "The Contest between Chanel and Courrèges. Refereed by a Philosopher" (Barthes, Stafford and Carter 2006: 99–103), Barthes utilizes the French luxury fashion design cultural icons, Coco Chanel (classical, elegant, sensitive) and André Courrèges (futuristic, innovative, rash), to critique their narrative significance and siting (both in fashion and in society) in French luxury fashion culture. His examination of Chanel and Courrèges's presence and impact on the French populace reveals their visual and temporal meaning as culturally structured fashion design icons through unraveling their "aesthetics of clothing" as the signification of "chic" or the rejection of "the look of newness" (2006: 100):

> "Chic," this subliminated time, is the key value in Chanel's style. Courrèges' ensembles by contrast do not have this fear [of the look of newness]: very fresh, colorful, even brightly colored, the dominant color in them is white, the absolute new. (2006: 100–101)

Chanel and Courrèges are, respectively, signifiers of French "chic" and "brand-newness" so that upon understanding their relationship to subliminated time, one gets a temporal view of French values and Parisian style. From this standpoint, the visual consumer can see Courrèges's fresh style and because of the power of the cultural signifiers, he or she is conscious that Courrèges's colors, brightness, and whites mean *"the absolute new."* We do not just observe a style but rather we observe connotative signs of "extreme youthful fashion" (2006: 101). While Barthes (2006: 101) analyzes Chanel and Courrèges's structural entrenchment in French luxury fashion culture to emphasize their contributions to its narrative configuration and purpose, the visual consumer of Chanel and Courrèges's fashion designs references their use of colors as structures, as cultural creations out of the meaning of the "brand" and the "new" and as an abstract "brand new" being created out of Chanel and Courrèges's cultural discourses and "grammar," to methodically disclose the technique through which another structure of value (style) produces meaning (what characterizes *"the absolute new"*). Chanel and Courrèges's classical and futuristic fashion designs thus stand and operate

as luxury-branded visual representations. It is owing to their national and international chic and "brand-newness" that Chanel and Courrèges's fashion designs are more than a visual barometer of feminine style and more than an indicator of lifestyle. This path of thinking directs us to Barthes's concern with cultural narratives and luxury-branded visual representations.

Cultural narratives and luxury-branded visual representations: Karl Lagerfeld and Chanel

Barthes's (1972a) interest is in the networks and structures in cultural discourses that apparently shift from mythology to reality. These networks and structures generate and maintain sociocultural discourses, which, in order, configure cultural narratives. Cultural narratives? Cultural narratives for our objectives are concerned with the significant bearing their configuration holds for the luxury-branded visual representation. Cultural narratives explain and classify the way culture represents or communicates itself. Cultural narratives are performed through any meaningful or representative medium, particularly visual mediums, for example, art and photography, cinema, television, and social media. Culture builds narratives from systems of relationships, from social discourses, so that these randomly selected signifiers are identical with the culture (e.g., Coco Chanel or André Courrèges). These relationships can incorporate such discourses as luxury fashion to literally configure a tale, an account, a yarn, a legend. An instance of a German cultural narrative staged visually can be discovered in the figure of the luxury fashion designer Karl Lagerfeld (1933–2019) (Figure 3.1), former head designer and creative director of the luxury fashion house Chanel. Lagerfeld's identity was a formation and manifestation of a particular, not to say peculiar, mix of German and French cultures and lifestyles, and part of this procedure was a luxurious visual-cultural narrative.

Here, Barthes's valuable methodology of critically explaining narrative structures aids us in understanding how luxurious visuality is invested with and in cultural narrative. In Karl Lagerfeld we can locate a web of relationships that have coalesced to create a luxury-branded visual representation of German–French luxury fashion culture. His clothing (sharp gray or black suits, dark glasses, neat silver haired ponytail, smart shoes) signified the creative director of Chanel of Paris in luxurious surroundings (therefore the contrasting gray with the white coloring of his high-starched shirt collar and black trousers)—a being attached to the realm of luxury fashion, as if nearly all Parisians are of this type,

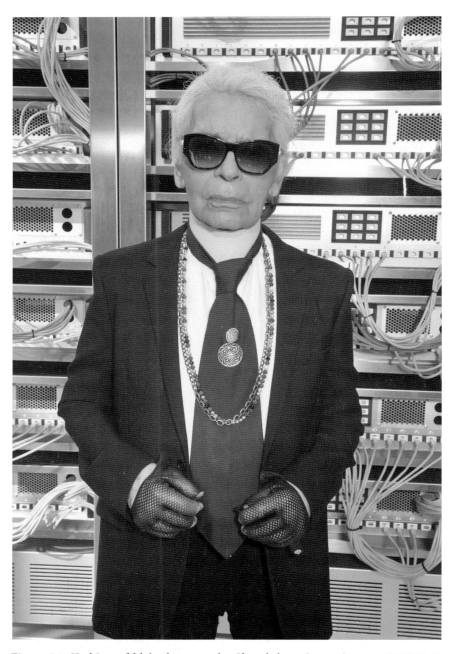

Figure 3.1 Karl Lagerfeld, backstage at the Chanel show, Spring Summer 2017, Paris Fashion Week, France, October 4, 2016.

Photo credit: Swan Gallet/WWD/Shutterstock.

which they aren't. Affixed to his clothing, which always also included luxury silver jewelry and belt buckles as well as black leather fingerless gloves, was Karl's profession: head designer and creative director of Chanel and the Italian luxury fashion house Fendi, of his own luxury fashion label, Karl, and a collaborator on various luxury fashion art-connected and photography projects. Simply with these straightforward extractions from what was Karl Lagerfeld, we can observe how a mixture of discourses (such as French luxury fashion and art) creates a system of relationships that contributes toward the configuration of a narrative structure and, then, a cultural narrative. The more the luxury fashion celebrity Karl Lagerfeld was dispersed through the visual medium, the more his luxury-branded visual representation was identical with Parisian luxury culture. His "character" was not only part of the French and Italian luxury fashion scenes but also part of the global luxury fashion scene, signifying that his characteristic white hair, dark glasses, and high-starched collars *were* luxury fashion for many.

Additional instances of how the luxury-branded visual representation is invested with cultural narrative are discovered in, for example, Chanel advertisements. Like Barthes (1977a: 32) in "The Rhetoric of the Image," we can examine an advertisement shot by Karl Lagerfeld, an accomplished photographer, for a Chanel spring campaign featuring Gisele Bündchen—the Brazilian supermodel, actress, and one of the highest-paid supermodels in the world—to answer the question: do luxury-branded visual representations "produce true systems of signs and not merely agglutinations of symbols?" Here we can explore the Chanel advertisement and assemble it into three messages to expose its structure. Like Barthes, what we need to do is to methodically inspect the Chanel advertisement through these three messages (linguistic, denoted, and connoted messages) to locate this luxury-branded visual representation as a visual-cultural narrative in a sociocultural context. In studying the configuration of the luxury-branded visual representation (the three messages functioning akin to layers), we can detect what allows the visual consumer to interpret and take part in visual-cultural narratives. How any sensation is configured of a luxury-branded visual representation of a supermodel, a café, some cars, some road signs, a road, a reflection, all arising from an urban night scene, in monochrome on a white background, depends on how this typology of luxury-branded visual representation is handled in France at large and in additional cultural contexts. While I am an Englishman perusing a luxury advertisement in England, part of my searching through of my three messages is appropriate to all cultures as a visual sensation occurs ubiquitously for each visual consumer—this is the configuration of cultural narrative through the visual. From here we can

reveal that part of the configuration of a visual-cultural narrative includes this conception of a visual sensation—but how is this configured and where does one obtain it?

Visual sensation shifts the visual consumer nearer to the luxury-branded visual representation through identification of cultural identity and performance. In our Chanel advertisement, the monochrome that has been selected is not even French but "Parisian," and the café represents a Parisian café. But, these meanings are only created visually as they rely on knowledge of the significance of the Parisian Café de Flore, and by way of this knowledge is detection of the philosophies and practices of Parisian coffee house culture. With this kind of visual illustration, it is simple to understand how stereotypes are configured, upheld, and constantly return as a method in luxury and other forms of advertising: consider, for instance, the Chanel advertisement's visual referencing of the Café de Flore. Here we have the monochrome lettering on the awning of the Café—located at the corner of the iconic Boulevard Saint-Germain and Rue Saint-Benoît, in Saint-Germain-des-Pres in the sixth arrondissement—and in the arrangement of the clothing of the attractive supermodel, posing in the publicity campaign outside a café famous the world over for its well-known customers such as the Spanish artist Pablo Picasso. The visual sensation of this advertisement is monochrome, which is representative of the black and white photographs of the Parisian café in its prime from the 1880s onward, and reproduces the philosophies of the French Third Republic, of Flora, the Goddess of flowers, and the season of spring in ancient Roman mythology. Buy Chanel and you will buy *into* the mythology of the Café de Flore and dress like Parisians do. Investing in cultural narratives through the visual thus influences a visual consumer's subjectivity, beliefs, and, eventually, a culture's self-understanding.

Identifying codes: Yves Saint Laurent

Narrative structures identify, contribute to, and/or oppose literary, visual, and cultural codes. Configuring the networks and structures that make meaning, codes are the main structures in rendering specific signs more meaningful than others. Consequently, notwithstanding the ability signs have for meaning, the codes through which they are read by contract and enlarge this ability. Codes function like enclosures, picture and photograph frames, cinema, television, and computer or mobile phone screens, as they frame the possibilities for

understanding. An instance of this is the accumulation of genres in luxury fashion (Kapferer and Bastien 2012: 44–45). With the Yves Saint Laurent brand, for example, a visual consumer's understanding is usually based on Yves Saint Laurent as a luxurious creator of "haute couture gowns, unique models manufactured by seamstresses in the workshop on Avenue Marceau in Paris," while with Yves Saint Laurent Couture Variations (perfume, make-up), the same signs are employed to mean "luxury" but the code through which they are read is changed to be "an upper-range brand . . . manufactured in France by the Mendès company" (Kapferer and Bastien 2012: 45). Accordingly, Yves Saint Laurent Couture Variations is removed from the creator and self-reflexive, in addition to being an upper-range brand for perfumes and make-up.

Another feature of a code's purpose is the partiality for some signs above others. The code of viewing a Yves Saint Laurent haute couture gown is dissimilar to the code of reading the sentence "Yves Saint Laurent Couture Variations, manufactured in France by the Mendès company." Which code permits which signs to mean and to control meaning? There is no answer to this question: however, it emphasizes that this component of configuration in a code is an essential ingredient in the act of reading. Here the visual consumer can imitate, oppose, and/or play on the favored signs in a code. The visual consumers' options are replies to the code's contribution to the creation of meaning, to the network through which signs are conjoined and structured. Like Barthes, we are concerned with the influence of codes and how their methodical structuring makes meanings for certain signs over others, and how the act of reading makes meaning from signs. From this structuralist viewpoint, literary and other meanings are configured and produced by identified codes within sociocultural discourses: received and comprehended by visual consumers, such meanings often remain unimportant components when reading luxury-branded visual representations. And, like Barthes's (1972a), our program is to analyze codes and interrogate the cultural instants where they continue undisputed and are signified as "natural."

Barthes argues that the role of visual consumers is to actively read texts, to question them, and, importantly, to interrogate their *own* viewing location within the system of cultural relationships. Visual consumers create meaning through their acts of reading that imitate, oppose, and/or play on the narrative structure of luxury-branded visual representations. For Barthes, a text's meaning is configured by the act of reading, which places and positions it within culture. The viewing of luxury-branded visual representations is what assigns their meaning and their connection to culture.

For visual consumers of luxury-branded visual representations, this means that it is the act of reading luxury-branded visual representations that contributes to their cultural meaning. Significantly, while Barthes authorizes the reader as a being with responsibility in reading a text, it is a role in reply to and in communication with a text that he is delineating. This "I" as a visual consumer, writes Barthes (1974: 10), "which approaches the text is already . . . a plurality of other texts, of codes . . ." Reading, therefore, "is a form of work" wherein our "task is to move, to shift systems whose perspective ends neither at the text nor at the 'I'" (Barthes 1974: 10). Thus, for luxury-branded visual representations and luxurious visual cultures, it is within visual consumers' act of viewing, and succeeding reading, where meanings are configured. As this meeting between visual consumers and luxury-branded visual representations happens, the act of viewing becomes a supplement to our increasingly luxurious visual culture. This is true even if visual consumers have not observed a specific luxury-branded visual representation before since they will have observed other luxury-branded visual representations. So, acts of viewing are the chief components of luxurious visual culture owing to this buildup of luxury-branded visual representations and our acquaintance with them. This is how we become visually and culturally knowledgeable about luxury.

The work of reading and the configuration of the text: The growth of luxury-branded visual representations

Today, visual culture is increasingly led by luxury-branded visual representations, leaving writing to complement such visual representations as structural props or as incitements into the meaning of luxury-branded visual representations. Our cultured individual eye inclines toward luxury-branded visual representations of Louis Vuitton bags in the pages of the *Financial Times* luxury supplement "How to Spend It" before the article clarifying what the representation is; it also inclines toward the superstars Amy Adams and Jake Gyllenhaal in the cinema placard for Tom Ford's (2016) *Nocturnal Animals* before gazing to understand what the movie is about; and this is because within luxury-branded visual representations, we have previously read sufficient to be knowledgeable, the writing finalizes luxury-branded visual representations. We identify what codes luxury-branded visual representations are to be read by and employ the writing that encloses them for additional clarification and strengthening of these codes. To decode luxury-branded visual representations only in this practice, though, is

restraining as it compels the need to revisit an authorial person and decrease the participation of the visual consumer in the configuration of the text's meaning.

In his essay, "The Death of the Author" (1977a: 142–48), Barthes contends that writing is an active procedure, breaking any connection to an author whose purpose is unconditional. He employs the contrast between the author and the reader to exemplify how writing is a developed procedure used to disturb the codes, networks, and structures that are created to construct and decipher it. Barthes employs the author as cipher to demonstrate how interpretation and codes are creations of culture and its narratives.

Superficially, Barthes's case that "the birth of the reader must be at the cost of the death of the author" (1977a: 148) seems concise and a simple concept to understand: the author does not exist; instead it is the reader who configures and can comprehend a text's meaning. This reading is naïve and upsets his proposition, changing the reader into a sort of author. In giving birth to the reader, Barthes is identifying the ability in readership to be disobedient, and he identifies the attraction of creating an authorial person in the explanatory procedure. He recognizes that there is force within culture to pursue the truth in a text and slays the author as an illustration but simultaneously does not want to reproduce one in a reader. What Barthes wants is the prospect for manifold voices and readership views to arise from a text. The birth of the reader is an idea that permits each text to be released from illumination or devotion to an author. The birth of the reader is a critical beginning, an encouragement to readers of texts to re-visualize a text beyond the culturally recognized and reinforced codes of explanation.

Although Barthes's theoretical exemplars depend on literary sources, there are allusions to luxury-branded visual representations, as we saw above, signifying that his philosophy is appropriate to any visual form. He mentions surrealism to show that investing in an author is to invest in elucidation. Surrealism is a "subversion of codes" (Barthes 1977a: 144), and one of its digressions was automatic writing where the writer would write whatsoever came into her or his mind, writing as quickly as possible. Barthes (1977a: 144) utilizes surrealism to recognize that there is no option of ignoring codes but a capacity to play off them exists and is fulfilled through the repudiation of pursuing the text's "truth" through the author. To evade this explanatory work of the reader, Barthes contended that writing was a varied task, and to appreciate the significance of writing requires a comparable method in readership. By encouraging readers or visual consumers to *involve themselves with a text*, Barthes unlocked all aspects of writing—its voice, its words, its creation, and its freedom. This reconsideration

of writing is powerful for luxury-branded visual representations as it gives visual consumers a viewpoint from which to re-visualize and re-involve themselves with luxury-branded visual representations. This is the birth of the visual consumer of luxury-branded visual representations.

The birth of the visual consumer is the perspective from which visual consumers view luxury-branded visual representations as a *creative* procedure. What develops in the viewing of luxury-branded visual representations is the work of questioning that permits visual consumers to view luxury-branded visual representations *otherwise*—beyond the limits of authorial discourse. We can view luxury-branded visual representations *critically*. Luxury-branded visual representations are a sequence of networks, a structure of discourses and codes sanctioning either a luxurious instant or branded disposition of a specific visual culture and society of representations. This is how some luxury-branded visual representations get selected over others in terms of admiration or for portraying luxuriousness, and how the configurations of luxury-branded visual representations are classified. An instance being why Coco Chanel's classical jackets keep an undisputed (haute couture) rank in luxury fashion culture and Karl Lagerfeld's contemporary Chanel jackets disturb that undisputed rank but invent one of their own. For Barthes, this involved engagement with a text, this critical beginning, is about exposing the relation of networks and structures, operational in and counter to codes, analytically evaluating discourses to discover the capacity for meaning and how it happens. Let us explore these codes to understand how they blend in with the visual consumer, culture, and luxury-branded visual representations.

Codes: Karl Lagerfeld's dark glasses, voice, and the fragments of meaning

In *S/Z* (1974), Barthes specifies five cultural codes classified through signifiers. They include the *hermeneutic* code, which arranges the signifiers and clarification of meaning; the *semic* code, which are the components within culture, whether they be luxury-branded visual representations or other texts, that possess no meaning but have meaning ascribed to them (e.g., Karl Lagerfeld as the typecast "fashion designer") that aids the visual consumer configure an explanation. Barthes stipulates the *symbolic* code to classify the shallowness of the categorizing of signifiers and our investment of meaning in signs. This code underlines that any arrangement of luxury-branded visual representations is a

random one whether it is an interior arrangement, such as understanding the components of luxury-branded visual representations (for instance, Lagerfeld's dark glasses concerning his luxury fashion design studio and his non-return gaze), or an exterior arrangement (discovering what the dark glasses signify in the greater arrangement of the luxury fashion world—such as their foundational "mystery"). The *proairetic* code differentiates consecutive traits when reading luxury-branded visual representations. We observe Lagerfeld's dark glasses, and we register the black plastic that protects them, the "Double C" that *make them* Chanel and thus *look* "cool." Such a register assists us in configuring the connotative meanings connected with Lagerfeld's dark glasses—those that are not even visually there but that rely on the visual to occur—for instance, the practices of the luxury fashion world where Lagerfeld acted as a cultural idol that signified a layer of the luxury fashion world and that characterized an important celebrity in twenty-first-century fashion thinking. These "things" cannot all be observed by eyeing Lagerfeld's dark glasses or his Paris luxury fashion design studio. But, finally, by blending these codes with Barthes's *referential* code, we can configure such categorizations of cultural meaning and knowledge through allusions "to a science or a body of knowledge, to the type of knowledge . . . referred to, without going so far as to construct (or reconstruct) the culture they express" (Barthes 1974: 20).

A further Barthesian (1977a: 188) instance of the reading of the unseen is "the grain of the voice," which is that beautiful impact of the voice as it *produces jouissance* in the listener through the body of the speaker, the hand of the writer, and the limb of the performer. This grain is attained, read, and comprehended through the five codes. Its visible sensation is appreciated as we adopt every one of the codes to experience its pleasure, besides discovering it within a cultural setting. For instance, when Lagerfeld spoke in a low pitched, "Germanic" yet French-inflected way, the visual consumer resorted to cultural knowledge and stereotypes of what embodies and epitomizes fashionable masculinity, in this example German aged chic masculinity situated within a high social class and cultural sphere. Lagerfeld's pitch and speech patterns created invincibility that further connected him as a "great" fashion designer, sticking to and working within the philosophy of the stylish photographer, defending aesthetic truth, design, and the creative direction of the luxury fashion house Chanel.

Barthes's five codes order the fragments of meaning in any text and structure and explain them as though they were "natural" features of culture. In embarking on luxury-branded visual representations as a Barthesian critical visual consumer, it is possible to observe the array of luxury-branded visual

representations alongside recognizing the codes that structure them. Luxurious visual cultures are thus disentangled instead of interpreted. Luxury-branded visual representations, even a genre such as luxury cinema (see Chapter 6), can be read like this so that this position of the visual consumer configures numerous luxurious visual cultures.

Visual consumers and luxurious visual culture: Anna Wintour, Stella McCartney's Kids' T-shirt, and Gucci jeans

Luxury-branded visual representations and their position within a luxurious visual culture are frequently thought of as still representations such as paintings or photographs. Additional configurations of luxury-branded visual representations such as the cinematic, the televisual, and the socially mediated are typically characterized and portrayed as moving luxury-branded visual representations: they are linked, yet each luxury-branded visual representation has a distinct presence.

However, to concentrate exclusively on these types of luxury-branded visual representation is to restrict debate over luxury-branded visual representations as it omits the possibility for luxury-branded visual representations as a network of interpretation. It ignores the significance of luxury-branded visual representations for contemporary visual consumers where, increasingly, luxury-branded visual representations *are* culture. My usage of luxury-branded visual representations in this chapter has been alluding to what is represented luxuriously and visually, namely, interrogating what it is concerning luxury-branded visual representations that configure luxurious visual culture through any basis or channel of media. The creation of a fashion editor's luxury-branded visual representation, such as Anna Wintour (Figure 3.2), the British-American editor-in-chief of American *Vogue*, contributes to the configuration of luxury-branded visual representations that signify a cultural grouping around her centered on the artistic direction of Condé Nast, *Vogue*'s publisher. Such celebrity editors function as signs for fashionable art direction, luxury culture, and Anna Wintour's luxury-branded visual representation (Wintour *is* American *Vogue* for many visual consumers) is an invention configured to provoke investment of luxurious subjectivity from her followers. Luxury-branded visual representations are therefore not limited to the arena of luxurious images. Instead, luxury-branded visual representations have an active role within culture and are, increasingly, a mainspring within culture in addition to the written word, which has important inferences. This

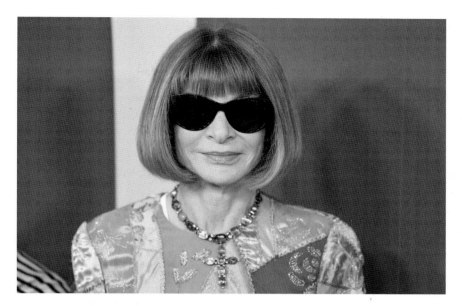

Figure 3.2 Anna Wintour arrives at the 2018 Council of Fashion Designers of America Fashion Awards, New York, United States, June 4, 2018.
Photo credit: Evan Agostini/Invision/AP/Shutterstock.

configuration of luxury-branded visual representation creation recognizes the financial worth of luxury-branded visual representations as they create—and are the counterpart of—wealth at a marketing level for *Vogue* and other luxury fashion magazines such as *Elle* and *Harper's Bazaar*. However, this creation is also the luxury-branded visual representation to be eyed and its luxury-branded goods and services to be wanted. It is invented to attract the gaze of visual consumers. In the obvious chic configuration of fashionable personalities such as Anna Wintour, this luxury-branded visual representation is clear. Nevertheless, regarding the luxury-branded visual representation of Wintour, with her characteristic pageboy bob haircut and, like Lagerfeld, dark sunglasses, it might be proposed that all this creative invention is part of a luxury-branded visual representation that she has fashioned herself. Consequently, Wintour has become an important player in the luxury fashion world, acclaimed for her appreciation of luxury fashion movements and her backing for younger creative fashion designers.

One feature of luxury-branded visual representations and their operation in configuring luxurious visual culture is that they are interdiscursive and depend on visual consumers to become complete. Luxury-branded visual

representations are a constituent in a multifaceted configuration of cultural, political, and social discourses and philosophies configuring luxurious visual culture. Visual consumers looking at luxury-branded visual representations are integrating themselves into a process of generating culturally feasible, maintainable, and familiar luxury-branded visual representations. It is their part in reading and investing in luxury-branded visual representations as visual consumers that permits luxury-branded visual representations to develop with other visual representations into an increasingly luxurious visual culture.

In *The Fashion System* (1983), Barthes examines luxury fashion as a signification network, in written, real, and photographic configurations. His analysis emphasizes how luxury-branded and other visual representations are produced and bestowed with cultural importance through the visual consumers' interpretation. This method focuses on the cultural function of luxury-branded visual representations (in this instance luxury fashion) instead of revolving around what luxury-branded visual representations of fashion are. It is the configuration of luxury-branded visual representations—how they hold meaning and how this meaning becomes comprehended, contemporary, and socially assimilated within cultural spheres such as luxury fashion—that is to be contemplated even in something as visually "uncomplicated" as garments. An illustration of how luxury-branded visual representations develop into a luxurious visual-cultural narrative can be observed in Stella McCartney's Kids' "Arlo Dokey Print T-Shirt MFM (Meat Free Monday)," featuring an English seaside donkey and made today at perhaps the pinnacle of "sustainable" luxury fashion (see, for example, Armitage, Roberts, and Sekhon 2017; Gardetti and Muthu 2018). Wearing this possibly provocative T-shirt might be offensive; some children might be instructed to remove their T-shirt in school or in public by ardent meat-eaters. Here McCartney employs the luxury fashion of the T-shirt, which ostensibly takes its stimulus from summers by the English seaside, to exploit the ability of luxury-branded visual representations and their power within culture (see also Faiers 2016). For McCartney's T-shirt not only evokes reminiscences of playing games at the fairground, of ice creams at sundown, but also supports Meat Free Monday—the charity started by her mother and father, Linda and Paul McCartney. The trend of sustainable luxury fashion to promote vegetarianism is one of the driving forces behind the feasibility and sociocultural currency of the McCartney sustainable luxury fashion kids' "Arlo Dokey Print T-Shirt MFM." What is being articulated through the T-shirt is the program of sustainable luxury fashion—the encouragement of vegetarianism in "Kids," the advocacy of corporate responsibility (the T-shirt is made from

100 percent organic cotton), and desire for an era of sincerity in contemporary commerce.

The McCartney T-shirt in the twenty-first century uses the interdiscursivity of luxury-branded visual representations to express the cultural political programs of a specific sustainable luxury fashion group that is concerned for the environment. "Kids'" bodies, employed to support the T-shirt, are used as a screen to support a growing sustainable luxury fashion culture with a view to working with rather than against nature. McCartney considers the domain of luxury fashion and supermodels in part as a stage for freeing previously socially suppressed luxury fashion cultures such as sustainable luxury fashion that uses organic cotton. Her luxury fashion designs operate in high fashion culture, where only the affluent can afford to buy and wear them. McCartney's tenor is responsible, sustainable, resource conscious, and watchful of the effect her company has on the earth. It mildly fosters a cultural political movement while strengthening high fashion culture. There is gentle power behind McCartney's collections concerning responsibility and maintaining a supply chain that values the earth together with the people and animals on it. The Meat Free Monday project, for instance, urges people to sacrifice eating meat once a week and instead choose vegetables or other meat-free replacements. McCartney's contemporary sustainable luxury fashion campaign has thus helped produce the luxury fashion culture of sustainability (e.g., through decreasing CO_2 emissions and the harm triggered by animal agriculture) in Britain and elsewhere through luxury-branded visual representations for cultural political aims, and, today, McCartney's luxury fashion supports luxury fashion as a field of luxurious visual culture.

Barthes's writings are influential within the field of visual culture, particularly for the visual consumer as, in this book, they allow us to concentrate on the links between luxury-branded visual representations and the visual consumer, between luxury-branded visual representations and other visual representations, and between various additional cultural connections and visual consumers. Barthes's work on the text is important in cultural studies and critical theory as it involves itself with the reader's participation in the text as an act of reading. Staying with the luxury fashion example, the Italian luxury-branded product Gucci denim jeans offers an instance of the interface between luxury-branded visual representations and visual consumers within and beyond luxurious visual culture. Originally invented by Jacob W. Davis in partnership with Levi Strauss & Co. in 1871–73, and becoming signifiers for cowboys and miners, denim or "blue jeans" have moved beyond occupations and former function. With film

stars such as Marlon Brando as a member of the "greaser" subculture in *The Wild One* (1953), jeans in the post–World War II era became part of a teenage disobedient outlook and, increasingly, visual representations worth investing in. Today, the traditional origins of jeans have progressed from signifying cowboys, miners, and manhood to signifying Gucci creative director Alessandro Michele's playful cultural visions of whimsy, youthful quirkiness, and visual nostalgia for the well-heeled and are worn not for work but for "fun." The primary purposes for the use of jeans as cowboys and miners' workwear are absent, and now a vintage-inspired spirit, issues of trendsetting, and what jeans (slim-fit, bootcut, etc.) are thought culturally fashionable (presently, jeans detailed with decorative embroidery) among the wealthy govern these luxury-branded visual representations and advertisements of the product as a timeless essential. No longer do advertisements for jeans transmit cowboy or miner susceptibilities or a feeling of revolt, for Gucci and other luxury-branded jeans, such as Tom Ford and Saint Laurent, are achieving other objectives, which include, among other things, the infusion of retro flair into contemporary luxury fashion designs. A luxurious culture born from the luxury-branded visual representations of Gucci and other luxury-branded jeans has been produced through, for example, their play on their long commitment to craftsmanship. To buy a pair of Gucci jeans is not to buy something but to buy *into* something—something much older, larger, and much more expensive on a worldwide cultural scale. Decorating the body with a pair of Gucci jeans associates the prosperous body with the culture of play that Alessandro Michele's jeans promote in Gucci's contemporary advertising campaigns. In creating this discourse of play for Gucci jeans, what ensues is more than purchasing a product. It is *Gucci* jeans made in Italy from the most desirable materials using state-of-the-art and complex construction methods that are the *only* jeans to possess and play in among the well-off. The advertisements not only show attractive and wealthy personalities, through the jeans they uphold a luxury-branded "heritage" and contemporary development that reveals one of the vital purposes of Gucci jeans—which is that they summon "the future" by cultivating components from history. Here we observe a cultural investment in luxury fashion as luxury culture and luxury fashion as luxury product.

This is critical to the theorization of luxury and visual culture, as it allows the subdiscipline to consider diverse configurations of luxury-branded visual representations and consider this variety of luxury-branded visual representation construction within its field along with supplementary traditions of fashion thinking beyond what is created for luxurious visual culture.

Studium and *punctum*: Gisele Bündchen and *Vogue* Australia

In *Camera Lucida*, Barthes (1981: 26) examines the idea and cultural signification of photographs, how their components create meaning, and how "the photographic message" (Barthes 1977a: 15–31) can occur minus a code. For Barthes, the communication between visual consumers and photographs is cultural. What visual consumers employ to understand luxury-branded and other visual representations derives from a variety of stored visual representations received and created by sociocultural discourses such as the discourse of luxury (Calefato 2014: 3). To examine the cultural influence and meaning of photographs, Barthes takes the Latin words *studium* and *punctum*, which have possibility for any discussion of luxury-branded and other visual representations, culture, and the aesthetic. For Barthes, *studium* is that feature of photographs, and, I argue, luxury-branded visual representations, that is culturally created and received. No *studium* of luxury-branded or other visual representations can survive beyond visual representations as this is the component through which visual consumers configure political, historical, and cultural meaning. In interpreting "the figures, the faces, the gestures, the settings, the actions" within luxury-branded and other visual representations, visual consumers partake in the *studium* (Barthes 1981: 26). Visual consumers are culturally created visual consumers: whether their readings of luxury-branded or other visual representations are obedient or disobedient—whether they interpret visual representations in their envisioned manner or contrarily—they are interpreting them as agents of a sociocultural order. For Barthes, and for me, this is the main method of understanding luxury-branded and other visual representations. The *studium* is an imaging element that confirms visual consumers' position in the discourse of, for instance, the luxury fashion photograph, besides its location in sociocultural discourses when reading the photograph. Within the sociocultural order of luxury-branded and other visual representations, the *studium* is the foundation from which clarification is produced. It is through the *studium* that luxury-branded and other visual representations are contextualized. To comprehend the *studium*'s purpose— why its concern is to culturally contextualize—is to comprehend what its contingency is regarding pleasure as an idea and as a discourse.

What is of importance in ascertaining a sociocultural order of the *studium*, and, consequently, the significance of pleasure within luxury-branded visual representations, for instance, is how luxury-branded visual representations and visual consumers, through a multitude of relationships, culturally create

and pursue pleasure. The visual consumer's pleasures to be discovered in the reception of the *studium*, in interrelating with luxury-branded and other visual representations, recognizing visual representations, and being recognized in response, are a few of the pleasures that Barthes considered. Only through a receptive engagement with a collection of recognized relationships and networks within sociocultural discourses do luxury-branded and other visual representations become meaningful. It is through numerous positionalities created by these sociocultural signifying networks that the *studium* becomes a dominant theme in the sociocultural order. It is the sociocultural configuration of luxury-branded visual representations within a sociocultural order, and the visual consumer's role in the formation and reception of luxury-branded visual representations, in which we are absorbed.

The *studium* is the stage of identification. In examining a randomly chosen photograph of supermodel Gisele Bündchen by Patrick Demarchelier on the cover of the January 2015 issue of *Vogue* Australia, visual consumers can identify several components. Primarily, it is a luxury photograph—visual consumers find its typology of visual representation. Any additional remarks arise from an engagement with *studium*, and these might be any clarifications from an opinion on how Bündchen's face appears, to the uniting color blue that stages the luxury-branded visual representation (the blue of her eyes reinforced by the blue of her denim jacket), to Bündchen's other garments, and toward occasions that are not in the photograph but are suggestions of it. For instance, in the garments of Bündchen is "Australia"—an allusion to Australian beach culture and, then, the supermodel's haute couture sociocultural and economic status (signified by her dress by Chanel). *Studium*, then, is identification and receiving of the photographer's purposes and practices ("education" about or "knowledge" of Bündchen, of the culture of haute couture jackets and dresses etc.) (Barthes 1981: 28). Visual consumers' remarks on such a luxury photograph, whether they enjoy or hate it, and thoughts about the photograph of Bündchen are created within the discourse of the *studium*. Visual consumers stare at the luxury-branded visual representation and automatically perceive it against the limits of the *studium*. They are working toward an identification that "this is a luxury photograph of Gisele Bündchen" and of the luxury photograph's implication in a broader cultural context (e.g., what it signifies in a "Western" luxury discourse when Australia is clearly in the "East") that they are identifying.

Visual consumers delight in identifying what is culturally identifiable and, in this instance, this is the *studium*'s purpose—to become a stage for identification of luxury photographs and their codes. Visual consumers who

look at luxury-branded visual representations want such identification as it confirms their location in the sociocultural order of luxury culture and, in having it corroborated, obtain pleasure through contextualizing luxury-branded visual representations in their luxurious cultural setting. This includes visual consumers' need to contextualize and to understand luxury-branded visual representations (which differ, from information to explanation), including the more multifaceted configurations of pleasure and desire, matters of class and race hierarchy, and gender politics, related to Barthes's notion of the *punctum*.

The *punctum* is the component that splinters the *studium* as the cultural foundation of the photograph for luxury-branded and other visual representations and for visual consumers. The *punctum* functions similarly to pleasure or *jouissance* (enjoyment, ecstasy, bliss) in that it is an inexpressible, unsecured, constituent of luxury-branded and other visual representations. At the bottom of the sociocultural order of luxury-branded visual representations, for example, is how visual consumers position, or are positioned by, their reactions to photographs as luxury-branded visual representations. The *punctum* disturbs the *studium*'s sociocultural arranging of luxury-branded visual representations such as luxurious photographs and the visual consumer's location. For Barthes, the *punctum* is personal to visual consumers, but its perturbing practice and influence is continuous. It is the place where visual consumers invest in luxury-branded and other visual representations and participate in the configuration of their meaning. The *punctum* is indispensable to luxurious and other visual cultures as it indicates the moment where luxury-branded and other visual representations shift from being the background to luxurious visual cultures to becoming the focus of it through activating visual consumers to re-visualize luxury-branded and other visual representations. The *punctum* captures the eye of visual consumers and functions to undermine the codes that try to create "natural" luxury-branded and other visual representations.

How luxury-branded visual representations appropriate the written word: Roland Barthes becomes a Hermès' silk scarf

We have explored Barthes's instance of Coco Chanel in terms of narrative structure, and we can also employ a comparable instance to examine how such cultural signifiers are iconic. In "The Contest between Chanel and Courrèges. Refereed by a Philosopher" (Barthes, Stafford, and Carter 2006: 99–103), Barthes considers the iconic prestige of luxury-branded visual representations

through the example of Coco Chanel. Her omnipresent luxury-branded visual representation is interdependent with any representation of French haute couture and is an appropriate instance of how luxury-branded visual representations appropriate the written word. Now Barthes himself has become a similar figure, yet "his" Hermès French luxury-branded limited edition silk carré (scarf) (Figure 3.3) printed with a motif inspired by his book *A Lover's Discourse* (2002) does not present the equivalent influence or significance as the cultural idol Coco Chanel. Rather, Barthes's scarf from Hermès's autumn-winter 2015 collection, available in blue or plum versions, and designed by Philippe Apeloig, is "French literature" become a silken luxury-branded visual representation, a scarf representing a book, excluding all its written text, lying smooth and horizontal as a deconstructed luxury object, recomposed branded item, and wholly fragmented and transfigured representation (Cohn 2015: 880–84). Yet, Barthes's scarf is not only writing become representation, become sign or symbol, but also a book become wearable, decorative, and applied art. Indeed, Barthes's scarf places French literature and represents its favored luxurious lifestyle, and in one

Figure 3.3 Carré Hermès' Roland Barthes 140 × 140 cm, 2015. Print on silk and cashmere. Photo credit: Studio des fleurs 2015.

luxury-branded visual representation it summarizes many other meanings of French literature visual consumers have created, ordered, and alluded to about French literature when reading other comparative cultural icons. Barthes has thus become more than a philosopher, semiotician, or even a scarf, for he has a visual and narrative existence throughout numerous visual texts, from limited edition silk scarves and cinema (Barthes plays William Makepeace Thackeray in André Téchiné's biopic *The Bronte Sisters* [Watts 2016: 77–80]), television, and advertising to luxury fashion. Barthes himself has therefore become a model of a luxury-branded visual representation, a "motif," which forever contains within it an influential amount of literary and other significations. Barthes surpasses his own cultural and historical borders not to mention his books; he brings specific meanings to the other signs that are located within a context to him.

Such usage of Barthes as a cultural icon emphasizes how luxury-branded visual representations are part of the sociocultural "fabric" (literally in this example of Barthes's literary work transformed into a silk scarf) through cultural investment in luxury-branded visual representations. Expounding luxury-branded visual representations (inclusive of books printed on silk scarves) as networks of signs moves the idea that luxury-branded visual representations are naturally apparent and places them in a critical structure of discursive practice. Barthes does not represent French literature, and yet he and his works such as *A Lover's Discourse* can *appear* to perform this purpose. Barthes is part of the visual consumer's sociocultural fabric (he can even be worn around visual consumers' necks), thus producing the condition where to identify with this cultural icon is to identify with a created representation of French literature. The visual consumer's identification is guided toward the sociocultural order of luxury-branded visual representations through the fabricated codes of Hermès's luxury fashion goods. The sociocultural order of luxury-branded visual representations is identified through the interface between luxury-branded visual representations and other sociocultural features of French luxury branding.

Luxury brand culture has always been attracted to visual representations and their effects. From Richard Avedon's luxury photography to Karl Lagerfeld's Chanel advertising campaigns to other contemporary practices of luxury-branded visual representations such as Yves Saint Laurent's arrogation of perfume and make-up into the prestige of contemporary haute couture, to the iconography of Anna Wintour, to Stella McCartney's Kids' T-shirt, Gucci jeans, the *studium* of Gisele Bündchen, and to Roland Barthes becoming a limited edition silk scarf. But what increasingly enthralls luxury culture are the effects of luxury-branded visual representations. Luxurious visual cultures and remarkable luxury-branded visual representations are variable and detached,

volatile, configurations that increasingly arrange and create luxury culture while remaining ubiquitous, performative, and able to attract the interest of visual consumers through luxurious effects. What are the consequences of luxury-branded visual representations' effects? What are the roles of visual consumers in terms of luxury-branded visual representations in luxurious visual culture? These are some of the questions that we will address in the following chapters regarding luxury and visual culture besides the configuration, the foundation, and the influencing of self-aware visual consumers who seriously connect with culturally created luxury-branded visual representations and figure in analyzing, creating, and distributing luxury-branded and other luxurious visual representations and their luxurious effects. Let us begin with the question of luxury and art in the next chapter.

4

Luxury and art

Today visual consumers live in an increasingly luxury brand–inundated atmosphere. And luxury-branded visual representations produced by contemporary artists are all about them. Visual consumers see glossy magazine photographs of Jeff Koons, the American contemporary artist, collaborating with luxury BMW cars; they watch television reports wherein Yayoi Kusama, the Japanese contemporary artist, is revealed as also a designer of Louis Vuitton handbags; visual consumers view Chanel purse "unboxing" reveals on YouTube; and they witness internet and social media accounts of Damien Hirst, the Young British Artist (YBA), collaborating with luxury French glassmaker Lalique. What does this mean for visual consumers' everyday lives? According to certain contemporary artists and critics, the transformations are huge. The boundaries between contemporary art and luxury-branded visual representations produced by contemporary artists are being breached it is contended. Visual consumers live in a world of luxury-branded contemporary art; in a world where luxury-branded visual representations produced by contemporary artists appear more contemporary and creative than contemporary art itself.

I will discuss this issue earnestly, but I will maintain that the transformations are not that extensive. Visual consumers' everyday life atmospheres are being transformed, and they do fill an ever-increasing part of their existence with luxury-branded visual representations produced by contemporary artists. However, luxury-branded visual representations produced by contemporary artists are still understood in real, and, increasingly, virtual, local places and global spaces. Visual consumers blend their comprehension of luxury-branded visual representations produced by contemporary artists with additional everyday life practices, and most visual consumers do still understand the difference between luxury-branded visual representations and contemporary art.

In this chapter, I will consider how visual consumers appreciate luxury-branded visual representations produced by contemporary artists, and I

will examine the diverse roles that luxury-branded visual representations produced by contemporary artists play in contemporary art. I will examine, also, how semiotics and luxury-branded visual representations produced by contemporary artists are blended in everyday life. Lastly, I will examine whether visual consumers live in a world of luxury-branded contemporary art.

Luxury-branded visual representations produced by contemporary artists

In preceding chapters, I examined the visual representations of contemporary visual culture. I contended that, apart from contemporary luxurious photographic, cinematic, and televisual selves, all the visual representations had their roots in modern visual culture produced in the advanced countries approximately between 1860 and 1970. This is also the case for luxury-branded visual representations produced by contemporary artists. The growth of luxury-branded visual representations was an essential formative influence in the configuration of modern art—even if, astonishingly enough, luxury-branded visual representations are frequently missing in examinations of modern art. In most examinations, luxury-branded visual representations are assumed as significant bases in the ingredients of modern art, but they are not examined in any detail, if at all. This is the case with Richard R. Brettell's *Modern Art 1851–1929: Capitalism and Representation* (1999), for example. However, there are instances of texts blending a modern art viewpoint with an interest in luxury-branded visual representations. Pierre Bourdieu's *Distinction* (1984) is the benchmark text of how, to some considerable degree, luxury-branded visual representations have configured modern visual culture and taste, art, and their histories. Additional instances of modern art influenced examinations emphasizing the sociocultural development of luxury-branded visual representations include Werner Sombart's (1967) investigation of the transformations of capitalism and Peter McNeil and Giorgio Riello's survey (2016) of the role luxury played in configuring the imaginaries of, among other things, exoticism and decadence. Within luxury brand studies, the modern art viewpoint is unexpectedly infrequent. Lately, though, the viewpoint has been used concerning crossover collaborations between luxury brands and contemporary artists, for example, in the writings of Kapferer and Bastien (2012) and Kastner (2013).

I will not contend with luxury brands and modern art here. My emphasis is on the visual culture of luxury brands and contemporary art. Contemporary art? The

classification of contemporary art as a singular kind of art belongs to the early phases of modernism in the advanced countries (Bonham-Carter 2013). In London, the Contemporary Art Society was created in 1910, by the art critic Roger Fry and others, as a private society for buying works of art to place in public museums. Many other institutions using the expression were created between the 1930s and the 1960s, for example, the Contemporary Art Society of Adelaide, Australia. Several institutions, such as the Institute of Contemporary Art, Boston, modified their names from institutions utilizing "modern art" in this period, as modernism increasingly became demarcated by contemporary artists and museums as a historical art movement, and a good deal of modern art ceased to be contemporary. The definition of what is contemporary art or who is a contemporary artist is thus always fixed in the present day. Historical moments typically understood as designating a shift in art styles include the end of World War II (e.g., Abstract Expressionism) and the 1960s (e.g., Op Art). Yet definitions of what comprises either contemporary art or a contemporary artist today are mutable and vague, including art and artists from the 1970s to the early twenty-first century. As an expansion and a refusal of modern art, it is scarcely astonishing that major art museums, looking to form permanent collections of contemporary art, unavoidably find it demanding not only to articulate what is denoted by modern and contemporary art but also to describe contemporary artists who remain creative after an extended career (e.g., David Hockney), continuing art movements (e.g., pop art), and thus the difference between the contemporary and the non-contemporary.

What is pertinent in the present context is that, of all the luxurious visual representations that typified modern art, luxury-branded visual representations produced by contemporary artists, I argue, are the ones that more than any others continue to influence and alter visual and cultural life to even larger degrees. Namely, not only do luxury-branded visual representations produced by contemporary artists continue to count—so do numerous additional visual representations—but it is the incessant development, even escalation, of luxury-branded visual representations produced by contemporary artists that distinguishes them from other visual representations. They become increasingly significant at the same time as they alter in ways that are premised on the presence of the now.

I would like to emphasize six features of the luxury-branded visual representations produced by contemporary artists in contemporary visual culture.

First, the visual culture of luxury-branded visual representations produced by contemporary artists is progressively altering from a visual culture of

luxury-branded visual representations founded on history or "heritage" (e.g., Cartier jewelry or Krug champagne, both over 160 years old) to a visual culture of *luxury-branded visual representations founded on the present period* (e.g., the luxury-branded visual representations of Tom Ford, the fashion designer, who launched his line of menswear, beauty, eyewear, and accessories in 2006, having formerly worked as the creative director at Gucci and Yves Saint Laurent). The roles played by the visual culture of luxury-branded visual representations founded on the present period and luxury-branded visual representations founded on heritage vary between visual cultures. In capitalist Britain and America, luxury-branded visual representations produced by contemporary artists often include, and are assumed to develop from, contemporary or postmodern art, while in communist Cuba this is not (yet) the case. But, luxury-branded visual representations founded on heritage, though in no way becoming outdated, are more limited to senior groups of a visual culture than are luxury-branded representations founded on the present period, the latter of which are increasingly seen by some as the successors to modern and postmodern art. This is increasingly because of the socially mediated availability of luxury-branded visual representations founded on the present period. These luxury-branded visual representations are not more "contemporary" or "creative" than luxury-branded visual representations founded on heritage, but they are more evocative of contemporary art produced within our lifetime. Conceptual art, particularly, "looks like" contemporary art; it is one of the mediums whose codes—the prevalence of ideas over traditional aesthetic and material concerns—visual consumers can comprehend (Goldie and Schellekens 2009).

Second, luxury brands are gradually immersed in *the transnational exhibition of visual representations within art institutions*. Historically, luxury objects rather than luxury brands aided in establishing national major art museums as visual consumers know them. Through luxurious art galleries such as those of London's Victoria and Albert Museum, art spaces, art schools, and art publishers, visual consumers in different parts of a country could sense that they belonged to the same aesthetic community founded on the theories and practices of individual contemporary artists, curators, writers, collectors, and philanthropists, even if they would seldom, if ever, meet (Anderson 2016; McNeil and Riello 2016). Now, not only luxury objects feature in the depiction of the national art world. Two significant transformations have happened. First, numerous national major art museums today exhibit a sizable amount of conceptual art. These exhibitions are expensive, and they draw huge numbers of visual consumers. And second, the crossover collaborations between luxury brands and contemporary artists,

such as the 2008 Brooklyn Museum exhibition of a fully operational Louis Vuitton store within, and as part of, © MURAKAMI, a retrospective of work by Japanese artist Takashi Murakami, and the construction of luxury-branded art institutions, such as the Fondation Cartier pour l'art contemporain in Paris, has meant that visual consumers can view additional luxurious things than the luxury objects and artworks presented by their national major art museums.

The distribution of luxury objects and artworks between national major art museums is unequal. Some national major art museums loan luxury objects and artworks and other national major art museums' exhibit them. The New Museum of Contemporary Art in New York may, for example, loan luxury objects and artworks, but also additional national major art museums, such as the Centre Pompidou in Paris, play important roles in various parts of the world. The luxury objects and artworks obtainable through crossover collaborations between luxury brands and contemporary artists such as © MURAKAMI are to a specific degree the same ones otherwise offered as loans, and, in that sense, they contribute to an unequal distribution. Yet, crossover collaborations between luxury brands and contemporary artists have also meant that visual consumers living beyond their own national major art museums' increasing fascination with global luxury brands are progressively compelled to become embroiled with their combined transnational exhibition strategies both within and beyond their own major art museum and its formerly national visual culture. Through these forms of visual representation, it is gradually becoming compulsory for visual consumers who for diverse rationales have avoided the increasing appearance of luxury-branded art institutions to submit to the latter's specific form of art and artworks. With the "help" of luxury-branded visual representations and contemporary crossover collaborations with contemporary artists, visual consumers are more and more compelled to make and maintain interaction with luxury-branded transnational exhibition strategies such as those formed by the Fondation Louis Vuitton in Paris while considering visual representations within the context of the progressive construction of luxury-branded art institutions, artworks, and the now wholly international or globalized major art museum.

Third, luxury-branded visual representations produced by contemporary artists are becoming *further commercialized and "deregulated."* Profitmaking has always been a significant reason for association with luxury-branded visual representations, and numerous luxury brand companies have begun exclusively for that purpose. Still, there have also been aesthetic and cultural motives behind luxury brand businesses. Within the context of contemporary visual culture, where a major division is between the for-profit and non-profit art sectors, the

Luxury and Visual Culture

commercial viewpoint is greater than ever before as the boundaries between for-profit private and non-profit national and international major art museums become increasingly breached. This can be observed in American contemporary art and its progressively commercially governed exhibition by leading artists at contemporary art galleries. For American contemporary art is gradually being supported not by private collectors, auctions, publicly funded arts organizations, or artist-run contemporary art spaces but by luxury brands such as BMW, Dom Pérignon, Lancôme, and Louis Vuitton.

The highly commercialized American contemporary artist, Jeff Koons, for example, was born in York, Pennsylvania, on January 21, 1955 (Koons and Rosenthal 2014). At the age of eighteen, having already produced various paintings, Koons enrolled at the School of the Art Institute of Chicago and, later, [...] where he would eventually create, [...] of banal objects, later developed [...] with mirror finish surfaces. In the [...] Dog (Orange) (sold at Christie's [...] ale in New York City for $US58.4 [...] porary art world harshly splitting [...] ndbreaking and of foremost art [...] as kitsch, tactless, and based on [...] declared that there are no hidden [...] his artworks, from the early "The [...] to the recent "Antiquity" series, [...] are in contemporary art. Among [...] Dali, which also included Koons's [...] ons not surprisingly concentrated [...] ould be considered the most Andy Warhol-like among his generation of artists, finally setting up a factory-like studio near the old Hudson railyards in Chelsea, New York, and operated by over ninety regular assistants, each allocated to a different part of producing Koons's canvases and sculptures as if they had been crafted by a single artist.

It may be puzzling why a self-confessed anxiety-ridden conceptual sculptor, even of Koons's versatility, would be included in a chapter on luxury and art. After all, conventional sculpture holds that luxury is something of a secondary phenomenon and that sculpture itself derives from more powerful material forces and forms. Luxury, in this view, is "painterly" and serves to focus attention overwhelmingly on the imagery of artifacts, or it serves to denigrate the achievements of sculptors working with three-dimensional material objects.

Handwritten note:
- create with popular culture
- topics = reproductions of banal objects.
- balloon animals. sold por $58.4 million.
- no hidden meanings in his work
- factory like studio = 90 assistants allocated to a different part of producing his work = like being crafted by a single artist.

Jeff Koons!

• lux brands = integrated into contemp?
art world ↗ contemporary
• exhibit art in their own galleries
• lux companies = increasingly central
to organisation, sponsorship +
collection of contemporary art,
↳ use it in advertising campaigns
↳ prestige of the art draws the
consumers attention
• Louis Vuitton + Jeff Koons bags.
↳ re-presentation of iconic painting
= contribute to deregulation of
major international art museums.
↳ by encouraging consumers not
to experience the painting at
a museum but at a flagship
store.

nce, luxury brand companies are
ion, sponsorship, and collection
in luxury-branded advertising
h contemporary art draws the
ds and services. Jeff Koons, for
Vuitton to produce a collection
ccessories printed with paintings
ypresses (1889) (Figure 4.2). Each
ie original artist's name across it
ton logo and Koons's own initials
haped leather bag charm. Yet, for
ip used to closely reproduce the
presentations of iconic paintings
eff Koons) and contribute to the
further "deregulation" of major international art museums (in the case of Van Gogh's *Wheatfield with Cypresses*, London's National Gallery) by encouraging visual consumers to experience paintings not as viewers in an art museum but as visual consumers in a Louis Vuitton flagship or department store.

For example, because of its role as a significant market for art and for luxury-branded goods, China has increasingly become an important location where luxury brands use their own luxury products to reach China's wealthy visual consumers through sponsorship of art exhibitions. Here, high-status museums and galleries blend art, luxury branding, and luxury products. Moreover, the luxury products are positioned together with the art in an apparent *equal setting*, as in Gucci's "No Longer/Not Yet" exhibition at the Minsheng Art Museum in Shanghai. Or the luxury goods "*become*" art, as when Dior had famous Chinese artists create their own "interpretation" of the classic Lady Dior handbag for its "Lady Dior as See...

• China = lux brands use their own
products to reach the wealthy
through sponsorship of art exhibits
↳ high status museums + galleries
blend art, lux branding + lux products
↳ lux products + art = an equal setting
e.g. Gucci's "No Longer / Not Yet"
exhibition at Minsheng Art Museum
• lux goods become art = Dior
had famous Chinese artists = own
interpretation of classic handbag.
• "Luxury art malls" = new pieces
+ exhibitions to entice footfall.

...ai and
Beijing exhibitions in ... reted"
by seventeen female ... uxury
brands in China and ... omary
exhibition venues, s... mand.
"Luxury art malls," ... ons to
entice footfall traffic. ... nown
artists. The first ever ... na, for
example, was not at ... 2012.
Likewise, shopping c... se art.

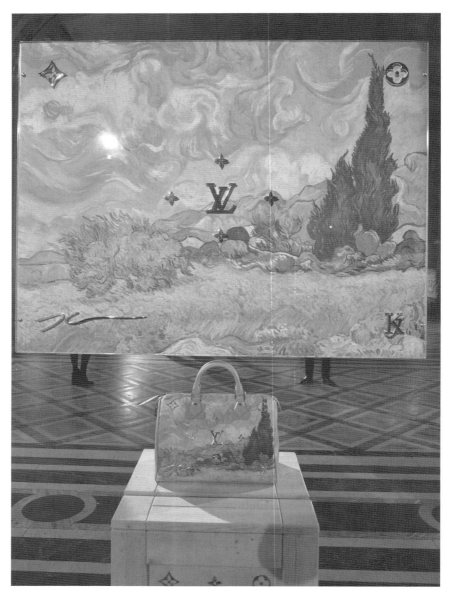

Figure 4.2 Louis Vuitton Van Gogh "Masters" Bag designed by Jeff Koons and launched at The Louvre, Paris, France, April 11, 2017.

Photo credit: Swan Gallet/WWD/Shutterstock.

Why? Because on Chinese New Year, well-off Chinese travelers tour the globe. Consequently, department stores, for instance, Bon Marché in Paris, have presented installations by major Chinese artists such as Ai Weiwei. Lastly, "luxury art hotels" are emerging throughout China so rapidly that art is now a prerequisite for any new property wishing to get the attention of the super-rich. Hotel Eclat Beijing, for example, exhibits artworks by Salvador Dali and Andy Warhol along with contemporary Chinese artists such as Zeng Fanzhi. Fanzhi also produced US$50 million worth of artwork for the *state-owned* luxury art hotel brand NUO, which opened in Beijing and which intends to take its brand global. Similarly, the Swatch Art Peace Hotel on Shanghai's Bund, which is owned by the Swatch luxury watch group, showcases retail space and an artist residency program. Small wonder, therefore, that many contemporary curators are uneasy about luxury-branded visual representations produced by contemporary artists and about the commercialization and deregulation of "their" art world as luxury-branded sponsorship of art exhibitions, luxury art malls, and luxury art hotels continues to grow in significance.

Fourth, luxury-branded visual representations produced by contemporary artists are increasingly seen as a common *concern* and have been since the mid-twentieth century. This common historical concern is chiefly to do with the question of what constitutes contemporary art rather than what constitutes luxury-branded visual representations produced by contemporary artists. An important trait of this common historical concern is less to do with contemporary art as a feature of popular culture, with artists becoming "stars," and more to do with the concept and members of the "avant-garde" (from the French "advance guard") or visual consumers that are experimental or innovative, particularly with respect to art, culture, and politics (Burger 1984; Wood 2004). On the one hand, this common historical concern over the avant-garde may come into play in determining what art is noticed by galleries, museums, and collectors; for the avant-garde produces widespread contemporary anxiety, which, in turn, produces criticism, skepticism, and confusion over "where" contemporary art is "going" when it is seemingly reliant on ever-intensifying theoretical discourses to "explain" it. On the other hand, this common historical concern over the avant-garde often tries and fails to understand how seemingly political propaganda (e.g., Shepard Fairey's American contemporary street art, graphic design, activism, and illustrations) or entertainment (e.g., Andy Warhol's pop art exploration of the relationship between artistic expression, celebrity culture, and advertising) can be regarded as art genres. In both cases, the consequence is that these common historical concerns over the avant-garde combine and

become yet bigger and more leading questions concerning what constitutes contemporary art.

Fifth, *contemporary art competitions, art awards, and art prizes* alter the visual representations produced by contemporary artists. I have previously pointed out crossover collaborations between luxury brands and contemporary artists, but contemporary art competitions, awards, and prizes, also, illustrate the continuous transformation to which the visual-cultural representational environment is subject. Through contemporary art competitions, awards, and prizes, luxury brands and contemporary artists can collaborate while visual consumers can get information on, for example, the luxury-branded Hugo Boss Prize awarded by the Solomon R. Guggenheim Museum, New York, without necessarily having to contend with the sorts of watchdogs that operate conventional international major art museums. The Hugo Boss Prize, for instance, honors exceptional attainment in contemporary art, commending the work of artists whose practices are among the most groundbreaking and powerful of our age. The biennial prize, which celebrated its twentieth anniversary in 2016, sets no limits on age, gender, nationality, or medium. Juried by a global group of illustrious museum directors, curators, and critics, it is managed by the Guggenheim Foundation, publicized globally, and carries an award of $US100,000. Since its beginning in 1996, the Hugo Boss Prize has been presented to Matthew Barney (1996), Tacita Dean (2006), and Anicka Yi (2016), among many other artists, and work by each artist who obtains the award is shown in a solo exhibition at the Guggenheim. Presently, it is impossible to predict where the Hugo Boss Prize and other branded art prizes, for example, the Ricard Prize (for French artists under forty), will lead.

And lastly, a crucial feature of the visual representations produced by contemporary artists in contemporary visual culture is the increasingly *luxury-branded history of contemporary art* that allows luxury brands to draw on a plethora of art movements and styles since at least the 1950s, inclusive of 1970s pop art and conceptual art, 1990s postmodern art, and, from the 2000s, the YBAs such as Tracey Emin and Damien Hirst (Lucie-Smith 2001). Luxury-branded artistic content, and particularly conceptual art content, is becoming increasingly stylized, intertextual, and self-referential. New luxury-branded artworks are founded on, and require of visual consumers a knowledge of, previous luxury-branded styles and artworks. Luxury-branded conceptual art is increasingly involved with itself, and representations appearing outside the luxury-branded artworld become less significant.

Luxury-branded visual representations produced by contemporary artists in everyday life

No one can sincerely doubt that luxury-branded visual representations produced by contemporary artists are altering visual consumers' everyday lives. A sign of this fact is the quantity of time that visual consumers are devoting to luxury-branded visual representations produced by contemporary artists on a regular basis if not every single day. Luxury-branded visual representations produced by contemporary artists also take time away from other cultural practices. But what does this mean? How should we explain the fact that visual consumers are devoting so much time to luxury-branded visual representations produced by contemporary artists, and what are the results of this?

In the present era, this question can be broached through a semiotic viewpoint. What do luxury-branded visual representations produced by contemporary artists mean to us? Initially, the answer to this question appears easy: a great deal. This can be determined by examining the acceptance of contemporary visual culture and by examining the significance of re-viewing it in the current era. Luxury-branded visual representations produced by contemporary artists appear to have instant or direct influences on visual consumers.

This perspective on short-term influences on substantial numbers of visual consumers, I argue, must be challenged. For our methodical examinations of semiotic influences must make it obvious that issues are more complex. Indeed, it must be made apparent that if there are semiotic influences, then these are not linear ones, influencing all visual consumers in equal ways. Instead, it is essential to consider visual consumers' diverse capabilities along with their motives for trying to understand luxury-branded visual representations produced by contemporary artists. For Barthes (1982a: 457–78) and for me (see Chapter 3), the semiotics and "language" of luxury-branded visual representations produced by contemporary artists are powerful cultural products.

The introduction of, for example, Jeff Koons's contemporary conceptual art into luxury-branded visual representations, I argue, initiates a possible new phase in semiotic research. For luxury-branded visual representations produced by contemporary artists are influential cultural artifices, though there is nothing natural about them. There is, also, the possibility of a shift in emphasis: from short-term, envisioned semiotic influences on chiefly meaning, to long-term, debatably unintentional semiotic influences on the myriad of relations that

mainly construct the meaning of visual consumers' values and worldviews and which often appear as a most natural part of their behavior and visual culture.

The image portrayed above of the possible development of semiotic research is not the usually accepted one. My research is more preoccupied with long- than with short-term influences, and my interpretations of semiotic influences aim to be delicately nuanced: luxury-branded visual representations produced by contemporary artists are influential cultural products and narratives. But, beyond an assumed accord on those points, not much is resolved within semiotic research. There is no agreement on how influential luxury-branded visual representations produced by contemporary artists are, and under what conditions. As Barthes in his "Inaugural Lecture at the Collège de France" and appraisal of the field of semiotics declares, notwithstanding the quantity of research, the discussion about semiotics remains unsettled because semiotics "is not a discipline" but an "ancillary relation: it can help certain sciences, can be their fellow traveler for a while, offering an operational protocol starting from which each science must specify the difference of its corpus" (1982a: 474).

This condition may appear odd, given the quantity of effort and time put into the subject. Conversely, attempting to provide a broad answer to the question of semiotic influences may be pointless. The subject is split into sub-areas dealing with diverse features of semiotic influences, such as narrative analysis, historical research, and ethnological research, and perhaps it would be more sensible to discuss these sub-areas individually (de Saussure 2013; Barthes 1972a, 1977a, 1983; Fiske and Hartley 1978).

Yet, there may be a more important difficulty with semiotic research, and that has to do with the inexact model on which research is founded, a model beginning "without a grid" and where the purpose of research is "to elicit the real, in places and by moments" (Barthes 1982a: 474). It is a model built on a "textual" notion of human action, and it does not consider the fact that visual consumers in their everyday lives do not laze about awaiting the real to arrive in space and time but instead exist in an environment wherein they continually can select between diverse realities within their cultural context and where they choose to move through time and create meaning out of certain moments, while they critique or refuse others. This may be seen as a distinction between a grid and a textual-narrative model of exegesis, iconology, and imagery.

The type of analysis summarized above must lead to different semiotic viewpoints on the role of luxury-branded visual representations produced by contemporary artists, viewpoints that take visual consumers sooner than luxury-branded visual representations produced by contemporary artists as the starting

point; viewpoints that pose the question: "what meanings do visual consumers *get out of* luxury-branded visual representations produced by contemporary artists?" before: "what do luxury-branded visual representations produced by contemporary artists *do to* visual consumers?"

The semiotic form of this viewpoint I call "non-substitutive" research, by which I mean that, as Barthes puts it, semiotics "has no substitute role with regard to any discipline" (1982a: 474) or inquiry. It begins with the desires of visual consumers and examines how they appreciate luxury-branded visual representations produced by contemporary artists to satisfy those desires. Studies must be conducted with the assistance of semiotics and the interest would be in finding generalizable knowledge of visual consumers' appreciation of the meanings of luxury-branded visual representations produced by contemporary artists.

My non-substitutive viewpoint on the appraisal of luxury-branded visual representations produced by contemporary artists has, admittedly, several potential limitations. First, it has an unsystematic and individualistic predisposition; it discusses contemporary knowledge of individual visual consumers as a "wild card" rather than as scientific knowledge of cultural beings (Barthes 1982a: 474). Second, it does not pay specific attention to the production of luxury-branded visual representations by contemporary artists themselves (to the production of "signs" and discourses that visual consumers sense and participate in). And third, by working with semiotics, the viewpoint might not be wholly successful when it comes to revealing what visual consumers get out of evaluating luxury-branded visual representations produced by contemporary artists.

These kinds of critiques might be submitted by researchers coming from the arts and humanities. To start with, analyses might be conducted with the emphasis on attempting to comprehend what diverse visual consumers may get out of analogous signs and discourses. What Barthes (1982a: 473–74) calls "negative" or "active" semiotics consists of a "semiotropy" where the emphasis is on the diverse types of interpretations that visual consumers may make of signs and discourses. Several of Barthes's and others' previous investigations within this tradition were conducted by turning "towards the sign": this semiotics is "captivated by and receives the sign, treats and, if need be, imitates it as an imaginary spectacle" (Barthes 1982a: 474–75). The rationale behind executing this research was an interest among some semioticians in becoming "artists" in a typological sense (Barthes 1982a: 475). The signs and discourses are also meaningful to examine as they are comparatively "playful" in nature. They are

possible to explain otherwise as they have diverse manifestations with which it is possible to identify and, in the instance of playing with "signs as with a conscious decoy," their fascination never ends, making it possible to continue enjoying them and wanting to continue making others enjoy and understand them (Barthes 1982a: 475).

Active semiotics therefore discusses *signs*, and visual consumers' explanations of them, sincerely. This area of humanistic research into luxury-branded visual representations produced by contemporary artists thus focuses on signs within the context of the discourses of luxury brands and contemporary art. Within the context of luxury-branded visual representations produced by contemporary artists the emphasis is on the material and increasingly immaterial sociocultural contexts within which luxury-branded visual representations produced by contemporary artists are being understood. Yet, instead of concentrating only on material and immaterial signs, attention is also turned to the role that luxury-branded visual representations produced by contemporary artists play in the discourses of everyday life concerning other sociocultural practices, along with the way additional practices, and additional visual consumers, figure in how luxury-branded visual representations produced by contemporary artists are comprehended. This area of research is founded on what Barthes (1982a: 475) calls "semiotic painting" and on the "texts of the Image-making process" in the narrative environments where visual consumers usually appreciate luxury-branded visual representations produced by contemporary artists, namely, in art galleries and on advertising billboards, cinema, television in the home, and on social media.

Taken jointly, I argue, these two areas of research can demonstrate that understanding the portraits and expressions, idiolects, passions, and structures of luxury-branded visual representations produced by contemporary artists are a much more multifaceted and diverse set of activities than they have been allowed to be previously since they "play simultaneously with an appearance of verisimilitude and with an uncertainty of truth" (Barthes 1982a: 475). Diverse visual consumers get diverse things out of examining Jeff Koons's conceptual art for Dom Pérignon, for example. Nevertheless, it must be recognized that, as with other semiotic research (e.g., Jobling 1999), it is challenging to sum up what active semiotics and the perspective of signs within the context of the discourses of luxury-branded visual representations produced by contemporary artists might yet educate us about the roles of luxury-branded visual representations produced by contemporary artists in everyday life, although for diverse reasons.

Perhaps one difficulty with active semiotics and the perspective of signs within the context of the discourses of luxury-branded visual representations produced by contemporary artists is connected to its possible ways of proceeding. Specifically, it is a viewpoint that is a *"semiotropic"* viewpoint; it deals with open-ended interpretations of visual consumers, and it does so in flexible and fluid ways (Barthes 1982a: 474). And this comprises the strengths and weaknesses of the viewpoint. The examinations can give us knowledge of how diverse signs and discourses are understood and explained, of how identical signs and discourses can be understood and explained otherwise, "as with a painted veil," of how the mechanisms within often immaterial "fictions" can determine the interpretations and pleasures of luxury-branded visual representations produced by contemporary artists, and of the role that an understanding of luxury-branded visual representations produced by contemporary artists, as a collection of imaginary signs and discourses, can play within immaterial fictions (Barthes 1982a: 475). Those are the strengths. However, most of this contemporary knowledge is of a specific type. It is hard to make methodical comparisons of the investigations conducted when Barthesian semiotics openly offers itself up as the "wild card" of contemporary knowledge. This is not a critique of the difficulties of making generalizable knowledge founded on semiotic painting and the texts of the image-making process. Instead, the sociocultural contexts within which luxury-branded visual representations produced by contemporary artists are understood are in turn located within the semiotic imaginary and the increasingly spectacular techno-cultural contexts of social media and so on that hitherto have not been discussed sincerely by the semiotic tradition. For example, visual consumers do not happen to find themselves in a semiotropic context in a haphazard way. Because of sociocultural upbringing, certain visual consumers are more liable to end up within some semiotropic contexts than others are, and if human action within a semiotropic context is to be comprehended, then it is essential to consider not only the semiotropic contexts but also their semiotic imaginary and spectacular techno-structural contexts. This is a type of research that remains to be conducted. I will revisit this subject in the last section of this chapter.

The roles of luxury-branded visual representations produced by contemporary artists

In the image of my contemporary Barthesian visual consumer research portrayed above, I argued that the semiotropic–imaginary–spectacular connection

remains problematic. However, notwithstanding that shortcoming, it is possible to understand the four main roles that luxury-branded visual representations produced by contemporary artists play in everyday life.

First, luxury-branded visual representations produced by contemporary artists help in the process of *luxurious identity creation*. Luxury-branded visual representations produced by contemporary artists operate as the luxurious component of a wider visual-cultural debate on representations of identity encompassing current aesthetic issues of ethnicity and class, gender, race, sexuality, and subcultures. It is, I argue, increasingly through luxury-branded visual representations produced by contemporary artists that visual consumers obtain luxury-branded desires about whom they want to look like, whom they want to be, or whom they want to become or identify with in the world of contemporary art. These luxuriously branded desires are inconsistent and erratic, incoherent, unstable, and replete with experiences of doubt and uncertainty. For luxury-branded visual representations produced by contemporary artists do not "instruct" visual consumers with their commanding yet somehow otherworldly voices that this is the way they must understand their meanings. Rather, as we saw in Chapter 3, through what Barthes terms "the grain of the voice" (1977a: 188), luxury-branded visual representations produced by contemporary artists tell visual consumers diverse, frequently indeterminate, things. In F. Scott Fitzgerald's 1925 novel *The Great Gatsby* (and recent movie by Baz Luhrmann [2013], featuring luxury-branded product placements by Miu Miu and Prada, Tiffany & Co., and Brooks Brothers, among others), for example, the luxury-loving "Gatsby" reflects on the grain or exquisite effect of the wealthy socialite "Daisy's" voice "full of money" (Fitzgerald 2000: 128) as it brings "inexhaustible charm," "jingle," and "song" or what Barthes calls *jouissance* (disconcerting enjoyment) to Gatsby as the listener. And yet it is up to readers or visual consumers to select between these novels and movies, characters, influences, voices, charms, jingles, and songs. Out of the multifaceted and wide-ranging luxury-branded visual representations produced by contemporary artists on offer, visual consumers consult the type of narratives and films, voices, attractions, tinkles, and refrains that appeal to and are pertinent to them and to their own luxurious development; pertinent in their potential to transform their usual, everyday state and probably extant non-luxurious identity. Of the luxury-branded visual representations produced by contemporary artists available, global aesthetic experience and altered cultural relations between Western and other visual cultures are significant for the process of luxurious identity creation.

For it is when visually consuming and sensing such relations that it becomes possible for visual consumers to abandon their usual existences and identities for a moment and traverse an individual frontier or border to *something else*, to *something luxurious* or *some luxurious elsewhere*; in the presence of Jeff Koons's Vincent Van Gogh bag or gazing into the window displays of Louis Vuitton by Yayoi Kusama, it becomes possible to experiment with the actual or the possible worlds of one's luxurious identity and to consider whom or where one wants to "become luxurious" (Armitage 2019: 25–46). Global aesthetic experience and altered cultural relations therefore offer possibilities for luxurious self-reflection in contemporary societies.

Second, luxury-branded visual representations produced by contemporary artists help in the process of *"common sense" creation*. In a cultural domain that is becoming increasingly concerned with compound questions of ideology, and where luxurious occurrences far afield are becoming increasingly significant, the more visual consumers seemingly must depend on luxury-branded visual representations produced by contemporary artists not only to understand the realm of luxury but also to understand its embedded, frequently incoherent, beliefs and assumptions that, as mentioned in Chapter 3, characterize its sociocultural order. Luxury-branded visual representations produced by contemporary artists do not so much establish the program for what luxuries visual consumers consider as offer a conventional or unquestioning form of "common sense" or what Barthes calls a "conformist opinion" about them that is already a deeply held, taken-for-granted, aspect of contemporary visual culture (Barthes 1972a; 1985b: 314). It is vital to highlight that, in this process, objective, actual, luxury brands and conceptual, theoretically driven, visual representations produced by contemporary artists are involved. Namely, in reflecting upon the world of luxury, visual consumers acquire "common sense" information about the sphere of luxury not only from luxury brands such as Hennessy cognac or from Louis Vuitton but also from the imaginary spectacle of Koons's conceptual art or from Kusama's pop art in the flagship store. The issue of whether the popular cultural domain of luxury as it is portrayed in different luxury-branded visual representations produced by contemporary artists and in different conceptual signs and interpretive artistic discourses is "truthful" is here apparently of less significance in terms of the organization of visual consumers' lives and experience. The central point is that visual consumers choose those "fragments of meaning," discussed in Chapter 3, that, significantly, make "common sense" to them and from these create an intelligible luxurious

viewpoint; one that therefore will not merely vary from those of other luxury groups but also from those of groups who view luxury as a crucial cultural site of ideological conflict or political struggle on which they see not only "common sense" at work but also the class character of capitalism (Sombart 1967; Armitage 2018).

Third, as also noted in Chapter 3, luxury-branded visual representations produced by contemporary artists provide visual consumers with *pleasure* (Barthes 1975). There is a pleasurable feature entailed in visual consumers' understandings of luxury-branded visual representations produced by contemporary artists. It is instant and direct in that it might be pleasurable to view a certain Koons conceptual artwork or a Kusama handbag, but there is also a deferred pleasure in that an appreciation of luxury-branded visual representations produced by contemporary artists not only provides visual consumers with things to say at other times but also helps determine and solidify the sociocultural order of luxury-branded visual representations produced by contemporary artists. The pleasure of luxury-branded visual representations produced by contemporary artists does not end for the visual consumer at the instant of sensation but, rather, continues, through a myriad of sensual relations, as the visual consumer seeks to construct and reconstruct further pleasures to be found in other luxury-branded visual representations produced by contemporary artists. It is imperative to state that there is no essential link between pleasure and luxury-branded signs, interpretations, and discourses. Conceptual art is pertinent for numerous visual consumers' understandings of the domain of luxury, as examined previously. Likewise, for countless visual consumers, interacting with luxury brands such as Hennessy could be as pleasurable for them as the visual consumption of a Kusama handbag in a Louis Vuitton window display could be for others.

Fourth, luxury-branded visual representations produced by contemporary artists also help in the *configuring of everyday life*. Everyday life is founded on practices, and luxury-branded visual representations produced by contemporary artists are comprehended as part of daily existence and in part as a means of scheduling everyday life. Visual consumers see glossy magazine photographs of Jeff Koons and television reports of Yayoi Kusama. And if the photographs and television reports do not satisfy their desire for luxury, it might be the dissatisfying disruption to the schedule that is more challenging than not being able to visually consume luxurious photographs of Koons and television reports of Kusama.

One increasingly significant role that luxury-branded visual representations play in the structuring of everyday life is exemplified by luxury-branded visual representations produced not by contemporary artists but by contemporary visual consumers themselves on YouTube, embracing what might be described as the "semiotics of the bedroom": luxury-branded visual representations of "unboxing" "reveals" produced by contemporary visual consumers, or perhaps amateur video or performance artists of luxury goods, such as Miss Kassandra Brooks, wherein her purchase of a Chanel purse is unboxed, revealed, and discussed. For me, such luxury-branded visual representations (though obviously not officially endorsed by luxury brands themselves, except in the case of a relatively small number of "social influencers" discussed in Chapter 8) produced by contemporary visual consumers as amateur video or performance artists combine many visual consumers' diverse contemporary public and private aesthetic domains. YouTube is perhaps viewed at home, but the unboxing reveals are debated in the public comments below the unboxing reveals on YouTube (e.g., the opening comment under Miss Kassandra Brooks's Chanel purse unboxing reveal noted above reads: "Congrats on your very first Chanel my Love it is stunning this is such a rare bag to find great job! So you babe 🖤Jerusha."). The luxury-branded visual representations seen and the grain of the voices heard on the video are appraised in the public comments. Luxury-branded visual representations produced by contemporary visual consumers as amateur video or performance artists on YouTube appear in numerous other areas of social media that visual consumers shift among, for example, Facebook, Twitter, and Instagram (see Chapter 8), and recent phenomena such as luxury-branded unboxing reveals constitute luxury objects of conversation when crisscrossing the borderlines between the spheres. However, the luxury-branded visual representations produced by contemporary visual consumers as amateur video or performance artists on YouTube can also alter these realms. Some domains are private, and some are public, but with the assistance of luxury-branded visual representations produced by contemporary visual consumers as amateur video or performance artists on YouTube, private domains, such as the bedroom, can be made more public and vice versa. Through YouTube, a visual consumers' bedroom can be linked to other parts of the realm of luxury. Correspondingly, through an understanding of a Jeff Koons "Masters" bag in a Louis Vuitton window, a public area can become the spark for more private reflections on paintings such as Vincent Van Gogh's *Wheatfield with Cypresses*.

A world of luxury-branded contemporary art?

In contemporary visual culture, luxury-branded visual representations produced by contemporary artists have increased in significance, and so have crossover collaborations and art competitions. This has led several contemporary artists and critics, Giulia Zaniol (2016) among them, to argue that visual consumers increasingly exist in a world of luxury-branded contemporary art. By this, Zaniol denotes that crossover collaborations, art competitions, and luxury-branded visual representations produced by contemporary artists progressively structure visual consumers' aesthetic experience by creating luxury-branded images and modes of contemporary art that are increasingly displacing contemporary art as the measure of what contemporary art is. How do visual consumers know what is contemporary and creative art? They visually consume Jeff Koons's luxury-branded visual representations and they see Yayoi Kusama's contemporary art for Louis Vuitton, and the modes of contemporary art displayed in these luxury-branded visual representations are the ones they appreciate to acquire an idea of contemporary art. Visual consumers reside in a world of luxury-branded contemporary art, a world wherein the boundaries between contemporary art and the modes of contemporary art fashioned by luxury brands have been breached, and where the modes create, or at least come to define, contemporary art (Kastner 2013; Adam 2014; Zaniol 2016).

How sensible is this account of contemporary visual culture, and of visual consumers' understanding of contemporary art? A difficulty with it is that it takes a visual culture that has altered (auction houses selling contemporary art at record prices that would have been difficult to imagine a few years ago etc.) as a sign that visual consumers have also altered. That is if the visual culture has become more infatuated with contemporary art, then visual consumers have likewise become more infatuated with contemporary art. But that does not necessarily follow. It is the identical sort of error that might be made if semiotic scholars maintained that by examining the popularity of visual culture, it would be possible to determine its semiotic influence on visual consumers.

Zaniol is captivated by the British celebrity YBA artist Damien Hirst, by his often luxury-branded visual representational environment in contemporary art, and by Hirst as a symbol of "the artist as luxury brand" (2016: 50). The French historic luxury crystal and glass manufacturer, Lalique, for instance, collaborated with Hirst in 2016 on "Eternal," which consists of a collection of exquisite, limited edition crystal panels available in twelve different colors. For Zaniol, an Italian artist working in the United Kingdom, these environments

appear far removed from contemporary art because they utilize "self-publicizing luxury marketing methodologies" (2016: 50). Of course, visual consumers might maintain that, for some of them at any rate, such luxury environments have become completely "naturalized." Yet, because these luxury environments have been a part of visual consumers' daily milieu for such a long period does not mean that they are not a social and ideological *imposition* (see Chapter 3) or that, because it would feel "unnatural" if they were not there, they are no longer ingrained in sign systems that do not proclaim themselves *as* sign systems. This last is the way most cultural phenomena, as an unmotivated system of meanings, find their way into everyday life (Barthes 1985b: 66).

Hence, while it may appear completely "natural" to visual consumers to devote an increasing proportion of their way of life to luxury-branded visual representations produced by contemporary artists, it is important to recognize that contemporary visual culture *always* presents its signs as justified by "nature" or "reason" (Barthes 1972a). Moreover, visual consumers do not have to travel much earlier in time to discover a similar condition, argument, and demonstration. Luxury-branded visual representations produced by contemporary artists have played a significant role in visual culture since the creation of luxury-branded visual representations founded on heritage such as Cartier jewelry. However, while the introduction of luxury-branded visual representations founded on the present period such as those of Tom Ford, the contemporary fashion designer, denoted a qualitative shift in the way that luxury-branded visual representations produced by contemporary artists configure everyday *outer* life, such luxury-branded visual representations, I suggest, are also qualitatively altering visual consumers' collective emotions, thereby reconfiguring their everyday *inner* lives. Through the ushering in of first conceptual art and afterward pop art, luxury-branded visual representations produced by contemporary artists have captured inner time and inner space in everyday life: inner space wherein luxury-branded visual representations produced by contemporary artists inhabit psychological emotional spaces in the body; and inner time where visual consumers increasingly spend their time in their bodies contemplating luxury-branded conceptual and pop art.

Such a "naturalization" process signifies that visual consumers in everyday life tend to take for granted phenomena like the press publicity surrounding luxury-branded visual representations produced by contemporary artists. But it also means that visual consumers in everyday life are inclined to take experiences such as the mass communicated irritations, intrigues, and occasional "scandals" concerning overly expensive yet sublime artworks, such

as Damien Hirst's diamond encrusted human skull, entitled "For the Love of God," for granted too (White 2009); the phenomena become parts of the everyday environment, parts of the day-to-day presentation of luxury-branded visual representations produced by contemporary artists in terms of an implicit "natural" psychology, and so do not usually merit any special consideration, as if what was said about these luxury-branded visual representations produced by contemporary artists was obvious, as if luxury-branded visual representations and their meanings coincided "naturally." Luxury-branded visual representations produced by contemporary artists are seemingly "just there" when, in fact, they are part of the process by which visual culture elaborates and, crucially, *imposes* specific meanings in the guise of "naturalness" (see Chapter 3). But this does not necessarily denote, as Zaniol would contend, that visual consumers have lost their analytical detachment concerning them, even if it does mean that visual consumers, inevitably surrounded by luxury-branded visual representations produced by contemporary artists as signs, tend not to either read or accept these signs *as* signs. As demonstrated in active semiotics, when considered, most visual consumers can interpret and ponder over why they contemplate the signs of luxury-branded visual representations produced by contemporary artists in the way that they do, although, as Barthes (1985b: 97) notes, those of us in the advanced countries are often inclined to create and deny signs *simultaneously*. Thus, while few visual consumers are incapable of differentiating between luxury-branded visual representations and contemporary art, pounding away constantly at the "naturalness" of the signs of luxury-branded visual representations produced by contemporary artists is an important struggle because, as with all other signs, it is a matter of recognizing the *arbitrariness* of luxury-branded visual representations produced by contemporary artists.

Consequently, Zaniol's vision of a world of luxury-branded contemporary art is rather overstated. Yet, importantly, it is also a vision that acts as a warning sign. For conformity to luxury-branded visual representations produced by contemporary artists, to their moral constraints, and to their increasing market dominance, implies conforming and referring to them as instances of an ultimate signified, as signs hypostatized not in the name of contemporary *art* but in the name of contemporary *business*. This suggests that luxury-branded visual representations produced by contemporary artists are not "innocent" when it comes to visual and cultural transformation or to visual consumers' understandings of contemporary art. I maintain that the role of luxury-branded visual representations produced by contemporary artists is increasing

in significance. However, rather than debating in terms of a world of luxury-branded contemporary art and "luxury branding strategies and advertising techniques involving popular culture" (Zaniol 2016: 50), it is more important to concentrate upon the more psychological aspects of luxury-branded visual representations produced by contemporary artists and on their consequences for visual consumers.

I contended in the preceding section that the roles luxury-branded visual representations produced by contemporary artists play are tied to visual consumers' creations of themselves and of their visual cultures. They help in luxurious identity creation and "common sense"-making processes. Also, I argued that visual consumers connect with those parts of luxury-branded visual representations produced by contemporary artists that appear pertinent, and they comprehend them in a manner that makes "common sense" to them.

In contemporary visual culture, as I discussed initially in this chapter, the production of luxury-branded visual representations produced by contemporary artists has increased. This means that the possibilities are greater than ever before for understanding luxury-branded visual representations produced by contemporary artists in individual ways. If visual consumers desire to visually consume contemporary art in Paris at the Fondation Cartier pour l'art contemporain it is easy to do so. And if visual consumers only desire to visually consume contemporary art, they can do that at the Fondation Louis Vuitton. This can be understood as part of what might be called the "luxurification" process, where increasingly "individualized" visual consumers select the luxurious existence they desire to inhabit, irrespective of conventions of necessity (Bauman 2000). However, it is important to be cautious when explaining this process. It is correct that visual consumers make individual choices concerning their understanding of luxury-branded visual representations produced by contemporary artists and read luxury-branded visual representations produced by contemporary artists in ways that make "common sense" to them. But it is vital to remember that interpretations of luxury-branded visual representations produced by contemporary artists, like other types of sociocultural practices, are decided by familial "habitus" (Bourdieu 1984: 165–222) and individual capabilities, social class background and position, status, education, ideology, and distinctive cultural tastes. Therefore, unless visual consumers mature with an embodied history wherein it appears "natural" to contemplate contemporary art as "second nature," they might not occupy that habitus or disposition later. Contemporary art does not appear pertinent to a visual consumers' sociocultural group under those conditions.

This indicates that the larger number of luxury-branded visual representations produced by contemporary artists on offer and the larger possibilities for visual consumers to select between diverse types of luxury-branded visual representations produced by contemporary artists (and each visual representation is unique in its difference) might lead not only to an increasing luxurification for some but also to an increasing level of necessity and austerity for others or to an increasing level of visual and cultural inequality (Piketty 2014) and to increasing disparities between different groups of visual consumers. Nowadays, visual consumers can understand luxury-branded visual representations produced by contemporary artists for their own reasons. They can comprehend them to become luxurious or *voluptuous* selves, which are discussed in Chapter 5. This is the optimistic feature of luxury-branded visual representations produced by contemporary artists. However, with larger dissimilarities in visual consumers' understanding of luxury-branded visual representations produced by contemporary artists, there is an equivalent variation in the creation of visual consumers' perspectives concerning luxurification and individualization. Different groups of visual consumers consult different parts of luxury-branded visual representations produced by contemporary artists and create discriminatory forms, accounts, and adaptations of the world of luxury, making it increasingly problematic to connect with each other in critical yet significant ways. A shared visual-cultural language or discourse of luxury-branded visual representations produced by contemporary artists—a visual-cultural language where all visual consumers contribute to refining its subtleties, intelligence, and operation—is increasingly hard to imagine let alone sustain. That is the pessimistic feature of luxury-branded visual representations produced by contemporary artists, but it is also essential to retain their optimistic features.

Luxury and photography

As we saw in Chapter 2, one of the principal issues for research into luxury and visual culture is the continuing reinvention of luxurious photographic selves and the groups of visual representations to which luxurious photographic selves belong. In this chapter, I initially explore the twentieth-century luxurious photographic selves of Edward Steichen and Richard Avedon and their range of responses along with the contemporary luxurious photographic selves of Annie Leibovitz. Yet I do so as a prelude to a consideration of the ever-increasing voluptuousness—of sensual pleasure, opulence, indulgence, and beauty— expressed in contemporary luxury fashion photography, as demonstrated by, among others, the photographs of Guy Bourdin, Miles Aldridge, and Tim Walker. Moving beyond Barthes's "The Face of Garbo" (1972a: 56–57), I argue that numerous changes concerning the face of supermodels, for example, the transgendered face of the supermodel Teddy Quinlivan, are occurring today, with significant implications for contemporary notions of luxuriousness, fashion photography, and the self.

Twentieth-century and contemporary luxurious photographic selves

Contemporary visual culture in the present context denotes a combination of luxurious visual representations wherein a series of visual representations from the most critical and controversial to the most favorable adjoin, summoning and requiring reactions at numerous levels, including that of the luxurious photographic self. We might envisage the contemporary luxurious photographic self as the imaginary control center of a global mission, receiving and being obliged to manage reactions to a diversity of contributions, but, finally—being a purely contemporary luxurious photographic *representation* of the self—*not*

being required to take responsibility for the consequence. Sharing this difficulty of representational management are important *real* others, contemporary luxury fashion photographers, advertisers, luxury fashion designers, luxury fashion models, luxury fashion hair stylists, make-up artists, and, of course, visual consumers. But only *real others* can release the contemporary luxurious photographic self from accountability and requirement of luxurious photographic self-management or cross the threshold into the contemporary luxurious photographic self's imaginary decision-making control center. How this contrasts with the luxurious photographic self's situation and role in the early- (pre-World War II [1900–39]) and late- (post-World War II [1945–2000]) twentieth-century worlds of the luxury photography of Edward Steichen and Richard Avedon is informative.

In the early twentieth century, the Luxembourgish-American photographer, painter, art gallery, and museum curator Edward Steichen's (1879–1973) luxurious photographic self, for example, was situated in the *internal spaces* provided by the photography studio or film set where he specialized in photographing dresses (Figure 5.1) (Johnston 2001; Ewing and Brandow 2008). Steichen's luxurious photographic selves are, of course, now regarded as the first modern fashion photographs ever published, with the limited (and limiting) internal spaces of photography studios being thought adequate for the promotion of dresses in magazines such as Condé Nast's *Vogue* and *Vanity Fair*. Like every other commercial photographer, though, Steichen was obliged to represent luxurious photographic selves that were acceptable to advertising agencies such as J. Walter Thompson, agencies whose wholly commercial idea of the representation of the world of luxurious dresses precluded the production of many other non-commercial conceptions concerning what the representation of the domain of lavish dresses might look like. Lacking means of communication from beyond the world of luxury, as luxury photographs, luxury magazines, and the ability to interpret luxury representations were relatively uncommon, the production and promotion of alternate cultural narratives of the twentieth-century luxurious photographic self beyond fashion (e.g., as an aspect of fine art or as anything other than a dress designed by couturiers such as Paul Poiret) was negligible. Where such readings occurred, it was difficult to conceal, and only photography studio isolation or the comparatively exclusive communities of luxury magazine publishers or modern luxury fashion photographers provided shelter. Deviations were numerous, but they circled near to the leading representations of the world of luxury provided by early-twentieth-century advertising agencies. Steichen's early-twentieth-century luxurious photographic self was thus represented

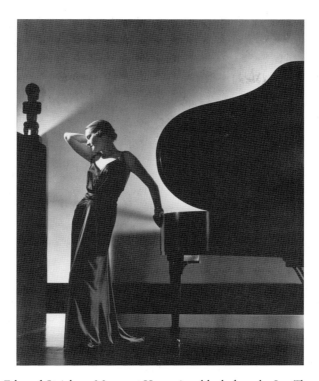

Figure 5.1 Edward Steichen, Margaret Horan in a black dress by Jay-Thorpe, 1935. Photo credit: AP/Shutterstock.

through its garments in such a way as to express a sense of their physical quality along with their formal appearance, as against only illustrating the object. Steichen's early-twentieth-century luxurious photographic self's task was to manage such qualities, appearances, and illustrations with the assistance of its couture dresses reflecting the ease of movement, through advertising, and the emergent internal spatial values of modern fashion photography. Primarily, Steichen's early-twentieth-century luxurious photographic self was perfection personified, precisely lit, painterly, *other-regarding*, and had to keep itself luxuriously fashionable for other reasons than self-centered or stylistic ones. This created an assortment of cultural and twentieth-century luxurious photographic self-configurations that contradicted most attempts at externalization and which situated Steichen's early-twentieth-century luxurious photographic self within narrowly designed, sharply focused, and internal spatial bounds.

In the late twentieth century, as Richard Avedon (1923–2004), the American luxury fashion and portrait photographer discussed in Chapter 3, showed,

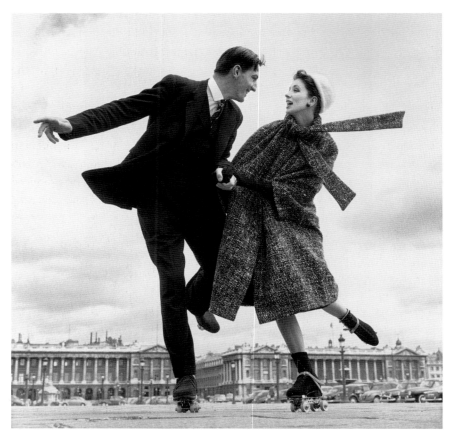

Figure 5.2 Suzy Parker and Robin Tattersall, dress by Dior, Place de la Concorde, Paris, August 1956.

Photograph by Richard Avedon. Copyright © The Richard Avedon Foundation.

the luxurious photographic self becomes subjected to a series of visual and representational influences that produces a luxurious photographic self more externalized, Americanized, and *self-regarding* concerning luxurious visual representations of style, beauty, and culture during the post–World War II period (Figure 5.2) (Avedon et al. 2009; De Ribes and Picardie 2015). Avedon's late-twentieth-century luxurious photographic selves are situated at the heart of a more American advertising and US department store set of *external spaces* provided increasingly by film sets and Hollywood. Avedon's realization of luxurious visual representations for magazines, including *Vogue*, *Life*, and *Harper's Bazaar*, is still dominated by the photography studio and by the advertising agencies, but his luxury fashion photographs are nonconformist and—unlike Steichen's early-twentieth-century method of taking studio fashion photographs, where models stood impassive and seemingly unresponsive to the camera—show models full of emotion and smiling, laughing, and, often, in action in external settings, which was groundbreaking at the time. With *Harper's Bazaar* and, later, *Vogue*, Avedon's photographs and covers could be produced and endlessly reproduced for cultured visual consumers. Enhanced air travel facilities and their related possibilities took Avedon's late-twentieth-century luxurious photographic selves to places of luxury fashion advertising such as Paris and luxury fashion advertising to the places of Avedon's late-twentieth-century luxurious photographic selves. The creative visual production, reproduction, and consumption of Avedon's alternatives of the late-twentieth-century luxurious photographic self and dresses designed by couturiers, such as Gianni Versace, increased, beginning with Avedon's shooting of the Versace spring/summer campaign of 1980, problematizing the control of luxury fashion advertising for the advertising agencies and fashion magazines.

The production of novel and more "American" cultural narratives of late-twentieth-century luxurious photographic selves and dresses designed by couturiers, such as Versace, became a requirement and also provided a lightning rod, seen not only in Avedon's photographs for the Calvin Klein Jeans campaign, featuring a fifteen-year-old Brooke Shields, and the accompanying television commercials, but also in Avedon's work with Shields in 1974 for a Colgate toothpaste advert, for Versace, American *Vogue*, and Revlon. Steichen's previously dominant idea of the early-twentieth-century luxurious photographic self being depicted through its costumes so as to communicate their physical attributes along with their formal look, contrasted with merely exemplifying the object, was either forced to coexist with Shields as the new focus of others' criticism, as with her apparent facility to focus the inarticulate fury people felt about the

deterioration in contemporary morals, or to surrender to what she seemingly represented, which was the obliteration of incorruptibility in the modern world. Avedon's late-twentieth-century luxurious photographic self, therefore, is represented and discussed as more outrageous, immoral, and photographed as being self-directed. Meticulous late-twentieth-century luxurious photographic self-management is thought vital by Avedon for advertising and economic reasons in *Vogue* and the late-twentieth-century luxurious photographic self-cultural narrative is more inner-directed. But the luxury fashion labels' playfully inventive advertisements, the luxurious visual representations of Christian Dior and so on, *Vogue*'s aesthetic and economic morals, and international mass forms of communication and information through Hollywood and television eventually produced more global, external, color, mass, and Americanized configurations of the late-twentieth-century luxurious photographic self, as in Avedon's 1982 advertisements for Dior, which were based on the idea of Hollywood film stills.

The American portrait photographer Annie Leibovitz's (1949–) contemporary luxurious photographic self is, somewhat paradoxically, more and less securely positioned than its precursors (Leibovitz [2008, 2017] cites Avedon's portraits as an important influence on her work.) For Leibovitz's contemporary luxurious photographic self is situated at the complex junction of a more *eternal* set of *spaces*, infinite in past and future duration, a never-ending set of "alter-nationalities" who apparently exist in an alternative state that is not so much a country but a *condition* without beginning or end, who have always existed and who always will exist, and an all-encompassing set of global, almost divine, international spaces and bases of perfect provision.

Leibovitz's distinctive *studium* (Barthes 1981: 27), her lighting style, use of bold colors, and poses, can, for example, be seen in the contemporary luxurious photographic self she achieved for Bulgari's Serpenti "Eternal Beauty" advertising campaign (2012–13), starring the Hollywood actress Rachel Weisz. "Snakes and Cleopatra—two symbols that exude seduction, power, mystery and eternity," purrs the advertising copy for the campaign. Indeed, Weisz, hair swept back, seated on gray stone rocks, with her right-hand fist and thumb pressed against her forehead to display the Bulgari bracelet, her left-hand around her waist, and gazing into the far-distance, is depicted as nothing less than a latter-day Cleopatra in a black, almost backless, dress, an "alter-national" of a purely mythical Egypt on her way to becoming a contemporary Bulgari divinity—beautiful and sensual, unreachable, secure, and in control. This, then, is a quest for unremitting beauty directed by Cleopatra as a muse and global symbol who has forever endured and who forevermore will endure and who is also the beholder of a magical

power, an inspirational character who enchants with the gleam of extraordinary Bulgari serpent-shaped jewels, classic and contemporary, with a gesture to the past, an eye on the future, and a heart set on the infinite. The location is at once a monumental and an essentially transhistorical space: weighty gray stone rocks that summon up the flawless temples of ancient Egypt in size and scale, a secure stronghold where celebratory rituals were customary.

Yet, I argue, Leibovitz's realization of the luxurious visual representation comes more persistently from the globalization of a kind of media heaven and—increasingly—from the internet as a high-tech refuge from contemporary insecurities: a realization of the luxurious visual representation that trades the insecure states of fashion models and their will to be in control for the *punctum* (Barthes 1981: 43) of an everlasting techno-paradise. In Leibovitz's March 2014 luxurious visual representation for *Vogue* of the American reality television personality Kim Kardashian West and her husband, the American rapper Kanye West, who is cradling their then ten-month-old daughter, "North West," for instance, these global stars clearly inhabit their own media dreamland, "flying high" as internet darlings, but seated within the enclosed confines of their own high-tech private plane, the ultimate techno-utopian sanctuary for them and for their daughter against the anxieties of the contemporary world.

As I noted in the preceding chapter, luxury-branded visual representations produced by contemporary artists added novel areas of luxury fashion advertising, which had unknown, eternalizing, and yet increasing influences, not least upon the self as visual consumer. Simultaneously, the connectedness of visual consumers and groups to the lifeworld of general visual culture was separating, if not being detached, in a process I called individualized "luxurification."

The production, reproduction, and consumption of contemporary luxurious photographic self-narratives has flourished in a way and to a degree that was hitherto unconceivable, seen in the myriad contemporary luxurious visual representations of eternal providence obtainable at every newsstand and inside the covers of luxury fashion magazines from *Vogue* and *Elle* to *Harper's Bazaar* and *Vanity Fair*. Through this expansion of bases of the contemporary luxurious photographic self, the possibilities of massified contemporary luxurious photographic self-production, reproduction, and consumption are lessening, whether at the level of photography, advertising, the alter-national, or the global.

The result of these processes gives rise to a strange historical condition where the contemporary luxurious photographic self can somehow acquire the eternal or consciousness of itself and its bases founded on the perfect comprehension of all things; liberation from some or all twentieth-century existential limits;

and an ability and desire to create and recreate itself from the varied, often "fragmented," and increasingly immaterial bases of meaning and resources it has access to (Barthes 1974: 19). A contemporary luxurious photographic self that finds itself in this perpetual situation with these seemingly otherworldly experiences, atemporal resources, and immaterial inclinations, I call *a voluptuous photographic self*. Not all photographic selves in the early twenty-first century find themselves in this situation. Not all photographic selves in the advanced countries are luxurious in my assessment. Numerous photographic selves are still entrenched in studio, advertising agency, and non-luxury brand–dominated circumstances where the eternal and the resources for contemporary luxurious photographic creativity are minimal or absent. Many other photographic selves exist in varied situations where some of these features occur, but not to the degree to allow the representation of voluptuousness. I will argue, though, that ever more photographic selves in the advanced countries can be described as voluptuous, namely, as being contemporary luxurious photographic selves.

Voluptuousness in contemporary luxury fashion photography

By voluptuousness in contemporary luxury fashion photography, I mean the representation of selves' desire and ability to ask questions such as "who am I?" to realize self-constructions, or identities founded on addiction to sensuous pleasures. Why choose this concept, what are its ancestries, and what twentieth- and twenty-first-century luxurious photographic selves, photographs, and photographers have informed my assessment? Voluptuousness has the benefit for me of encapsulating various features of the contemporary luxurious photographic self that I classify above. My method here will use the semiotic model proposed by Barthes (1977a) discussed in Chapter 3. I examine the concepts "voluptuous," "luxuriance," "voluptuosity," "voluptuous desire," and "voluptuousness."

Numerous usages of the concept voluptuous are current, one of the most widespread being an adjective regarding gratification of the senses, especially in a refined or luxurious manner. In this usage, it denotes being marked by indulgence in sensual pleasures, by the luxuriously sensuous (Barthes 1975). In the languages of desires or appetites, being voluptuous alludes to thoughts and/or deeds of love, but more certainly feelings and feats of lust. Voluptuous might here imply sensuality, delight, or longing for the answer to the question

"what am I?" It might additionally convey the erotic need for the body of the other. Consequently, a Christian might understand God as having corrected the apparent endlessness of human cravings by withholding human physical strengths and diminishing human sexual capacities (Cloutier 2015). A more wide-ranging usage of voluptuous means to communicate or signify, by a kind of physical contagion, our most sexual yearnings to other human beings. Yet, the allusion to yearnings is carried over in the use entailing pleasurable sensations, as when we might be perceived to be abandoning reason for sensuality, covetousness, bodily hungriness, and erotic enjoyments. Also, voluptuous has a usage as an adjective to explain the real or imaginary construction and seeking of pleasure, say sexual desire or in that smooth satisfaction, which the assured prospect of visual pleasure to be found in the luxurious visual representation bestows.

Luxuriance is frequently used as a noun to express the condition of being luxuriant, specifically a superabundant growth, development, or exuberance. It is operable concerning leafy forests standing majestically on display. Another use is to expand this to include the luxuriances of citizens, as with the luxuriances of their freedom, which indicates their capacity to indulge in and thus undervalue their hard-won liberty. This can be extended to the calm luxuriance of blissful light, such as the heavenly glow often seen on a beach at sunset. Luxuriance is moreover utilized to designate our persistent needs, wishes, and wants to burst forth into life. Luxuriance, though, has a commonplace use to denote the extreme luxuriance of vegetation, as in cattle being driven from considerable distances to feed on lush grasslands.

Voluptuosity I use as an adjective to allude to the work of a diversity of twentieth- and twenty-first-century luxury fashion photographers. Here I apply it to a variety of French and British luxury fashion photographers. Most frequently, I refer to the luxury fashion photography of Guy Bourdin (1928–91) in France. In the United Kingdom, the contemporary blossoming of voluptuosity, I argue, is signified primarily by Miles Aldridge (1964–) and Tim Walker (1970–).

There do not appear to be any shared roots in twentieth- and twenty-first-century luxury fashion photography concerned with voluptuosity except the engagement with the luxuriance of love, particularly that fashionable imagery which somehow occurs beyond economic activity and the "real world," and a photographic dialogue with luxurious visual representations and ideas of love as an indispensable and voracious desire. Voluptuosity in twentieth- and twenty-first-century luxury fashion photography, however, is impossible to impose a single meaning upon. What I will do here is take those features of numerous

twentieth- and twenty-first-century luxury fashion photographers and their photographs that signify my requirements and use.

First, I argue that twentieth- and twenty-first-century luxury fashion photographers inclined toward voluptuosity are usually against the attitude and practices of documentary photography (Franklin 2016). Documentary photography is a form of photography that attempts to reproduce reality by using the chronicling of events or environments that are demanded to satisfy a visual consumer's expectation or meaning of history, historical things and events, and everyday life. Consequently, Edward Steichen, or contemporary documentary photographers, such as Sebastião Salgado (2016), might provide professional photojournalism and real-life reportage to evoke an unknown place or hidden circumstances, such as ancient ruins or areas of wilderness destroyed by mechanical excavation. The belief is that the external world can be documented through photographs that accurately describe often forbidden or difficult-to-access places and circumstances in a way similar to the earliest nineteenth- and twentieth-century daguerreotype and calotype "surveys" of the ruins of the Near East, Egypt, and the American wilderness (see, for example, Golia 2010). To document through photography is to act as the nineteenth-century archaeologist John Beasly Greene did, for instance, by traveling to Nubia in the early 1850s to photograph the major ruins of the region (Stewart Howe 1994). One early documentation project was the French *Missions Heliographiques* organized by the *Official Commission des Monuments Historiques* to develop an archive of France's fast vanishing architectural and human heritage; the project included such documentary photographic celebrities as Henri Le Secq, Edouard Denis Baldus, and Gustave Le Gray (see, for example, Aubenas 2006). This other-regarding, outer-directed world of external things, documented and photographed, accurately impressing forbidden places and circumstances on inert receptors is exactly what, I suggest, twentieth- and twenty-first-century luxury fashion photographers focused on voluptuosity implicitly reject as mere "surveys," "archaeology," and "archiving." For them, luxury fashion photography is preoccupied with something internally, and perhaps eternally, inexpressible, something unfulfilled, a perpetual desire. Luxury fashion photography is luxuriance, not documentary; a construction of reality from inside love sooner than the reconstruction of reality from outside love. The fashion shots by Guy Bourdin, originally published in the February 1955 issue of *Vogue Paris*, are transitional, for in voluptuous visual representations such as "La Baigneuse" (The Bather) (Figure 5.3), he shaped quirky anthropomorphic compositions and then employed these intricate *mis-en-scènes* as the stimulus

Figure 5.3 Guy Bourdin, "La Baigneuse" (The Bather), 1955.
Copyright © The Guy Bourdin Estate, 2018.

to voluptuousness, to his individual cultural narrative of being in the world of luxury. His goal was to articulate richly sensuous inner beliefs through incitement and the ability to shock. But what inner beliefs, of what reality, and how is luxuriance achievable?

Let me focus my explanation by examining and responding to the critique of voluptuosity in luxury fashion photography offered by other luxury fashion photographers such as David Bailey (2014: 54), a luxury fashion photograph for whom is simply "a portrait of someone wearing a dress." For luxury fashion photographers of Bailey's persuasion, voluptuosity is an inadequate if challenging form of luxury fashion photography because its important luxurious visual representations of thoughts and/or deeds of love (i.e., luxuriance) are commercially driven and as a group no more than advertising campaigns for *Vogue, Harper's Bazaar,* and *Versace.* The voluptuous reality, the inner or subjective meanings they aspire to communicate are, first, richly sensuous and advertising driven, second, faux "new," and, third, incapable of offering a radical alternative to conventional luxurious fashion visual representations that make beauty and clothing their central elements. Employing no obvious theoretical context, the argument is that, say, Bourdin's inner subjective surrealism-inflected opulently sumptuous advertising driven photographs are unworldly and shaped by a "contemporary" form of luxury fashion photography and pseudo-idiosyncratic reality.

Second, the argument is that Bourdin's and others' search for the "new" anthropomorphic composition, for the complicated *mis-en-scène*, for the luxuriantly fleshly advertising visual representation, for the splendidly lush inner reality not tainted by banality, is fated to end in failure, as in the talent to scandalize that Bourdin had discovered in his search for the various configurations of erotic reality (Figure 5.4).

Third, according to such arguments, offering a radical alternative to conventional luxurious fashion visual representations that make beauty and clothing their central elements assumes a surreal or sinister component or a whole "new" visual vocabulary with which to associate the luxury goods of haute couture. Bourdin's search for voluptuosity, in strange cultural narratives and mystery, in implied violence or graphic sexuality, in Man Ray (Comis and Franciolli 2011) and Edward Weston (Pitts and Heiting 2017) dreamlike luxurious visual representations, for articulation of his ornately affective advertising imagery will either remain a disappointment or yield to the menacing constituents of surrealist paintings, such as those of René Magritte (Gablik 1985) and Balthasar Klossowski de Rola (Balthus) (Neret 2003), implicated in all luxury fashion photography.

Figure 5.4 Guy Bourdin, advertising image for Charles Jourdan Shoes, 1979. Copyright © The Guy Bourdin Estate, 2018.

Voluptuous twentieth- and twenty-first-century luxury fashion photographers such as Bourdin were and are certainly preoccupied with the richly sensuous luxurious visual representations of advertising. But they were and are also concerned with the examination of love as an indispensable and voracious desire. Indeed, they were and are less pornographers committing Bourdinian mistakes and more witnesses to an existential inferno that can never be extinguished, as is exemplified by the adoration, concern, distress, and anxiety everyone senses before their beloved, by, in other words, sensations of desire, of seeking possession of the beloved, and of the refusal to be possessed by the beloved. They seem to convey voluptuous being and not some mere advertising driven artlessness they cannot identify. Most of the twentieth- and twenty-first-century luxury fashion photographers inclined toward voluptuosity did and do use the concept "new" to seek to encapsulate the experience and the impression they were and are after. However, by the 1980s, voluptuous luxury fashion photographers had advanced beyond Bourdin's advertising driven voluptuosity to its more random and agitated alternatives, and to touching and stroking, patting and embracing, none of which experienced the difficulty of a purely advertising driven capacity to outrage. As the main basis for creativeness was and is love as a crucial and ravenous need, which is not necessarily erotic, the "new" should be comprehended in another way, as the urges for contemporary voluptuous photographic selfhood that direct countless voluptuous visual representations of human life attempting to enter the inaccessible. The feeling of being voluptuous is the mainspring behind many of the extraordinary visual representations of voluptuosity by Helmut Newton, with some of the best known being those of Elizabeth Taylor and Salvador Dali (see, for example, Newton 1996, 2009).

Lastly, many twentieth- and twenty-first-century luxury fashion photographers who have focused on voluptuosity have an approach to surrealist paintings and their ominous elements that is a challenge to the prevailing photographic practices of Western documentary photography. In fact, they offer a radical alternative to conventional luxuriously fashionable visual representations that make beauty and clothing their central elements but which is not imagined by them as being without disturbing factors, implied violence, or the sex war over possession and control. Twentieth- and twenty-first-century luxury fashion photographers centered on voluptuosity see their visual engagement as revealing the fever and ecstasy of lovers consuming and overwhelming each other through kisses and indeed revealing the passion of love itself; they seek the voluptuous and accept that they must use baleful ingredients and a vocabulary of desire. Where they vary is in the threatening constituents and vocabulary of desire where they seek

the visual impression, in their usage of voluptuous visual representations of yearning which single out "something," but which everyone knows is a yearning for eternal nothingness or for the other as a kind of image of infinity. It is, then, a vocabulary of desire taken from voluptuousness, from the quest for an ever-deeper potential that twentieth- and twenty-first-century luxury fashion photographers engaged with voluptuosity believe to be made up of an eternally expanding longing which will eventually depart from all of us.

Voluptuosity as a form of luxury fashion photography, therefore, is about producing—not imitating or reproducing—a reality, employing sources of the luxurious photographic self, conveyed through an original vocabulary utilizing a combination of ancient and recent desires. It aspires to evoke a being that has no objective, no purpose in sight, but it knows that intricate *mise-en-scènes* and surrealist luxurious visual representations are their only way to attain such luxuriance. Like most usages of voluptuous and luxuriance, they mean to suggest thoughts and/or deeds of love that are enduring, eager, and erotically exciting. Voluptuosity, like luxuriance, can convey many objects and pursuits, but essentially it is the digging below the banal; it is the escape from the ties of the unadventurous, and the discovery and then the production and activation of the "unfulfilled" through luxuriant visual representations of sexual lusts and cravings, of the desires and terrors, that propel luxurious photographic selves and other similar luxurious visual representations of people in their attempts to occupy and to influence their own individual world of luxury.

My usage of voluptuousness and voluptuosity, much like Barthes's *Camera Lucida* (1981), seeks to extract some basic phenomenological-photographic characteristics of being I consider to be shared by all human beings, namely, voluptuousness and voluptuosity as a hurling onward into an infinite, unfilled, dizzying future. Voluptuousness welcomes this assumption of some final feasting on unalloyed time, a "foundation" which not even luxury objects can satisfy. Voluptuousness is thus not based on essentialism but primarily on a communal phenomenology, a "reality" that is not a Barthesian (1975) pleasure, because the mainstay to the voluptuous photographic self in the contemporary world of luxury is not always a lone voluptuous photographic self but, rather, a voluptuous photographic self that is subjugated by the extraordinary role and controversial status of "feminine luxury" (Marinetti 2018), and on the lack of any ultimate union in the sensual. Voluptuous photographic selves are created from resources and bases that are dependent on the spaces (*internal* [Steichen], *external* [Avedon], *eternal* [Leibowitz]) and times (twentieth-century, contemporary, future) occupied by a specific photographic group. Voluptuousness becomes comprehensible through

what visual consumers have grasped about the internalization of meaning from portrayals of the voluptuous photographic self; a self who is seemingly "in contact" with another but who, in some way, goes "beyond" this contact and whose visual "discourse" is that of a "contact" or a "sensation" made up almost entirely from the world of luxurious light. The meaning of voluptuous photographs of touching and stroking, inclusive of self-touching and self-stroking, visual consumers have understood, comes from an interior beyond a specific "touch." For such meaning is not some indispensable vocabulary of gentleness or balminess of the human hand. Rather, the voluptuous photographic self is constructed beyond discourses of interaction, some offered by others pursuing touches from elsewhere and redirected, but some being self-created, and self-produced because self-touching and self-stroking do not know what they want.

Voluptuousness and luxuriance are, then, bottomless and wide-ranging configurations of not knowing. They share the idea that the aim is to state something indescribable about what voluptuous photographic selves are and want to be and not to seek to duplicate what usually is and has been. Thereafter, they aspire to produce a novel way of being "disordered" along with a novel way of appearing "superfluous" or involved in a game wherein the purpose is, by some means, to steal away, to vanish or evaporate, and that supplants the old games bound to "rational projects" and to those established games associated with "plans." Voluptuousness aspires to shape the photographic self and cultural reality in luxury fashion, and in a style, that is unfamiliar and far away from what visual consumers sense documentary photographic selves are and want to be (chroniclers of significant historical events) and close to *something else*, to something other, always other. Voluptuousness as a form of luxury fashion photography is appealing to cultured people as visual consumers because luxurious photographic selves appear safe and confident yet always inaccessible in their ability to establish themselves as selves that are always still to come and their apparent voluptuous lifestyles from obtainable haptic, spatial, and temporal resources and who avoid the reproduction of the existing in favor of touches and self-stroking as the expectation of a somehow purer, unadulterated, uncontaminated, future. Luxuriance and voluptuousness in luxury fashion photography try to offer hesitant, indistinct, and enduringly desirous thoughts and/or deeds of love without substance about what its photographers feel about an ever-growing yearning, knowing that each photographer will have a unique voluptuous photographic self and cultural narrative concerning ever-lavish assurances to express. I argue that much of twentieth- and twenty-first-century luxury fashion photography opens new perspectives onto the inaccessible and

exemplifies the voluptuous turn as a feeding on the uncountable appetites, desires, and cravings portrayed here.

Voluptuousness, then, is the approach, method, and photography of many luxury fashion photographers in twentieth- and twenty-first-century visual culture who try to create and shape an identity for their voluptuous photographic selves and to have such selves enact, perform, and arrange their world of luxury to correspond to this identity. It is the inclination to life of those voluptuous photographic selves and their visual consumers whose primary concern is the future itself; selves and consumers who appear to see their luxurious lives not as the anticipation of some future "fact" but as the assertion of voluptuousness as the very event of the future and a cultural narration of the voluptuous photographic self as the future cleansed of all substance. Being within the world of the voluptuous is about being within the world of the unknown, of the future, for the voluptuous photographic self and for its visual consumers, in their different lifestyles, spaces, relationships, and cultural groupings. Such voluptuous photographic selves have been unearthed by Miles Aldridge (Figure 5.5) when photographing luxury fashion for *Vogue*, the American monthly fashion magazine *W*, *The New York Times Magazine*, *GQ*, *The New Yorker*, *The Face*, *Paradis*, *Harper's Bazaar*, and for luxury fashion brands such as Longchamp, Karl Lagerfeld, Giorgio Armani,

Figure 5.5 Miles Aldridge, "Minuit," 2007.
Photo credit: Miles Aldridge.

Yves Saint Laurent, and Paul Smith (Aldridge 2013). Aldridge's voluptuous photographic selves are those selves who appear to seek and invent their own lavish forms of relationship with the other through an eros of the weird, erotic beauty, a grasping for love, and practices involving surreal yet cinematic forms of possession and carnal knowledge. Disgruntled with the customary forms of possession and lovemaking and resolved to produce forms that encapsulate his own individualized, yet Richard Avedon influenced sense of style, Aldridge moves beyond eros and possession, grabbing, and seeking to "know" the other. Instead, Aldridge seeks a sense of the other partly inspired by the psychedelic graphic design of his father, Alan Aldridge (2009). In so doing, (Miles) Aldridge sets up his own other through cinematic effects and the avoidance of color-coordinated visual discourses of possession, through the graphic representation of untainted bodily knowing, and through voluptuous visual representations that evoke hard-bitten reality as a synonym of power. I am trying to broaden this use here to incorporate other sorts of voluptuous photographic selves and concerns than luxury fashion brands such as Longchamp.

Aldridge's constructions of voluptuous photographic selves are dreamlike and occasionally nightmarish selves who give the impression that their relationship with the other is the lack of the other or the lack of unification with the other. Indeed, what shapes the identity of Aldridge's aesthetic and commercial practices concerning voluptuous photographic selves is the contestation of the other rather than the unification with the other. They understand and show a respect not for lack, but for the lack of the fundamental elements of reality, for the unalloyed oblivion of the dream. These are not simply perfectly visceral individualized and highly crafted voluptuous photographic selves left adrift as a film still or from some "whole" cultural narrative that lies elsewhere, but absent voluptuous photographic selves who look as if their dream lives and fashionable pursuits can be of potential worth but only within the context of a consumer-driven absence that is their dream horizon of the future. Aldridge's voluptuous photographic selves display high levels of absence from time itself and an apparent aptitude for self-management, for conquering new fairylands, but embrace and are capable of existing within and establishing groups that live within a horizon where their ostensible personal lives can be constituted not only in a luxury consumer dreamland but also in the heart of often superficially yet transcendent events. Such voluptuous photographic selves are comfortable in many increasingly cultural, eternal, dreamlike, spaces and roles, being ecstatic at their triumph over death. But they are particularly contented in outwardly unhappy emotional environs where their superior abilities in complacent

pleasure and artful suffering can be completely transformed into a sort of human happiness that is, in some way, "wrong" since it challenges the rational or usual orderliness of things.

As should be comprehended from the analysis above, not all photographic selves are voluptuous photographic selves. An apparent respect for one's own ability for dreamlike erotic desire is required, and that respect is archetypal for voluptuous photographic selves who give the idea that their lives are going, and will remain going, in the "right" desirous direction at each instant, voluptuously and culturally. Voluptuosity does not come to please erotic desire; it is this erotic desire itself and provides occasions for voluptuous photographic self-fulfillment and self-luxuriance, besides the provision of helpful yet desirous companions. This means that cultural impatience is an essential aspect of voluptuosity (eternal impatience in cultural space), but even more significant is the perceived sensation of belonging to an unreal group with a voluptuous, impatient, dreamlike, trajectory within an eternal cultural space. Voluptuous photographic selves are thus more liable to be widespread among those luxurious photographic selves who are not only outwardly impatient to make dreams happen but also surprised by their dream's end, for voluptuosity vanishes before reaching any end, inclusive of the end of the dream.

Recognizing their discovery of an extravagant yet hidden theater *as* hidden and avoiding the documentary motifs of the disclosed, voluptuous photographic selves can manage such exceptional relations. Agitation with the current situation I consider to be a characteristic of voluptuous photographic selves, who are forever eager to discover novel ways of being exceptional and living within a dreamtime wherein the hidden is not disclosed and the time to drift and to daydream is not dissolved. Voluptuous photographic selves are impatient with the daydream-like bases that establish them and with their style of luxuriance. They blend twentieth-century modesty with twenty-first-century immodesty, the clandestine "somewhere" newly uncovered with the realization that such an uncovering of, for instance, luxury fashion earrings does not develop into the status of the disclosed. For voluptuous photographic selves, therefore, discovery is a kind of defilement rather than the disclosure of an enticing secret, a defilement that does not recover from its own impudence, from its own, sometimes-shameful, sometimes-profaned, "uncovered," erotically playful lifestyles, and often near-naked or childlike habitus. While they value the "lite" resources essential to allow for the self-creation of a sense of "fun" and the creamy luxuriance of the inexpressible, voluptuous photographic selves often pay the highest respect to the mysteriousness of childhood wonder. The

inexpressible of the cinema of Powell and Pressburger (Moor 2012) or the luxurious photographic selves of Cecil Beaton (Beaton and Vickers 2014) rather than, for instance, the grim "realism" of the cinema of Ken Loach (Hayward 2004) is the telos of their "innocent" lives. A strange voluptuous photographic ethic of high romance supplants the documentary photography ethic, and the borders of objects and the self are deemed porous yet opaque. Documentary realist photographic selves do not know, accept, or acknowledge such voluptuous photographic selves, unfettered by the motifs of the disclosed, by the "realism" that they assume, adapting to the experiences of exceptional relations like the near-silent movement of a ballerina sooner than pursuing mirrored clarity in a documented, disclosed, and circumscribed cinematic world.

Photographic sources that have informed my explanation of the contemporary voluptuous photographic self and my choice of the concept voluptuousness include Tim Walker, a former assistant to Richard Avedon (Walker and Ansel 2012; Walker 2015). I employ the concept of voluptuousness concerning Walker's luxury fashion magazine photography in two different contexts. To start with, I allude to Walker's mode of seeing or of telling a visual story where his often fantastical historical and contemporary voluptuous photographic selves and their visual culture I understand as the hiding *while* uncovering of playful instincts and visual possibilities.

Let us consider Walker's "A Forest Fairytale" advertising campaign for the luxury brand bag and accessories manufacturer Mulberry, which was launched in the autumn of 2012. Shot in an autumnal brown clearing in an English forest, these delightful, suggestive, luxurious visual representations engage with the allure and fearfulness associated with children's folktales. Featuring two huge, cream-colored, bear-like, imaginary forest animals, mischievously hiding behind tree trunks, legs akimbo, padded paws and claws on display, and the supermodel Lindsey Wixson center-stage, the *mise-en-scène* incorporates luxuriously encrusted shadows wherein a dreamlike woodland vision is set against a representation of the Mulberry tree logo and the word MULBERRY clearly placed in the bottom right-hand corner. Iconic, tongue-in-cheek, and impish, charm, dread, and childhood adventures combine as in a flight of fancy. Alchemist, creator of his own legends, and photographing deep in the forest, Walker, surrounded by his monsters and the puppet-like Wixson, is a sorcerer at work.

Walker's "A Forest Fairytale," I suggest, evokes a kind of "spoken silence," a voluptuous realization that encompasses numerous visual possibilities. For me, Walker's use of luxuriant backdrops is connected to the inexpressible stories

played out in his memorable work, but it is an inexpressible that does not visually exasperate. While his ideas and modes of voluptuous seeing might initially be understood as unequivocal, clear, and unambiguous ("A Forest Fairytale" is visibly an advertisement for Mulberry bags), they are, in fact, the results of an equivocal personal scenario that is vague and ambiguously performed. The image sources are the equivocal rigged constructions of contemporary visual culture, achieved by hidden scaffolding and a lighthearted spoken silence without an unambiguous objective or rationale.

Futhermore, I argue that there are three sources of the voluptuous photographic self that Walker constructs into a staged, contemporary, yet luxurious performative identity: the equivocal play between the story and the renouncement of the story; the equivocal play between the significance of visual language (Walker wants us to believe his visual stories) and the apparent non-significance of the visual language of the voluptuous (all fairy cakes and tales of selves head-over-heels in love); and the idea of voluptuosity as something mysterious that no one can understand. Of these three, the idea of voluptuosity as something mysterious that no one can understand is bound to Walker's increasingly dark voluptuousness. I see his sense of dark voluptuousness as flourishing most in the contemporary world of what we might call "black luxury"; indeed, I see it as a strange poetic intent wherein the unexplained generates pleasure. The idea of voluptuosity as something mysterious that no one can understand, as the poetic extravagance of the photographic self, is a conceptual discovery that does not present itself as a signifier, such as the Gothic (which is, increasingly, Walker's major concern), and so illuminates no semiotic horizon or, as in Barthes's discussion of "The Face of Garbo" (1972a: 56), often stages the very beautiful feminine face, like the face of the supermodel Lindsey Wixson, as a dark and beautifully ecstatic face that in some way goes beyond the face to "a kind of absolute state of the flesh" (Barthes 1972a: 56). My critique of Walker's luxury fashion photography is twofold. For one thing, the requirements of any one kind of signifier are not supreme, and the hazards of including the voluptuous photographic self in a feminine facial image order are countless. For another, while recognizing the assessment of the "face" of the beloved Mulberry bag promoted by Walker ("I don't actually care for fashion," he says in interviews, for example, Smith 2012: 1), visual consumers are not obligated to recognize the "law" of the generally excluded masculine or transgendered face from his photographs and opt for their other—the feminine face. Voluptuous photographic selves are visual, expressive beings whose stories, illuminated selves, and secret sexual identities are formed within the voluptuous

groups to which they belong. Yet, these photographic groups can be numerous and erotic, desirous, and coinciding, and no one Gothic or surreal signifier can require visual consumers' total and undivided devotion.

Contemporary voluptuous photographic selves learn to manage and accommodate various intersecting, often sexual, signifiers and facial identities, some of which are constructed through the eyes of an irreverent, childlike, waif, and many of which are sexually modest. Walker is ostensibly dedicated in "A Forest Fairytale" to the notion that only the signifier of the estimable sexualized feminine face (eyes lowered, mouth open, hair touched and tousled) can deliver the essential "expression" that can engender a suggestion of "something" that is in fact a refusal to express sexuality, whereas I argue that coinciding *plural* signifiers of the feminine, masculine, and transgendered face are more visually discursive and productive of sexually modest and visual-cultural presences. For example, I not only acknowledge Walker's abrupt interruption of the order of human presences in the shape of faceless furry and phallic monsters in the woods, and see the worth of new alternative orders of presences, but also the flaws of the view formed through the eyes of an impertinent, ingenuous, orphan, and the sexually restrained order of presences that are the disagreeable aspect of the sexual signifier of the feminine face frozen in plaster—that of a supposed visual "purity" of expression that is, in fact, already disturbed by the equivocation of the timid and wounded world of the voluptuous. An order of feminine, masculine, and transgendered photographic facial presences, as we might call it, which includes visual expressions of good-natured sexual modesty and sexual immodesty, equivocal photographic tropes that depict less than nothing but are replete with shy laughter, coquettish teasing, and voluptuous significations, would offer expressions that are perhaps more sexually tainted, visually experiential, asexual, "offensive," and pleasantly revelatory than their impudent alternatives. Walker's feminine faces are a kind of irreverent, if humorous, evasion of these expressions, and are constructed upon a male myth of the order of perfect if ephemeral feminine presences, of the feminine hidden as hidden, and appear attached to a daydream that tries to control the order of the feminine and the number of biological and cultural models of being fantastically luxurious. A subscription to a view centered on the "genuine" archetype of the human feminine face might have analogous faults and risks, for its objectifying practices concerning being extremely luxurious, however un-intentioned, endanger the potential voluptuosity and irreducibility of other miscellaneous signifiers of the sensual world that is the human face.

Beyond "The Face of Garbo": Teddy Quinlivan

Closest to my idea but varying in vital respects is that of Barthes in his view of "The Face of Garbo" (1972a: 56–57) as the archetype of the twentieth-century luxurious photographic self. Theoretically based in Barthes's theory of semiotics, it shares with me the idea of sociocultural facial identity as a constant series of "moments" and ones wherein, through photography (as well as through cinema and television), there is the possibility of portraying the human face for visual consumers. In Barthes's semiotic theory (1972a: 109–59), the signs we create become the agencies for generating the next generation of luxurious photographic selves for visual consumers, thus signs replicate luxurious photographic selves for visual consumers who then reconstruct and then duplicate those signs in an eternal process of visual and representational change. In the historical context of contemporary visual culture, we get a process of visual and representational "semioticization" we might describe as the elated loss of ourselves in the human photographic representation where several of the visual representations I have explained above are paramount. At the level of the individual luxurious photographic self, this semioticization creates luxurious photographic selves that are estimable faces and objects, made-up, masked, plastered, colored, and authorized to be luxuriously overexcited by newly delicate facial representations and states of human flesh (Barthes 1972a: 56).

Clearly, writing in the 1950s, and ostensibly addressing a cinematic rather than a photographic luxurious self (although, in a sense, every image is a still image for Barthes: Watts 2016: xv), Barthes does not recognize the break with the twentieth-century luxurious photographic self that I propose. But such estimable faces and luxuriously frenzied visual representations have created novel luxurious photographic selves at corporeal and communicative levels. Barthes (1972a: 56) contends that a transformation of the eyes, of "strange soft flesh," and human expression is under way, disclosing a new logic and demand for visual, tactile, and communicative rather than sightless, indifferent, and taciturn relationships between exceptionally beautiful faces, both soft and flawless. Released from the seeming permanence of a familiar hardened corporeality created by novel insights into the insubstantial condition of human skin, luxurious photographic corporeality becomes more about visual ephemerality and the complexion of unfamiliar smooth skin than about the reproduction of human visual expression and countenance (Barthes 1972a: 56). Both masked and corporeal identities become more provisional, unconfirmed, luxurious, or excited, as individual luxurious photographic selves and groups of luxurious photographic selves'

experiment in living with new models of the face, and the twentieth-century gaze and role of the luxurious photographic self becomes idealized as a different kind of luxurious human being.

Although the explanation of visual and representational change is comparable, the effects upon the luxurious photographic self are different. For me, Barthes's account of "The Face of Garbo" is too absolute in terms of the likelihood of depicting the human face for visual consumers and concerned with the state of the flesh; I do not see one beautiful feminine face in corporeal and communicative identity but a plurality of frequently deviating developments regarding the face of supermodels such as Lindsey Wixson and beyond. Barthes's interpretation is too facially binaristic, as in his general subscription to the twentieth-century idea of the condition of the flesh as a fully corporeal masculine *or* feminine face. Masculine and feminine faces are historical and cultural narratives formed by those either unaware of or perhaps against alternative facial types, such as the transgendered face of supermodel Teddy Quinlivan, discovered in

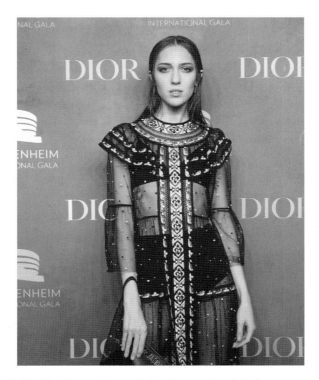

Figure 5.6 Teddy Quinlivan, Guggenheim International Gala pre-party, New York, United States, November 15, 2017.

Photo credit: Samantha Deitch/BFA/Shutterstock.

2015 by Nicolas Ghesquière, Louis Vuitton's creative director (Figure 5.6). But transgendered faces are themselves frequently legitimatory of the romanticized feminine face as a stimulus to male attentiveness and thus regulatory, if sensuous, visual and cultural discourses with problematic results for those mired in the void of the sexualized feminine face. For me, corporeal identities and relations are being transformed rapidly but not always in ways that can be termed masculine or feminine.

Having now expounded my interpretation of luxury and photography, twentieth-century and contemporary luxurious photographic selves, and the essential concept of voluptuousness in contemporary luxury fashion photography beyond "The Face of Garbo," we can continue in Chapters 6 and 7 to investigate the implications of these for luxurious and voluptuous selves' and visual consumers' lifestyles in twentieth-century and contemporary cinematic cultures and their luxurious and voluptuous televisual values.

6

Luxury and cinema

In this chapter, I examine luxury lifestyle choices in twentieth-century and contemporary cinematic cultures. For luxurious cinematic selves living in contemporary cinematic cultures, the "chore" of making decisions about what to do with their life has become a vital element of everyday existence, much more than it was for luxurious cinematic selves living in twentieth-century cinematic cultures.

Primarily, luxurious cinematic selves today must take responsibility for what they want to do with their lives. Twentieth-century ties have slackened, and it is neither expected nor feasible to follow the path of one's parents. If, in twentieth-century cinematic cultures, luxurious cinematic selves had few alternative life-strategies to choose from, in contemporary cinematic cultures luxurious cinematic selves must make choices between numerous diverse alternatives without the safety, confidence, or guarantee of knowing what they will bring about.

Luxury lifestyles in contemporary cinematic cultures are more *and* less varied than they were in twentieth-century cinema cultures. Luxurious cinematic selves nowadays shift between several different spheres of luxury in everyday life, and the way they behave in one sphere of luxury often has nothing to do with how they act in another.

Moreover, luxury lifestyle decisions for cinematic selves are chores that must be performed constantly. Most luxurious cinematic selves can alter their luxury lifestyles if they do not enjoy the way their luxurious lives are going. It is viable to relocate, to switch occupations, and to transform one's luxury leisure behaviors.

Choosing a luxury lifestyle and being capable of altering it when one wearies of it is an appealing idea, and for countless luxurious cinematic selves it is an emancipatory experience. Yet, it can also be shocking. The relative safety that twentieth-century luxurious cinematic selves experienced has vanished: not every luxurious cinematic self can satisfy their visions of luxury, especially since not all luxurious cinematic selves are given the chance to do so.

In what follows, I examine the shifting traits of luxury lifestyle in twentieth-century and contemporary cinematic cultures. I consider whether visual consumers are seeing the individualized luxurification of everyday life. I furthermore contemplate how luxurious cinematic selves cope with taking responsibility for their lives.

Luxury lifestyle in twentieth-century and contemporary cinematic cultures: A question of lavish choice

What is a luxury lifestyle in twentieth-century and contemporary cinematic cultures? A luxury lifestyle is the consequence of the lavish choices that a luxurious cinematic self makes about their occupation, leisure pursuits, and living arrangements. Luxury lifestyle research (contrasted with luxury lifestyle *in twentieth-century and contemporary cinematic cultures* research, which remains mostly nonexistent) throughout recent years has concentrated upon excessive lifestyles and on luxurious consumption; on luxurious lifestyles of cultured people with abundant, chiefly economic, but also cultural capital (Chaney 1996; Featherstone 2007, 2016a; Calefato 2014). And, like luxury lifestyle research, I also want to focus below in part on "the new middle class" or what might be called "the new *petit* bourgeoisie." But, unlike luxury lifestyle research, I want to concentrate on cinematic depictions of royalty and the aristocracy, "the old upper class" or "the *haute* bourgeoisie" in the sense that these are luxury lifestyles that are relatively simple to define and to examine. They also appear to visually represent an age stretching from the 1900s to today. But that does not denote that cinematic selves other than luxurious ones do not have well-defined lifestyles. Every cinematic self has an individual, inimitable lifestyle, one that is like the lifestyle of certain cinematic selves and separate from those of others.

Luxury lifestyles in twentieth-century and contemporary cinematic cultures are furthermore obviously visual. Luxurious cinematic selves show themselves to the world through their luxury lifestyles. This emphasis on the often-voluptuous aspects of luxury lifestyles can be tracked back in sociological literature to the late nineteenth and early twentieth centuries, to the era of Thorstein Veblen's *The Theory of the Leisure Class* (2009), Werner Sombart's *Luxury and Capitalism* (1967), and, in cinema, to early twentieth-century silent movies, such as Elsie Jane Wilson's (1918) *The Lure of Luxury*, with its visualization of snobbish attitudes and cinematic representations of the lives of the wealthy in the sophisticated city. This indicates that luxury lifestyles are voluptuously represented in movies such

as Marcel Perez's *Luxury* (1921) through specific forms of appearance (through choice of opulent garments for a wild bachelor party and behaviors concerning the inheritance of a family fortune); but it is also voluptuously represented through actions (through choice of expensive leisure interests), things (through choice of luxurious furnishings or plush car in a luxurious cinematic self's luxury residence, for example), and, as in the case of Paul Powell's 1922 movie, *A Daughter of Luxury*, through the "wrong" choice of an imposter as a "friend."

Luxury lifestyles in twentieth-century and contemporary cinematic cultures should be differentiated from luxurious cinematic self-identity. Following Giddens (1991), I contend that a luxurious cinematic self's identity takes a particularly luxurious configuration, and that luxurious configuration, whether cinematically apparent as life lived in a Hollywood mansion or a leading lady wearing costly jewelry, is the luxurious cinematic self's luxury lifestyle. This luxurious association should not be considered as straightforward or essential, though. While it appears sensible to claim that luxury lifestyles in movies such as Lothar Mendes's (1933) *Luxury Liner* are multifaceted and voluptuous representations of various social classes on a luxury cruise liner, of their luxurious self-identity, it should be observed that luxury lifestyles have a mutual influence on luxurious self-identities. Following a specific path in their luxurious cinematic lives, perhaps as an employee of a luxury cruise liner rather than as a passenger, might either imperceptibly or radically cause alterations in luxurious cinematic selves' self-identity. Furthermore, luxurious cinematic selves with comparable luxurious cinematic self-identities, from a ship's doctor to an onboard murderer, might end up with dissimilar luxury lifestyles. This is because luxury lifestyles in twentieth-century and contemporary cinematic cultures are about *lavish choice—often without limits*. Luxurious cinematic selves make different decisions about their luxurious lives, whether, for example, as in *Luxury Liner*, it is to avoid the "shame" of ending up in steerage or whether it is to indulge in swindling stocks and shares. Not all luxurious cinematic selves have the identical chances to choose the luxury lifestyles of their reveries of luxury, perhaps to board a luxury cruise ship about to leave Germany for America, but then no luxurious cinematic selves are deprived of lavish choices either, whether it is to become the ship's doctor, or whether it is to scheme one's way from steerage into first class.

Luxurious cinematic selves have always had luxury lifestyles in the meaning explained above. Moreover, in twentieth-century cinematic cultures, luxurious cinematic selves, such as Shirley Temple's "Mytyl" in Walter Lang's *The Blue Bird* (1940), literally had the chance to choose between alternative routes of

searching for the "Blue Bird of Happiness." Yet, the choices were for Mytyl not that numerous, given that her dream-induced search in the land of "Mr. and Mrs. Luxury" (Nigel Bruce and Laura Hope Crews) results in her discovery that happiness lies not in riches, and they were not dissimilar either from parental love or from each other (Taroff 2014) (Figure 6.1). Mytyl's alternatives did not bring about fundamental alterations in her way of living (since she escaped from the "Land of Luxury") from those of the twentieth-century luxurious cinematic selves preceding her either. Indeed, Mytyl returns home to the environment that she matured in (a woodcutter's cottage in the Royal Forest), and it was probable that this young girl would practice the identical profession as had her kindly mother (perhaps become a gentle woman who has learned to appreciate all the comforts and joys of her home) or for her to become a housewife just like her mother (perhaps marrying the boy in the next cottage and raising another family of woodcutters).

In the later twentieth century (i.e., post-1945), this environment began to alter. In Richard Whorf's *Luxury Liner* (1948), for instance, *The Blue Bird*'s Mytyl's homecoming is *reversed* as another young girl, "Polly Bradford" (Jane

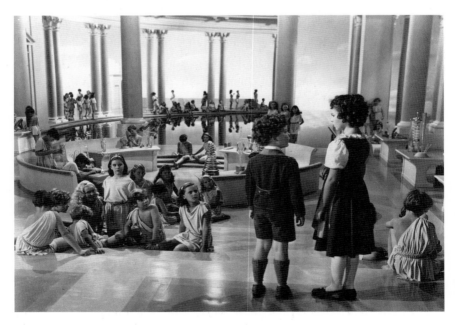

Figure 6.1 "Tyltyl" (Johnny Russell) and "Mytyl" (Shirley Temple) enter the Land of Luxury in *The Blue Bird*, 1940.

Photo credit: 20th Century Fox/Kobal/Shutterstock.

Powell), stows away aboard a luxury cruise liner, which is full of Hollywood musical stars, while her father just happens to be the captain, rather than a woodcutter living in a cottage in the Royal Forest. Distinct from *The Blue Bird*'s Mytyl, who will eventually take up the same position as her caring mother, Polly escapes from her tedious boarding school, stows away on the luxury cruise liner of the movie's title, and has a wholly self-identified ambition to become a singer. In short, the potential tender woman of the home ratified by *The Blue Bird* is replaced by the aspiring single woman of the stage, by the desire not to become a housewife. Likewise, Francis Searle's 1952 comedy *Love's a Luxury*, unlike *The Blue Bird*, not only interrogates the institution of marriage through the visual representation of marital infidelities at a remote English West Country estate but also questions the idea of the family as the only objective for love between men and women.

Of course, in contemporary cinematic cultures, the processes described above have only accelerated. In Sofia Coppola's (2003) *Lost in Translation*, for example (starring Bill Murray as an aging actor, "Bob Harris"), the luxurious cinematic self "Bob" befriends American college graduate "Charlotte" (Scarlett Johansson), who is seemingly unlikely to persist in the paths of her now absent parents in the sense explained earlier regarding *The Blue Bird* (Figure 6.2). First, young luxurious cinematic selves nowadays, such as Charlotte, are not developing in—or even attempting to forge—a customary nuclear family, since she has been left in the Park Hyatt Tokyo luxury hotel room by her husband, "John" (Giovanni Ribisi), a celebrity photographer on assignment in Japan. Besides, even if Charlotte had plans to do so, she is unsure of her future with John, feeling detached from his luxury lifestyle and dispassionate about their relationship. It is thus not only doubtful that Charlotte will work in the identical location or position that her parents worked but also probable that she will have to rely on her small friendship network for survival if she wishes to continue experiencing other luxurious cultures such as Japanese nightlife. With the farm, office, or factory of Charlotte's parents no longer in existence, with her troubled relationships with Bob and John, and, ultimately, with Charlotte's own placelessness, even and especially within the confines of a luxury hotel, she remains lost on the crowded and untranslatable streets of Tokyo if, finally, embraced and kissed by Bob before he returns to the United States leaving Charlotte alone.

Such disorientation, I argue, and developing the visual and cultural theory of Barthes (1975), implies that contemporary luxurious cinematic selves suffer from what I call "*pleasure dysphoria*." Luxurious cinematic selves are deceptively liberated from twentieth-century cinematic ties, relationships, and models of

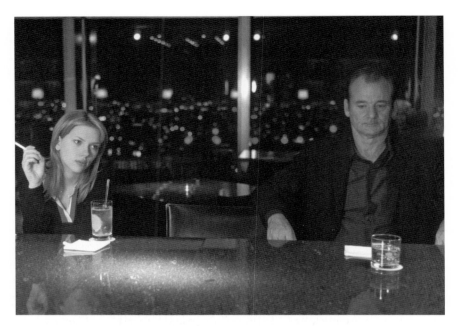

Figure 6.2 "Charlotte" (Scarlett Johansson) and "Bob Harris" (Bill Murray) in the bar at the Park Hyatt Tokyo luxury hotel, *Lost in Translation*, 2003.
Photo credit: Yoshio Sato/Focus Features/Kobal/Shutterstock.

cinematic existence yet are continually in a state of malaise about such hedonism. It is no longer conceivable for luxurious cinematic selves to inhabit their lives in the planned way that their parents were represented as doing, and they are both touchingly sentimental about and discomforted by that. The decisions taken by their cinematic parents have minor significance for the lavish choices that they must make, and luxurious cinematic selves find that the search for love is especially hard to bear.

Pleasure dysphoria is an ambiguous occurrence. Encouragingly, it signifies hedonism. It is not essential for luxurious cinematic selves to do the identical (or even any) sort of job that their cinematic parents did, and it is not compulsory to remain in the identical place for the entirety of their lifetime. The chance is provided to change and experience different things in habits, conditions, and customs inconceivable for twentieth-century luxurious cinematic selves.

Discouragingly, however, pleasure dysphoria does not only signify that luxurious cinematic selves get an opportunity to make individually lavish decisions. It also denotes that they *must make decisions under conditions marked by personal and individualized feelings of unease.* This is something

twentieth-century luxurious cinematic selves did not have to do (in the sense that, like Mytyl in *The Blue Bird*, they could return to persist in their cinematic parents' ways in situations *not* indicated by simultaneous feelings of being both a pleasure-seeking luxurious cinematic self and mentally discomforted by the result). Also, if they were to select other options, they understood more concerning what the options may bring about, which was an important source of personal and pleasurable satisfaction. Their luxurious cinematic lives were safe against feelings of indulgence, perversion, and restlessness. Currently that is no longer the situation. Luxurious cinematic selves must take responsibilities themselves, and they must do so in circumstances where they do not know where their lavish choices will direct them, but they *do* know that such choices will direct them to a position of often self-indulgent suffering.

Additionally, luxurious cinematic selves today are conscious that there are diverse conceivable ways of living with luxurious forms of "sin," with immorality, incest, and with feelings of shame, with "pleasurable" feelings that are, in fact, the very opposite of well-being and which might be called "ill-being." Through their cinematic travels and through the representation of fashion and art, photography, television, and social media *within* contemporary cinematic representations, luxurious cinematic selves understand what is taking place beyond their proximate cinematic environment, but they are generally apolitical and severely unhappy about gaining such understanding. This generates immense hopes of pleasure yet also produces mental disorders of various kinds. Hence, not all contemporary luxurious cinematic selves can become what they want to become, and the understanding that there are potentialities and options out there that they cannot attain can not only make such states disturbing but also make the luxurious cinematic self feel pleasure and ill-being *at once*. In some way enjoyably uncomfortable in their bodies, contemporary luxurious cinematic selves consequently and repeatedly intuit that they are in the "wrong" (i.e., poor, austere, Spartan) body or suffering from pleasure dysphoria.

The fragmentation of meaning and transformation of luxury lifestyles in contemporary cinematic cultures

The pleasure dysphoria of contemporary luxurious cinematic selves, seemingly liberated from twentieth-century cinematic ties, examined above, involves vicissitudes in responsibility from adhering to twentieth-century cinematic cultures to being obliged to make individually lavish choices. However, there

are moreover additional luxury lifestyle alterations in contemporary cinematic cultures. Furthermore, as with the pleasure dysphoria, these are variations that became obvious in twentieth-century cinematic cultures before becoming conspicuous in contemporary cinematic cultures.

First, luxurious cinematic selves' lifeworlds have become fragmented and resistant to potential solidification. My idea of a luxurious cinematic lifeworld has its genesis in Barthes's *The Pleasure of the Text* (1975), and it signifies the continually shifting cultural world that individual luxurious cinematic selves occupy. I contend that in twentieth-century cinematic cultures this world was relatively cohesive and, I might add, previously excluded from film theory's line of vision. Anywhere individual luxurious cinematic selves traveled, they were always in a similar, if not identical, luxurious cinematic world. In contemporary cinematic cultures, this is no longer the situation. The lifeworld of luxurious cinematic selves has become fragmented, increasingly meaningless, and, above all, totally hedonistic. Today individualized luxurious cinematic selves must shift between many diverse spheres of pleasure every day, not only private and public ones, but also immoral, dishonest, skewed, and leisurely ones.

Being required to shift between an increasing number of spheres of hedonism in pursuit of one's pleasure as an end in itself is an important change from preceding luxurious cinematic eras. Nonetheless, the radical change is that these spheres of hedonism are so dissimilar that the frequently unethical behavior of luxurious cinematic selves, which is thought legitimate and sensible in one sphere of luxury, might not be legitimate in another sphere of luxury, as such unethical behavior presupposes *an attention to the luxurious cinematic self at the expense of all others.* There are primarily the dissimilarities between how to behave hedonistically in private and public spheres of luxury, as the pursuit of pleasure is often individualized and either antisocial or lacking in social utility, but there are also differences within these spheres of luxury. Generally, this denotes that an individual luxurious cinematic self's lifeworld nowadays entails many diverse worlds of luxury, and in these varied cinematic worlds, different aspects of a luxurious cinematic self's luxury lifestyle come to the fore, often involving philosophical and/or ethical taboos. The fragmentation of the meaning of the lifeworld of the luxurious cinematic self therefore initiates more fragmented, more *and* less varied, or, at least, more *contradictory* luxury lifestyles.

Second, I have claimed that a luxury lifestyle in contemporary cinematic cultures is the consequence of the recurrently shameful if lavish choices made by luxurious cinematic selves in their everyday lives. Nevertheless, this is always

a *momentarily pleasurable consequence*. Individual luxurious cinematic selves shifting between diverse spheres of hedonism in their everyday lives continually must make—and resist—novel lavish and habitually uncertain choices. Must they switch their occupation, relocate, or move beyond who they are and become *someone or something other* than a pleasure-seeking luxurious cinematic self adrift in an outwardly "acultural" yet scandalous and immoral "atopia" that denies the expectations of established cultural discourses? Consistent with making these "pleasurable" choices, an individual luxurious cinematic self's luxury lifestyle continually alters, if only through its increasingly antisocial and anti-collective proclivities. Occasionally the luxury lifestyle alters indiscernibly in a specific place, occasionally radically beyond any previous conception of place. The argument, as we shall see in the next section, is that the luxury lifestyle is continuously transformed by the pleasure, comfort, and delight taken in the *rejection* of perceived shared cultural values.

Coping and not coping with lavish choice: *Spring Breakers, The Bling Ring,* and *Pain & Gain*

I have contended that luxurious cinematic selves in contemporary cinematic cultures are compelled into taking responsibility for their own—often radically antisocial—lives in ways not mandatory beforehand. In Harmony Korine's sexually explicit *Spring Breakers* (2013), for instance, which shadows four college girls on their spring break in Miami, their meeting with a weird local drug dealer, "Alien" (James Franco), and their ultimate disintegration into a realm of drugs, crime, and violence, the college girls must make ecstatic decisions concerning their lives in a fast altering sociocultural environment, and they are confronted with an increasing amount of luxurious choices, presented to them through, for instance, luxury fashion accessories, and the ever-expanding luxury leisure industry in Miami (Kohn 2016). The college girls know that they are confronted with many lavish alternatives. They must also tackle numerous significant moments, and they know that surviving them will unavoidably initiate others. They are also conscious of the reality that there are no sociocultural footholds and no "right" or "wrong" lavish alternatives to be discovered.

How do the luxurious cinematic selves in *Spring Breakers* cope with this? To start with, their everyday life has become more *and* less varied. In terms of luxurious leisure pursuits, there are ever more options to choose between,

and *Spring Breakers'* luxurious cinematic selves mix these options in diverse ways. Yet there is only one identical luxury fashion style that stands out—the bikini. Some cinematic selves in *Spring Breakers*, such as the parents of "Candy" (Vanessa Hudgens) and "Brit" (Ashley Benson), "Faith" (Selena Gomez), and "Cotty" (Rachel Korine), live twentieth-century cinematic lives, within a twentieth-century idea of a nuclear family. However, an increasing number of contemporary luxurious cinematic selves, such as "Alien," inhabit other sorts of loose-knit groups that are not families at all but, rather, blissed out criminal gangs bent on permanent sexual climax and other forms of ecstasy such as gunplay (Figure 6.3). In contemporary cinematic cultures, then, it is viable to select between many diverse luxurious choices in terms of one's luxury lifestyle. Furthermore, many luxurious cinematic selves, when confronted with these choices, not only choose luxury *differently* but also choose luxury *similarly*, with sex as a group activity as the default choice in *Spring Breakers*, for instance.

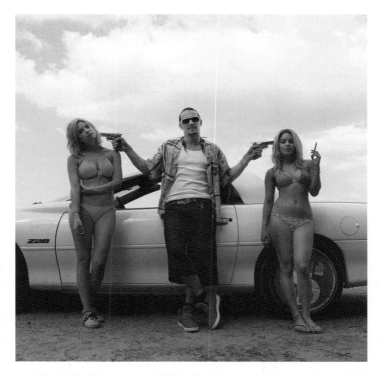

Figure 6.3 "Brit" (Ashley Benson), "Alien" (James Franco), and "Candy" (Vanessa Hudgens) engage in gunplay in *Spring Breakers*, 2013.

Photo credit: Moviestore/Shutterstock.

Has everyday life in contemporary cinematic cultures increasingly become an issue of individual choice? Are luxurious cinematic selves capable of doing what they want to do and of becoming what they want to become? Are visual consumers seeing an individualized process of pleasurable *luxurification*, as I called it in Chapter 4? What of twentieth-century configuring issues, for example, the "necessities" of class, ethnicity, and gender? Are they losing their significance? Do cinematic selves increasingly make individually pleasurable selections, founded on individualized luxurious interests?

I maintain that luxurious cinematic selves increasingly are unshackled yet burdened with pleasure dysphoria in contemporary cinematic cultures. Hence, this does not unavoidably denote that visual consumers are *always* seeing an individualized process of pleasurable luxurification in the sense explained above. It is correct that luxurious cinematic selves cannot carry on with their luxurious lives in ways like their parents. It is essential to undertake more responsibility. How do the luxurious cinematic selves in *Spring Breakers* cope with the "necessity" of lavish choice?

One difficulty with arguing only for a continuing process of individualized pleasurable luxurification is that such a claim overlooks that luxurious self-identity is not so much socioculturally based as increasingly socioculturally *unglued* and that luxurious cinematic selves in periods of pleasure dysphoria are also socioculturally *separated* beings. I contend that it is in periods of pleasure dysphoria that luxurious cinematic selves are socioculturally detached beings, beings who *live only for the moment* in which, instead of finding or communicating with themselves or with others, they only *lose themselves and others* through alcohol misuse or drug abuse, for instance. The key alteration in everyday life in contemporary cinematic culture is not one based on twentieth-century cinematic culture but based on finding individualized pleasurable luxurification as the "solution" to groundless, separated, estrangement. It is a shift from twentieth-century cinematic cultural attachment to making regularly ill-informed decisions within luxurious cinematic selves' sociocultural contexts characterized by a disconnected, brief yet *"blissful" state of loss*. Furthermore, when making such lavish choices, contemporary luxurious cinematic selves make discomforting choices that seem sensible to them, if not to us as visual consumers (and perhaps to the point of a certain kind of exasperated boredom), in their real sociocultural circumstances.

This indicates that the luxury lifestyle choices that the luxurious cinematic selves in *Spring Breakers* make vary not predominantly because of dissimilarities in individual pleasure interests but owing to diverse unsettling experiences

connected to belonging to real sociocultural environments. The luxurious cinematic selves in *Spring Breakers*, for example, are maturing in comparable sorts of environments and attending the same college, thus developing comparable viewpoints on life. Given their sociocultural upbringing and everyday environment, some of their actions in everyday life appear normal, while other actions—like their staging of an armed robbery to fund their spring break in Miami—do not. If, like "Faith" in *Spring Breakers*, a luxurious cinematic self is raised in a household where churchgoing is a habitual pursuit, attending church as a young adult will appear normal. If other *Spring Breakers*' luxurious cinematic selves, like "Candy," "Brit," and "Cotty," are not raised in a household with such assumptions, the likelihood of them developing a liking for the church is not impossible but doubtful.

Consequently, the contemporary luxurious cinematic selves in *Spring Breakers* have not just become individually pleasurably luxurious. However, this does not signify that things have not altered. The circumstances in contemporary cinematic cultures *are* dissimilar from the circumstances in twentieth-century cinematic cultures. The luxurious cinematic selves in *Spring Breakers* might still behave as sociocultural beings and make luxurious decisions that are like those made by other luxurious cinematic selves in parallel circumstances. Nevertheless, that does not make everyday life in contemporary cinematic cultures as steady and calm, secure and intelligible, or as clearly pleasurable as it was before.

For one thing, there are more luxurious options than ever. Even if luxurious cinematic selves make lavish choices that are linked to their location in what Pierre Bourdieu (1992: 229) calls "social space" ("a [multidimensional] space constructed on the basis of principles of differentiation or distribution constituted by the set of properties active in the social universe under consideration, that is, able to confer force or power on their possessor in that universe"), they do have additional luxurious choices no matter what the location. Yet everyday life is more *and* less varied than previously. This is also why we must not exaggerate my individualized pleasurable luxurification supposition. Because it is now feasible to choose between, for example, in *Spring Breakers*, a larger number and variety of beach pastimes in Miami than ever, it appears as if luxurious cinematic selves make more individually luxurious choices than earlier. Yet these lavish choices might still be chiefly reliant on class, ethnicity, and gender, for instance.

For another, contemporary luxurious cinematic selves shift between an increasing number of diverse spheres of luxury, and they alter their sociocultural contexts frequently: contemporary luxurious cinematic selves exchange occupations and shift between or to new cities like Miami. They meet

diverse, often dangerous, contemporary luxurious cinematic selves with diverse luxurious experiences, such as *Spring Breakers*' "Alien," a wealthy local rapper and drug dealing gangster, charmer, and all-round "bad boy," and listening to "Alien" explain his luxury lifestyle in his bedroom, they obtain novel viewpoints on what a luxury lifestyle might be:

> This is the fuckin' American dream. This is my fuckin' dream, y'all! All this sheeyit! Look at my sheeyit! I got . . . I got SHORTS! Every fuckin' color. I got designer T-shirts! I got gold bullets. Motherfuckin' VAM-pires. I got Scarface. On repeat. SCARFACE ON REPEAT. Constant, y'all! I got Escape! Calvin Klein Escape! Mix it up with Calvin Klein Be. Smell nice? I SMELL NICE! That ain't a fuckin' bed; that's a fuckin' art piece. My fuckin' spaceship! U.S.S. Enterprise on this shit. I go to different planets on this motherfucker! Me and my fuckin' Franklins here, we take off. TAKE OFF! Look at my shit. Look at my shit! I got my blue Kool-Aid. I got my fuckin' NUN-CHUCKS. I got shurikens; I got different flavors. I got them sais. Look at that shit, I got sais. I got blades! Look at my sheeyit! This ain't nuttin, I got ROOMS of this shit! I got my dark tannin' oil . . . lay out by the pool, put on my dark tanning oil. . . . I got machine guns. . . . Look at this, look at this motherfucker here! Look at this motherfucker! Huh? A fucking army up in this shit!

Third, in a rapidly shifting culture, with increasing interactions not only between contemporary luxurious cinematic selves within one state or region but also between national and regional luxury cultures, the ties that structure everyday life conduct become increasingly multifaceted, contradictory, and, as in *Spring Breakers*, driven by various *crises*. If in twentieth-century cinematic cultures class and gender were key causes of luxury lifestyle, in contemporary cinematic cultures other causes also must be considered, for example, a black club boss's ethnicity and Faith's religion in *Spring Breakers*. Social space has become increasingly multilayered and multiethnic.

This means that luxurious cinematic selves in contemporary cinematic cultures, such as those in Sofia Coppola's *The Bling Ring* (2013)—a true tale of a teenager and his gang of fame-obsessed female friends who use the internet to follow the whereabouts of celebrities like Paris Hilton, then steal from their houses—just like in twentieth-century cinematic cultures, make luxury lifestyle choices within a crisis-driven structure not of their own creation. Moreover, within this crisis-driven structure, the lavish choices obtainable by luxurious cinematic selves are reliant on their contradictory location within the structure. Furthermore given the swelling number of visual and highly visible media celebrities, such as Paris Hilton, and other "unattainable" possibilities,

and given the increasing fragmentation of the meaning of luxurious everyday life, including an increasing number of vicariously mediated "contacts" via TV and social media with diverse people like Paris Hilton, there is now an increasing consciousness that life can look otherwise, certainly more pleasurable, and that *life can be changed immediately into a state of bliss.* Looking otherwise, experiencing gratification, and entering a condition of apparent ecstasy are all dominant drives behind *The Bling Ring*'s "Nikki" (Emma Watson) and her accomplices' robbing Paris Hilton's Bulgari and Dior Fine Jewelry, Herve Leger, Hermès, Louis Vuitton, and Rick Owens's luxury-branded dresses, bags, and jackets, for instance (Figure 6.4).

Contemporary luxurious cinematic selves such as those represented in *The Bling Ring* explore diverse "choices," they debate them with allies in their "ring," but they *do not* want to "choose between" diverse choices; *they want to have them all.* Each choice, for instance, becoming a luxurious media celebrity like Paris

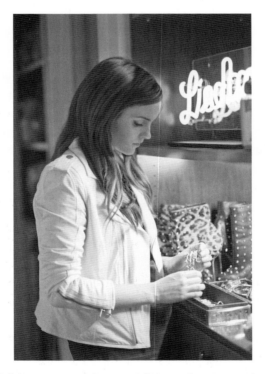

Figure 6.4 "Nicki" (Emma Watson) contemplates stealing Paris Hilton's jewelry in *The Bling Ring*, 2013.

Photo credit: American Zoetrope/Kobal/Shutterstock.

Hilton, might not be feasible to reach, but that does not halt such contemporary luxurious cinematic selves from going after them, including robbing Paris Hilton's wardrobe in her luxurious home. There is a conflict between what contemporary luxurious cinematic selves do and what they would desire to do, a conflict never sensed by so many contemporary luxurious cinematic selves earlier, not least because a sense of *blissful loss* is recurrently the consequence of the search for pleasure.

How do contemporary luxurious cinematic selves such as those in *The Bling Ring* manage this conflict? At the outset, it is essential to recall that, like all luxurious cinematic selves, the contemporary luxurious cinematic selves in *The Bling Ring* belong within crisis-driven structures and that these structures are empowering and disempowering. They are empowering and disempowering for the same contemporary luxurious cinematic self, clearly, but chiefly crisis-driven structures are more empowering for some contemporary luxurious cinematic selves than for others. Contemporary social space is structured in crisis, yet the higher contemporary luxurious cinematic selves are in social space the more power they have over their own luxurious life, the more they are empowered by crisis-driven structures.

Michel de Certeau distinguishes between "strategies" and "tactics": "I call a *strategy* the calculation (or manipulation) of power relationships that becomes possible as soon as a subject with will and power (a business, an army, a city, a scientific institution) can be isolated" (2009: 35–36; original emphasis). By contrast, he defines "a *tactic*" as "a calculated action determined by the absence of a proper locus. . . . The space of a tactic is the space of the other" (2009: 36–37; original emphasis). In our example of *The Bling Ring*, real contemporary luxurious selves with power over their luxurious lives, such as Paris Hilton, use luxury strategies, marketing, and branding (Kapferer and Bastien 2012). They arrange their luxurious lives consistent with these luxury strategies, and they have the power to make their luxury strategies, marketing, and branding succeed most of the time.

Real people and contemporary luxurious cinematic selves with less power over their own lives—such as those in Michael Bay's *Pain & Gain* (2013), the true story of Danny Lugo (Mark Wahlberg, all Ray-Bans and tank tops), manager of the Sun Gym in 1990s' Miami, who, alongside accomplices, kidnapped wealthy businessman Victor Kershaw (Tony Shalhoub) and persuaded him to hand over all his possessions to them—cannot cope with or use luxury strategies as they do not have the power to make the luxury strategies succeed any of the time (Figure 6.5). Alternatively, as contemporary luxurious cinematic selves

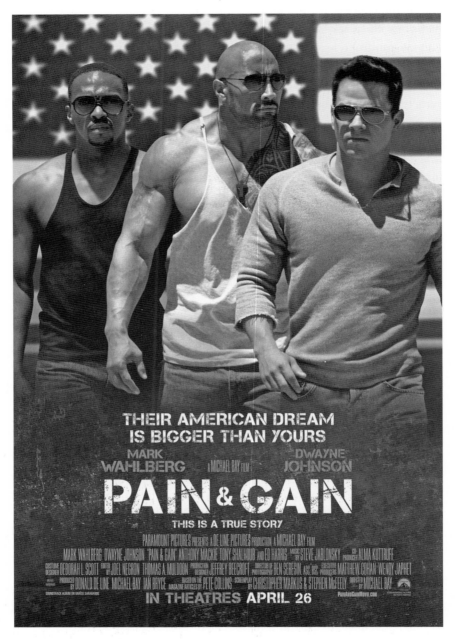

Figure 6.5 "Adrian Doorbal" (Anthony Mackie), "Paul Doyle" (Dwayne Johnson) and "Daniel Lugo" (Mark Wahlberg) pursue their own version of the American dream in *Pain & Gain*, 2013.

Photo credit: Platinum Dunes/Kobal/Shutterstock.

split twice over, doubly perverse, they must depend on sometimes-desperate tactics to relieve their pleasure dysphoria. They live in a sphere not of their own creation, and they are in situations of self-denial, as Lugo is, as a lowly gym instructor to rich clients, for instance, and that they have not selected themselves. Given these truths, they must make the best of such circumstances, even if those situations entail planning and executing the kidnap of the wealthy gym user Victor Kershaw. Danny Lugo and his partners in crime cannot challenge the abstract capitalist "system" inside which they survive in a society or culture-wide antagonistic way, but they can engage in a thoroughgoing war on successful representatives of the capitalist system by taking them hostage and stealing their money. What they can do, and *do* do in *Pain & Gain*, is carry out paramilitary warfare against the rich, and with disastrous consequences, since, at the very moment of a long-awaited perceived pleasure, these contemporary luxurious cinematic selves blissfully dissolve and become lost to themselves and to others through infighting over the rewards of abduction and robbery. This necessitates exploiting the luxury consumer culture, and the merchandise and services of that luxury culture, in the worst possible ways, in ways that were certainly not the intentional ones. In *Pain & Gain* this requires, for example, contemporary luxurious cinematic selves mistreating shopping malls, banks, and other contemporary luxurious cinematic selves' luxury homes, cars, and boats not so much as locations but as an *elsewhere* to waste their days enjoyably and, crucially, for a few hours, days, weeks, perhaps months, without such contemporary luxurious cinematic selves ever experiencing pleasure dysphoria (Figure 6.6). It additionally entails making euphoric "statements" with other contemporary luxurious cinematic selves' luxury consumer merchandise (in *Pain & Gain* demonstrating antagonism literally and emblematically to the capitalist system by driving someone else's luxury sports car or speedboat). Furthermore, it involves obtaining non-luxury dysphoric pleasures out of other contemporary luxurious cinematic selves' money and possessions than those envisioned by their actual owners.

Clearly, given that Danny Lugo and his companions' tactics and paramilitary warfare against the rich end in squabbling among contemporary luxurious cinematic selves located low in social space, it is easy for us as visual consumers to grasp how they understand their everyday lives as initially being fought out against more powerful "enemies" but ultimately being fought out against each other. For most contemporary luxurious cinematic selves, however, such as *Pain & Gain*'s retired "Detective Ed Du Bois, III" (Ed Harris), hot on the trail of Lugo

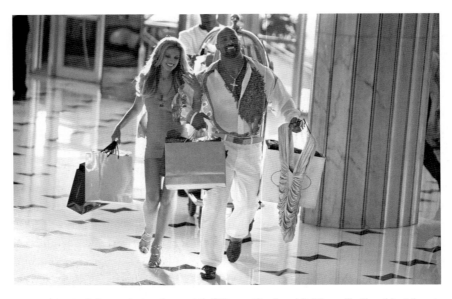

Figure 6.6 Indulging themselves with "Victor Kershaw's" (Tony Shalhoub) riches in Miami, "Paul Doyle" (Dwayne Johnson – The Rock) and "Sorina Luminata" (Bar Paly) squander Kershaw's money on luxury goods at the mall in *Pain & Gain*, 2013.

Photo credit: Paramount Pictures / Collection Christophel / ArenaPAL www.arenapal. com.

and his comrades, everyday life is more ordinary, and it is practiced in a largely non-confrontational if habitually dispirited way.

In summary, contemporary luxurious cinematic selves' options in everyday life change in ways that often seem to them, but are not, accidental, and, as our last example of *Pain & Gain* demonstrated, the reactions contemporary luxurious cinematic selves can make rely on their locations in social space and their ability or not to use the power of strategies or the oft-seeming powerlessness of tactics.

The field of luxury lifestyles in contemporary cinematic cultures: *A Five Star Life*

In the previous section, I defined and used the concept of social space, a concept connected not with Barthes (who always signaled his preference for conceptual questions concerning culture and literature over society and space) but with Bourdieu. Employing Bourdieu's concepts in this setting, in lieu of any offered by Barthes, is uncontentious. Bourdieu's writings on luxury lifestyles, chiefly in

Distinction (1984), are some of the most persuasive on the subject, and I will present them here.

For Bourdieu, social space is founded on capital. The more capital people, or, in our case, contemporary luxurious cinematic selves have, the higher they are in multidimensional social space. Bourdieu differentiates between economic and cultural capital, with the former being predominantly financial, while the latter is principally artistic or intellectual. Most people obtain one of the two valuable kinds of capital.

Bourdieu contends that people near to each other in social space have shared ideas, even if they have never met. Their life experiences, value systems, and, in our context, luxury lifestyles are alike (Bourdieu 1984: 280–93). In other words, people located equally in social space develop comparable tastes. Developing Bourdieu's work, I maintain that it is viable to envisage a "field"—the setting in which contemporary luxurious cinematic selves and their sociocultural positions are located—of luxury lifestyles that tallies with the luxurious sociocultural space represented in contemporary cinematic cultures (see, also, Armitage and Roberts 2016a: 1–21). In my examinations below, unlike those of Bourdieu, I demonstrate that contemporary luxurious real and cinematic selves with high amounts of economic capital and low amounts of cultural capital, such as the real person, Jordan Belfort, represented in Martin Scorsese's *The Wolf of Wall Street* (2013), which portrays Belfort's career as a stockbroker in New York City and how his company, Stratton Oakmont, engaged in uncontrolled corruption and fraud on Wall Street that led to his ruin, have analogous subjective tastes and aversions, and thus related luxury lifestyles. Their luxury lifestyles, increasingly seemingly without anchorage, are dissimilar from those of contemporary luxurious cinematic selves with high amounts of cultural capital and low amounts of economic capital, as in Todd Haynes's *Carol* (2015), which narrates the story of a prohibited affair between an aspiring female photographer (low amounts of economic capital) and an older sophisticated woman (high amounts of cultural capital) going through a divorce, and, likewise, from those of contemporary luxurious cinematic selves with other mixtures of capital.

Bourdieu's experiential studies in *Distinction* are mostly concentrated on France in the 1960s, but, I argue, his thought is pertinent for my investigations of contemporary cinematic cultures. To begin with, Bourdieu brings a much-needed sociocultural interpretation of luxury lifestyles into the spotlight over and above Barthes's theory of semiotics, an interpretation that is just as essential for my own inquiries into contemporary cinematic cultures as for twentieth-century cinematic cultures. Bourdieu's writings are critical of unsophisticated

ideas of increasing everyday life individualized luxurification, and through such writings we can connect contemporary luxurious cinematic selves' luxury lifestyle choices to their locations in social space. Like Bourdieu, I do not refute that luxurious cinematic selves can and do relocate up, down, and sideward in social space. Quite the reverse, contemporary cinematic representations of social space are lively and active with continuous movements for contemporary luxurious cinematic selves and groups of contemporary luxurious cinematic selves. But these movements rely on where contemporary luxurious cinematic selves begin and where they want to get to. It is likely that some contemporary luxurious cinematic selves from a position in social space might enlarge their capital, and move up, but it is unlikely that most contemporary luxurious cinematic selves from that position will do so.

I argue that capital, social space, and the field of luxury lifestyles are applicable concepts for my explorations of luxury lifestyles in contemporary cinematic cultures. Yet, social space and the field of luxury lifestyles in contemporary cinematic cultures, as examined previously, have become more multifaceted as twentieth-century notions of the self are not so much dismantled as reconfigured as something to play with.

In my Bourdieu-inspired conceptualization, social space in twentieth-century cinematic cultures was primarily two-dimensional. It was founded on economic and cultural capital, signified in cinema chiefly by the occupations of luxurious cinematic selves. It might initially be debatable whether economic and cultural capital are the two sorts of capital that best encapsulate the luxurious selves and configuration of social space in contemporary cinematic cultures and if those two sorts are adequate in today's shifting cinematic landscape. What is apparent, though, is that cinematic occupation alone is not a wholly effective signifier of capital. That was, debatably, not the situation in twentieth-century cinematic cultures, and it is not the situation in contemporary cinematic cultures, where customary ideas of the singular luxurious cinematic self are increasingly disturbed.

Occupation can, however, be used as a signifier of capital if we incorporate other important issues, for example, age, gender, class, and education. The likelihood of becoming, for instance, a luxury hotel critic, as in Maria Sole Tognazzi's *A Five Star Life* (2013), wherein single forty-something middle-class "Irene" (Margherita Buy) is forced to reassess the choices she has made in her personal life after her support network crumples, relies on the above specified issues. However, as becomes clear in *A Five Star Life*, that does not signify that their significance can be limited to their bringing about a specific occupation.

It does make a difference whether luxury hotel critics are principally male or female, originate from the working or middle class, or shift *between* the middle class and the elite as Irene does within the luxury hotels she reviews. And with the mounting global transfers of this specific luxury hotel critic between classes and luxury cultures that typify contemporary cinematic cultures, issues—for instance, her ethnicity (Italian) and religion (Catholic)—complicate the configuration of the luxurious social space of the hotel in contemporary cinema even more.

It is also worth noting that globalized luxurious cinematic selves maneuver not only between classes but also within a luxury culture that is shifting beyond contemporary cinematic cultures' ever-increasing reliance on luxury product placement, on embedded luxury marketing where references to specific luxury-branded products are incorporated into a movie, with the express intent to promote such luxury-branded products, and toward a luxury culture that might be called "*mise-en-scène* replacement." The figure of Irene, for example, already complicated by the configuration of the luxurious social spaces of hotels in contemporary cinema is further complicated, not to say compromised, by the fact that *A Five Star Life* was sponsored by the Leading Hotels of the World Group and the *mise-en-scène* of the movie, its design, visual themes, narrative, and cinematography and was produced almost in its entirety in the Group's luxury hotels, including the Fonteverde Tuscan Resort & Spa in Italy, the Palais Namaskar, Marrakech, Morocco, the Hotel Adlon Kempinski, Berlin, Germany, and The PuLi Hotel & Spa, Shanghai, China. Such developments are far beyond mere luxury product placement because it is no longer a matter of simply implanting luxury marketing or of evoking one or two luxury-branded products within the narrative of a movie but, as in the example of *A Five Star Life*, *replacing the whole mise-en-scène* of the movie with luxury hotels and with an explicit aim to publicize such luxury-branded hotels. This is the new luxury culture of *mise-en-scène* replacement.

The field of luxury lifestyles in contemporary cinematic cultures thus comprises more and more diverse luxury lifestyles than twentieth-century cinematic cultures. This is the fragmentation of the meaning of luxury lifestyles examined previously. Luxury lifestyles alter suddenly in contemporary cinematic cultures. Such issues make the field more multifaceted and brimming with shifting references than ever before.

Yet another trait of the field of luxury lifestyles is that in contemporary cinematic cultures, as in *A Five Star Life*, luxury lifestyles become more like each other in diverse countries and more existentially decentered in terms of the fragmentation of their meaning. When Irene's manager asks her to

undertake additional work in increasingly near-identical luxury hotels, for example, she says yes, frankly saying what he is too well-mannered to mention: "I'm your ideal inspector because I have no life." The field of luxury lifestyles in contemporary cinematic cultures will always have a luxurious appearance that is historically significant and culturally specific; two luxury lifestyles—like two luxury hotels—are never quite undistinguishable. Nevertheless, in contemporary cinematic cultures, with more and more luxurious contacts between luxurious cultures, identical luxurious criteria and practices become well-liked and are thus demanded in diverse luxury hotels in various countries. While we watch Irene's inspection procedures, for instance, her voiceover lists the criteria she considers: "Does the hotel use a distinctive scent in the halls and rooms? Was the temperature suitable? Did the steward wish the guest a pleasant stay?" In one scene, Irene even drops a thermometer into a glass of white wine that has just been delivered to her room. "It's two degrees too warm," she complains, instantly recording the transgression on her employer-provided extensive checklist. This last is connected to the problem of globalized luxurious cinematic selves and their existential decentering of the "necessities" of corporate measurement and the incalculable personal comforts of drinking wine in a luxury hotel room. Such luxurious practices as repeatedly crossing the thresholds of luxury hotels in contemporary cinematic cultures stem from the growing demand for, and supply of, luxury vacations and luxurious hotels in everyday life. Nonetheless, it is vital to recall that such luxurious practices nearly always take a culturally identifiable toll on contemporary private lives and their postindustrial occupational configurations, configurations that, as we saw in Chapter 4, might well make a certain kind of Barthesian (1972a; 1985b: 314) "common sense" within the culture of luxury travel, but which often result in, as in *A Five Star Life*, meaningless personal lives and effectively unoccupied home apartments, few family gatherings, part-time lovers, and, ultimately, an unfulfilled and isolated one-star existence.

Voluptuous lifestyles in contemporary cinematic cultures: *Farewell, My Queen* and *Blue Jasmine*

A crucial feature of the field of luxury lifestyles in contemporary cinematic cultures is that it encompasses voluptuous lifestyles relating to the voluptuous photographic self considered in Chapter 5. These voluptuous lifestyles are characteristic of cinematic selves attempting to generate something gratifying and sensuous within their lives. The voluptuous lifestyles are distinguished

by being refined and marked by indulgence in sensual pleasures; previous differences—between, for example, work as pleasure and leisured *jouissance* or bliss, individual sensuousness and shared work as pleasure, and high social space and low social space—are fused.

I mean that cinematic selves seek to become voluptuous through the lavish choice of voluptuous lifestyle, and, in that sense, voluptuous cinematic selves will choose lifestyles that might be voluptuous (and which will then have a mutual influence on a voluptuous cinematic self's already somewhat unstable sense of self).

But, the development of voluptuous lifestyles in contemporary cinematic cultures cannot be comprehended exclusively by examining the association between voluptuous cinematic selves and their voluptuous lifestyles. Only desiring a voluptuous lifestyle is not sufficient to acquire one. The financial circumstances must also be there. And while those circumstances are more extant in contemporary cinematic cultures than in twentieth-century cinematic cultures, they are also more precarious and subject to dispersion at a moment's notice. Specifically, in contemporary cinematic cultures, while the options for gaining refined voluptuous lifestyles are there for voluptuous cinematic selves who want to—and can—profit from them, so are the options for *losing* sophisticated voluptuous lifestyles, since not all voluptuous cinematic selves can either retain their advantages or fend off the moment of dispersion.

As summarized in Chapter 5, voluptuousness is a form of photography that represents voluptuous photographic selves who are insecure in themselves. However, as in Benoît Jacquot's *Farewell, My Queen* (2012), which offers a fictional explanation of the final days of "Queen Marie Antoinette" (Diane Kruger) in power seen through the eyes of "Sidonie Laborde" (Léa Seydoux), a young servant who reads aloud to the queen as the French Revolution breaks out all around them, I do not mean that in a clear-cut psychological or individualistic way regarding French royalty. To keep this insecurity at bay, and, for voluptuousness to continue "making sense," what is demanded is a belonging to a sociocultural setting— such as the palace of Versailles on the eve of the French Revolution in 1789— within which that insecurity, with its rapidly crumpling etiquette, dangerous, and melancholy, "amusements" at the heart of an unfolding revolution, and the interest in voluptuousness, might no longer be fostered, but which can still be insecurely maintained, if only for a short while longer before the deluge dispatches by guillotine the royal cinematic self into oblivion.

Which are those dangerous settings in *Farewell, My Queen*? Contemporary voluptuous cinematic cultures are sign cultures replete with images of power and

wealth, with, as in *Farewell, My Queen*, images of imperial voluminous hair and equally imperious manners and mannerisms (Figure 6.7). They are cultures where voluptuous *jouissance* and the culture industries of French royalty are declining, and it is mostly within these spheres that one discovers voluptuous cinematic selves with voluptuous lifestyles caught in an asocial moment, such as the French Revolution, which will never recur, but which will reverberate forever. It is, for instance, not just Queen Marie Antoinette's luxuriousness that is embattled in *Farewell, My Queen* but the fact that the queen experiences her own body as a kind of *jouissance*, whereupon the queen's body becomes for the revolutionaries a symbolic site of battle against the culture of the voluptuous body. Accused of neglecting French industry while participating in saturnalia, same-sex revelries, and even incest, French royalty, the revolutionaries' argument went, had descended into lust in the bedrooms of Versailles. Such voluptuous cinematic selves are, on the one hand, the essence of selves living voluptuous lifestyles in palace boudoirs under the sometimes-disdainful yet watchful eyes of various ladies-in-waiting, lovers, and courtiers. On the other hand, they are not only living through an asocial moment wherein, as players in this barely continuing and increasingly insecure court intrigue, they are not only becoming ever more confused witnesses to history as the Bastille is seized but also living as the already walking dead of the French Revolution. But, even on the edge of this sociocultural and political abyss, and knowing that the old life will never return, Queen Marie Antoinette persists

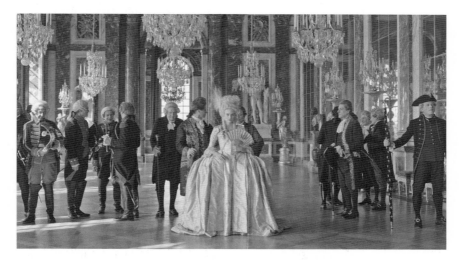

Figure 6.7 "Marie Antoinette" (Diane Kruger) holds court at Versailles in *Farewell, My Queen*, 2012.

Photo credit: Gmt Prods./Kobal/Shutterstock.

in caressing and craving her lovers. Rejecting mere "politics," Versailles's most illustrious inhabitant has therefore no interest in the social space of truth, only in the fantasy space of false mirrors and gilded rooms, sumptuous satin clothes, and the eternal halls of the palace. There, in a daze that still resonates with visitors to Versailles to this day, Queen Marie Antoinette can still see flickering candlelit dinners, hear servant bells tinkling, dispense with constitutional quarrels, and luxuriate in the very real and widespread fantasy that is human beings granting themselves absolution, release, and freedom through voluptuousness.

These voluptuous lifestyles are commonplace among voluptuous cinematic selves belonging to cinematic royalty and to cinematic aristocracy (i.e., groups comprising voluptuous cinematic selves with appointed "positions" as, for example, kings, queens, dauphins, etc.). But they are also increasingly commonplace among voluptuous cinematic selves belonging to the new *petit* bourgeoisie (i.e., groups comprising voluptuous cinematic selves with habitually ambiguous "occupations" in, for instance, "business," perhaps as nothing more than a prominent and fashionable "socialite").

The fact that today's voluptuous cinematic selves and their lifestyles—and, indeed, their voluptuous cinematic groups—are commonplace among the new *petit* bourgeoisie is predictable. Employed within "business" or within its sociocultural networks denotes—positively—tackling issues such as commercial sophistication and elegance, occupational finesse, and corporate and professional delicacies of various sorts every day. And by having access to "business" and by being noticeable in public social and cultural spaces such as photography, cinema, and television, this group also succeeds in turning its own interests in the voluptuous lifestyle into everyone else's interests. The new *petit* bourgeoisie not only admit a taste for voluptuous lifestyles but also disseminate such voluptuous lifestyles as the most preferred ones.

Voluptuous lifestyles are typified by a fusion of former differences that is, for example, at work in Woody Allen's *Blue Jasmine* (2013), which narrates the tale of the formerly wealthy Manhattan middle-aged socialite Jeanette "Jasmine" Francis (Cate Blanchett), who falls on hardship and must move into her working-class sister "Ginger's" (Sally Hawkins) apartment in San Francisco. First, there is a fusion of the former difference between the leisured *jouissance* of Jasmine and the work as pleasure of her money manager husband "Hal Francis" (Alec Baldwin), who is arrested for administering a fake fund with his clients' money. For voluptuous cinematic selves, such as the socialite Jasmine, work is something that other people, namely Hal, must find pleasure in for her to continue living in a luxurious world of classic white Chanel jackets and costume pearls, silk

shirts and scarves, Hermès Birkin bags, Hermès "H" Constance belts, Oscar de la Renta twinsets, and Carolina Herrera gowns. But within Jasmine's voluptuous lifestyle, even other people's work must be more than pleasure. Jasmine's leisured *jouissance* and Hal's work as pleasure are represented as creative and positive elements of their everyday lives. Their work, along with their pleasure, must be financially, spiritually, and culturally satisfying. When Hal purchases Jasmine a luxurious house, the dialogue is as follows:

> Hal: "So what do you think?"
> Jasmine: "I love it! You shouldn't spoil me so."
> Hal: "Well why not? Who else am I going to spoil?"

This means eliminating the difference between the two spheres, wasting their leisure time at the new house with like-minded voluptuous cinematic selves from Hal's pleasurable work together with Hal working happily at home (which is easy to do through the internet and cellphones).

Second, Jasmine and Hal's voluptuous lifestyle aspires to bind together an attention to individual sensuousness with an attention to additional voluptuous cinematic selves and in making ever more sociocultural "contacts": their satisfying life cannot be maintained by abandoning one for the other. It is essential for them to achieve their personal goals—to not discard their individual aspirations—besides working pleasurably with others in diverse, frequently fast-moving settings.

Third, a comparable fusion in *Blue Jasmine* involves the association between high social space and low social space. This fusion of high and low social space can be seen by examining Jasmine's (high social space) luxury-driven horrified reaction to her sister Ginger's (low social space) "necessary lifestyle." When, for instance, "Chili" (Bobby Cannavale), Ginger's boyfriend, asks Jasmine: "Well how long you planning on staying with Ginger?" Jasmine replies: "No one wants to get out of here as fast as I do." High social space voluptuous cinematic selves such as Jasmine reject attitudes from Ginger's low social space and vice versa, as Jasmine's socially downward spiral, where everything is lost, points increasingly to the (con)fusion of the unpalatable "facts" of Ginger's necessary lifestyle and the necessary "fictions" integral to Jasmine's former luxury lifestyle. But the outlook also spreads to voluptuous cinematic selves such as Jasmine experiencing pleasure dysphoria as *loss* rather than consolidation or the reassertion of the self when faced with Ginger's necessary lifestyle. I argue that in contemporary cinematic cultures voluptuous cinematic selves like Jasmine and "necessary" cinematic selves such as Ginger are not so much uninterested in each other's high or low social space as "lost" or suffering from pleasure

dysphoria when experiencing those spaces that are not "theirs." Jasmine, for instance, finally beaten down by the anxiety of a future life to be lived without Stoli martinis with a twist of lemon, by the nightmare of no prospective handsome guys with money, has a nervous breakdown where, far from the smooth talkers like Hal who used to pamper her, she cuts a traumatized figure on the streets of San Francisco and starts mumbling to herself constantly. Indeed, her last, almost senseless, certainly irrational, lines in the movie are delivered by her talking to her dysphoric self on a bench in a public park (Figure 6.8) where, still wearing her classic white Chanel jacket, she continues to evoke the pleasures of high social space to herself, of voluptuousness, and of luxury-branded clothing:

> It's fraught with peril. They gossip, you know, they talk. I saw Danny. Yes, did I tell you? He's getting married. A weekend in Palm Beach means I can wear . . . what could I wear? I can wear the Dior dress I bought in Paris. Yes, my black dress. Well, Hal always used to surprise me with jewelry. Extravagant pieces. I think he used to buy them at auction. It's so obvious what you're doing. You think I don't know. French au pair.

> ["Blue Moon" begins playing]

> This was playing on the Vineyard. Blue Moon. I used to know the words. I knew the words. Now they're all a jumble.

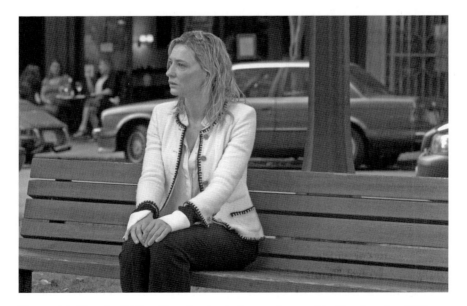

Figure 6.8 "Jasmine" (Cate Blanchett) spirals out of control in *Blue Jasmine*, 2013. Photo credit: Gravier Prods/Perdido Productions/Kobal/Shutterstock.

In contemporary cinematic cultures, voluptuous cinematic selves such as Jasmine do not effortlessly shift between, or unite, high and low social space.

Hence, it is problematic for Jasmine post-Hal's arrest to fuse the difference between Hal's pleasured work and her leisured *jouissance* unless she lands a new rich husband or a new high paying occupation or both that makes such a fusion achievable; it is also hard for Jasmine to shift between high and low social space because she only feels "at home" within high social space. Voluptuous cinematic selves such as Jasmine only make *lavish* choices, choices that make a sort of Barthesian (1972a; 1985b: 314) "common sense" to them in their specific circumstances. The fact that, theoretically, it is conceivable for Jasmine to become involved in "different" (read unacceptable) activities with Ginger, and to build a necessary lifestyle with no high social space and only low social space components, does not mean that she will freely consent to do so. Voluptuous cinematic selves like Jasmine have no intention of abandoning high social space for low social space since, in contemporary cinematic cultures, voluptuous lifestyles are the *only* ones that voluptuous cinematic selves like her wish to be a part of because these environments, with these constituents, appear, as Barthes (1972a: 58) puts it, so "natural."

This denotes that many voluptuous cinematic selves do *not* unite high and low social space or seek admission to both sorts of social space, and this limits the amounts of potential practitioners. High social space in contemporary cinematic cultures is broadly limited to voluptuous cinematic selves with higher quantities of cultural capital, and low social space is usually occupied by cinematic selves with lower quantities of cultural capital (voluptuous cinematic selves with higher quantities of cultural capital have usually exhibited aversion toward low social space).

In contemporary cinematic cultures, as evidenced by *Blue Jasmine*, this has been transformed into a game of love and hate based on *sociocultural* and *spatial separation*. What has occurred is principally that younger less-educated cinematic selves such as Ginger functioning without signs of power or images of wealth have begun to exhibit a taste centered on the hatred of high social space. For these selves and groups of selves, uniting low social space and high social space appears "unnatural"; it is an abnormal experiential pattern. For older age groups, like Jasmine, initially with high quantities of political, economic, and cultural capital, and for younger age groups with the equivalent sort of capital, this is also the situation. Today, political and economic capital, rather than cultural capital, is increasingly connected to high social space. In the increasingly unequal future, a knowledge of low social space might only be required by those who must live in it.

The role of luxury lifestyles in contemporary cinematic cultures: *Madame Bovary*

Since Veblen (2009) and Sombart (1967), the belief has been present in academic circles that having a specific luxury lifestyle denotes exhibiting a belonging to a certain group in culture and of indicating social distances, sometimes confrontationally, from additional groups. Furthermore, this method of indicating social distances, of exhibiting differences between groups of luxurious cinematic selves, might lead not to the maintenance of these differences but to circumstances where a luxurious cinematic self is *called into question*. In this chapter, this argument has been presented through my development of the work of Barthes (1975) and Bourdieu (1984).

What becomes of this vital role of luxury lifestyles in contemporary cinematic cultures? As contended above, the field of luxury lifestyles comprises numerous diverse structured luxury lifestyles, although its fragmentation of meaning occasionally makes the structure less visible even in cinema and leads to my thesis of an increasingly individualized luxurification.

Yet, the fragmentation of meaning within the field has had consequences: with such a fragmentation of meaning, the class structure of the field is increasingly doubted. Consider, for instance, Sophie Barthes's 2014 film *Madame Bovary*, wherein the provincial wife "Emma Bovary" (Mia Wasikowska) wishes to be fused with the metropolitan bliss of luxury, to undergo release from the alarming dysphoria of a singular necessary self that is economically powerless to obtain, yet desirous of, lavish choice, of the "sensual pleasures of luxury," of the "joys of the heart," of "elegance of manner," and of a cultural allegiance with the "delicacy of feeling" of high social space (Flaubert 2003: 98). In other words, even cinematic selves with insignificant quantities of economic capital sometimes select luxury lifestyles or simply moments of bliss, sometimes those of luxurious cinematic selves with higher levels of economic capital than they themselves have access to in a bid to undo the vexed question of their actual culturally dysphoric identity. However, if in twentieth-century cinematic cultures almost all luxurious cinematic selves within the field admitted that some luxury lifestyles were better than others, in contemporary cinematic cultures that is not always the case. Luxurious cinematic selves with diverse quantities of capital have diverse lifestyles and thus diverse means of "escape" into luxury. With increasing information, chiefly through cinematic representations of the mass media *within* cinema, of what other luxurious cinematic selves are doing,

the glow encircling the identity of other real people's and luxurious cinematic selves' luxury lifestyles—one thinks of Paris Hilton and *The Bling Ring*—has become ever more disturbed, immoral, and fragmented. The symbolic value of possessing a luxury lifestyle sooner has become *radicalized* as the search for the new, for the fresh, even to the point of mimicking clichéd media celebrities or repeatedly robbing them.

This indicates that the role of luxury lifestyles has become ever more significant in contemporary cinematic cultures because it has in some strange way not yet been fully acculturated. I claim that the comparative value of possessing various luxury lifestyles instead of one has increased in significance and is now nothing short of a *cultural demand*. And an adverse thing that is too because the field remains structured. Certain groups of luxurious cinematic selves have more control, ability, strength, and wealth in social space than do other groups of luxurious cinematic selves, and the lavish choice of luxury lifestyle might increase *and* decrease a luxurious cinematic self's power and wealth for a time, as we saw with kidnapper Daniel Lugo in *Pain & Gain*. Luxurious cinematic selves located high in social space, such as *Pain & Gain*'s kidnap victim Victor Kershaw, who openly declares he is a "self-made man" who has "made a lot of money," have the option of choosing ever new luxury lifestyles that give them connections, moment by moment, with additional luxurious cinematic selves situated likewise in social space. They obtain direct valuable knowledge in all sorts of subjects. They can (disastrously in the case of Victor Kershaw) choose to let their loud voices be heard in discussions in the Sun Gym in Miami. Luxurious cinematic selves located lower down in social space, such as *Pain & Gain*'s Daniel Lugo, must depend on sometimes-desperate tactics of luxurification rather than the luxurification strategies of the influential and the wealthy. Lugo, for example, continually talks of "winging it," of being willing to "do the work," of "chowing down" on the "shitty shame sandwich," of "watching a lot of movies" to figure out what to do, or of simply "putting up with stuff." This requires Lugo to make the best of his rotten situation, and tactics of luxurification like his that appear correct and essential at specific times might even be ultimately fatal (the real Daniel Lugo was sentenced to death and executed on August 31, 1998). I will turn in the next chapter to the question of how luxurious televisual selves located otherwise in social space to diverse degrees, and in diverse habits, methods, conditions, and respects make luxury parts of their everyday lives.

7

Luxury and television

Having expounded the new luxurious photographic self and the new (ir)rationality of luxury and lifestyle cinema and culture, we can now advance to critically investigate the consequences of this for luxurious televisual values. My argument is for a link between television and new cultural forms of luxury that I will theorize in this chapter. I argue that those luxurious selves most adjusted to contemporary televisual culture are those who are portrayed in new luxurious activities, such as those depicted in *Versailles*, which is set during the construction of the palace of Versailles during the reign of Louis XIV, and represented in *Harlots*, which focuses on "Margaret Wells" (Samantha Morton), who runs a brothel in eighteenth-century England, and not those shown in traditional luxurious activities, such as those pictured in *The Crown*, a biographical story about the reign of Queen Elizabeth II of the United Kingdom. In this chapter, I elaborate this argument by examining the formation and revelation of new luxurious televisual selves and, like Barthes (1977a), emphasize the bourgeois and other inflections that configure cultural forms of value, including influences of televisual consumerism and new voluptuous behaviors, and I offer some televisual evidence in confirmation. Here I want to consider this last argument to examine, exemplify, and probe its consequences.

Luxurious televisual values: *Stoney Burke* and *Dallas*, *Miami Vice*, and *The X-Files*

Luxurious televisual values, I suggest, are the beliefs that, for example, "Stoney Burke" (Jack Lord), a rodeo rider who was competing for the Golden Buckle, the award given to the world champion saddle bronc rider, in the American western television series *Stoney Burke* broadcast on ABC from 1962 until 1963, have concerning what is good and bad. Good and bad, and related moral binary

terms in Stoney's language, for example, right and wrong, establish the chart for Stoney's quest and moral behavior at the personal and the group level as he becomes entangled in the lives of numerous people. In episode 3, "Child of Luxury," they also establish the chart for, and provide direction to, "Sutton Meade's" (Ina Balin) furious behavior when Stoney scorns her affections offered in the manner of a spoiled rich girl whose father is the town's power broker. This is true of Sutton's moral terms involving the rightness and wrongness of Stoney putting off an heiress's sexual advances in a manner that is not true of her non-moral terms. The rationale for this is in Sutton's use of specific terms, for instance, "love," "hate," and "revenge." The moral terms of this overindulged rich girl are predominantly inflexible—she *must* have revenge upon Stoney because he spurned her proposals—whereas her non-moral terms, like ours, are predominantly evocative or explanatory. When Sutton uses the terms "good" or "right," she signifies her endorsement and her endorsement that this act (getting what she wants) or group of acts (such as Stoney turning down her approaches and her invitation to a dance) must be done or opposed. When she uses an evocative term, for example, "dance," she does not suggest that the act or group of acts is something she holds with and recommends. In summary, the important feature of luxurious televisual values is that they signify or recommend what luxurious televisual selves such as Sutton Meade should or should not to do as a beautiful but selfish heiress contrasted with what is or is not the situation.

Likewise, in American prime time soap operas such as *Dallas*, which aired on CBS from 1978 to 1991, the luxurious moral terms of the central wealthy and feuding Texas family, the Ewings, who own the independent oil company Ewing Oil and the cattle-ranching land of Southfork, vary from others in vital ways (Ang 1985). Whereas the Ewings might give us instances of the appropriate use of a luxurious moral term, such as "greed," it is difficult beyond the landscape of television to indicate an experiential thing, visible article, or behavior. Yet, *within* the landscape of television, luxurious moral terms and their implications *can*, in fact, be observed, as in the marriage of "Bobby Ewing" (Patrick Duffy) and "Pamela Barnes" (Victoria Principal), whose families were sworn enemies with each other. In brief, the luxurious televisual moral values of oil tycoons, such as *Dallas*'s "J.R. Ewing" (Larry Hagman), are visible to visual consumers on television as dirty business schemes and shootings, dreams, sex, intrigue, and power struggles. Like many other television programs, *Dallas* made numerous attempts to discuss, if not to legitimate, luxurious moral assertions or demands by allusion to visible events, as when the longtime rivalry between the Ewings and the Barnses came to a head when the Barnses's daughter, Pamela, eloped with an Ewing son, Bobby, in the first

episode. Consequently, luxurious moral terms in *Dallas* do assert some abstract complexity and ontological superiority. J.R., the eldest Ewing son, for instance, is luxuriously and morally unscrupulous as well as unhappily married to a former Miss Texas, "Sue Ellen Shepard" (Linda Gray), and is frequently at metaphysical odds with his youngest brother Bobby, who has the complex morals and ontological integrity that J.R. lacks, whether he can verify such superiority or not. Luxurious moral terms in *Dallas* are, therefore, used in often conflicted conversations rather as a five-card hand is used in Texas hold 'em poker; they are held to subdue or have some singular and superior position over other kinds of assertions, as, for example, those concerning the immorality of one Ewing teenage girl sleeping with the ranch foreman. Owing to this feature, and its ability to overwhelm useful or instrumental concerns, we might explain the luxurious televisual moral values of *Dallas* as true without allusion to the experience of adolescent girls adoring ranch foremen as against relying for their efficiency on that experience. Whether this belief concerning teen girls idolizing ranch foremen can be supported is less significant than that it is believed by other luxurious televisual selves to be the situation. Luxurious televisual values in TV series such as *Dallas* consequently have a superior position as action-ordering values, codes, and rules in luxurious and other lifestyles and are thus important as an object for our investigations.

Similarly, in *Miami Vice*, the American television crime drama series created and produced for NBC from 1984 to 1989 starring Don Johnson as "James 'Sonny' Crockett" and Philip Michael Thomas as "Ricardo 'Rico' Tubbs," luxurious televisual values do not endure separately from other kinds of "inclinations," such as becoming detectives working undercover in Miami, which might themselves affect their activities ranging from law enforcement to concealing their true identities from drug dealers (Sanders 2010).

The important concept of inclinations I take from the German philosopher Immanuel Kant's (1724–1804) critical moral philosophy, where it forms the complement to the idea of duty. Inclinations are based in the realm of the senses and subjectivities, perhaps as a police officer like Crockett operating covertly in Miami, under plural influences, performing partial actions, or as the dark side of the overtly impartial, comprehensible, integrated, and all-embracing categories of the duties of the police. Inclinations communicate the reliance of the human faculty of desire on sensations, perhaps the sensation of hiding one's real identity from drug pushers and born of the need to hide one's real identity from drug pushers and react to that need. Inclinations are ascribed by Kant (2002, 2015) to the "animal" within humanity because they react to dissimilar, partial incentives from the environment, and not to duty or to cohesive and

universal moral laws. Hence, inclinations communicate the will to action as determined by objects and subjects rather than by any law. Because of their partiality, inclinations cannot operate as rules for moral judgment. In fact, they are frequently considered adverse to morality. In my explanation of twentieth-century and contemporary luxurious televisual value inclinations below, I highlight how they are continuously in the shadow of some other responsibility that is being neglected or subjected to critique by the sometimes-suspect moral philosophy of luxurious televisual selves and "re-assessed" as a self-given "right" that questions inclinations as the opposite of duty.

Thus, an inclination for vice over traffic does affect luxurious televisual behavior along with luxurious televisual selves such as Crockett and Tubbs's choice of urban activities. However, we must be careful to disentangle luxurious televisual duties and inclinations. A luxurious televisual duty is one that makes an action, such as *Miami Vice*'s law enforcement agencies confiscating the property of convicted drug dealers for official use based on asset forfeiture statutes, categorical, imperative, or compulsory. On the other hand, an everyday, if now famous, luxurious televisual fashion inclination toward wearing a T-shirt under an Armani jacket worn with white linen pants, slip-on sockless loafers, and tortoiseshell Ray-Ban Wayfarer sunglasses, only makes them stylistically desirable for visual consumers in the 1980s. Yet, as are well-known, such luxurious televisual fashion inclinations as Tubbs's east coast gangster double-breasted couture, Crockett's white and pastel-toned linen suits from Hugo Boss, Nino Cerruti, and Gianni Versace, worn with jacket sleeves pushed up to display his Rolex watch, urged innumerable style conscious visual consumers to buy countless Armani jackets if not a Ferrari Daytona identical to the one Crockett drives (Sanders 2010). Accordingly, the perceived luxurious televisual moral value duty of criminalizing drug trafficking and prostitution makes the practices offensive and impermissible by law, whereas the non-moral inclination for trafficking in drugs rather than prostitution does not have the result of making trafficking in drugs imperative nor prostitution impermissible for dealers and pimps. Luxurious televisual inclinations in *Miami Vice* exhibit a gradation only on a gradation of desire, perhaps the desire to apprehend criminals, and not on the gradation of the desirable, comprehended as something like *Miami Vice*'s drug interdiction that is considered worthy of being desired, especially if the drug cartels are destroyed. Luxurious televisual values in *Miami Vice*, conversely, are ideas of the desirable described in this manner. Luxurious televisual values are, though, frequently mingled with luxurious televisual inclinations, and this makes examinations of luxury and television somewhat problematic because, occasionally, values and inclinations are difficult to disentangle.

Numerous investigations of television around luxury might be made about inclinations which would be enlightening in terms of a shift to contemporary televisual culture, but those are not the focus of this chapter, which focuses instead upon luxurious televisual value inclinations. Relatedly, consider the luxurious televisual "attitude" of *The X-Files*, which is not only a famous American science fiction horror drama television series which aired from 1993 to 2016 on Fox but also a repository for an entire collection of paranormal longings, alien terrors, and medical and scientific inclinations (Knowles and Hurwitz 2016) (Figure 7.1). Among or in FBI special agents "Fox Mulder" (David Duchovny) and "Dana Scully's" (Gillian Anderson) attitudes are numerous non-moral and non-value inclinations. For instance, in "Triangle," the third episode of the sixth season of *The X-Files*, in which Mulder races to a luxury liner, the *Queen Anne*, which has mysteriously appeared on the edge of the Bermuda Triangle, he exhibits an inclination to favor the present to a vulnerable historical situation since, once on the ship, Mulder realizes with horror that he has traveled back in time to September 3, 1939—the outbreak of World War II. Luxurious televisual moral attitudes, such as those of Mulder when confronted by German soldiers, who have boarded the ship in search of "Thor's Hammer" (a scientist capable of building advanced

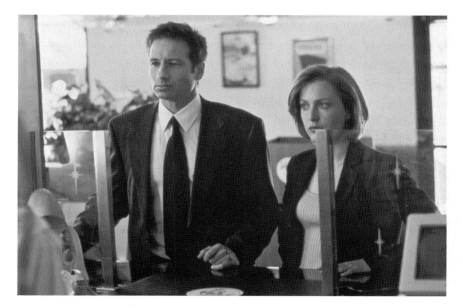

Figure 7.1 "Fox Mulder" (David Duchovny) and "Dana Scully" (Gillian Anderson) on the case in "Triangle," *The X-Files*, 1996.

Photo credit: Moviestore Collection/Shutterstock.

weaponry), vary in being those that have imperative, categorical, and inflexible components, such as the securing of Thor's Hammer, who can categorically ensure military victory for one side or the other in the coming conflict. Typically, however, luxurious televisual attitude systems, such as Scully's after being informed of Mulder's disappearance, are propelled by value inclinations centered on human concern, assistance, and the restoration of the status quo.

The luxurious televisual values at work in *The X-Files*'s "Triangle" are of interest because, unusually, initially at least, they are held in isolation by Mulder, who is the only person who believes that the *Queen Anne* vanished in the Bermuda Triangle in 1939 and reappeared in 1998. Hence, Mulder is unusual because he is frequently the only person with merely one or a seemingly implausible collection of luxurious televisual values, which is also why the *Queen Anne*'s crew dismiss his story and suspect that he is a Nazi spy. However, Mulder's (and Scully's) luxurious televisual values are regularly combined in what we might call luxurious televisual value inclinations concerning scientific discovery and debunking, or, what, more philosophically, we might name luxurious televisual value or luxurious televisual ethical systems entailing constant conflict and distrust, configurations of selective cultural belief, or moral philosophies of friendship and practices and forms of romance. I am less involved with these methodically connected philosophies of suspense or second-order considerations of them, specifically ethical systems concerning speculative fiction or moral philosophies of the night and its darker sides. Rather, I am involved with first-order luxurious televisual value inclinations; the last being delineated as ordered configurations of luxurious televisual value inclinations since 2000. For when a group of television programs is combined and arranged it has more influence and force than when individual programs are contemplated alone or in total. Consequently, I consider contemporary luxurious televisual value inclinations to have more possibility for understanding the influence of luxury than any one luxurious televisual value or combination of these values.

Contemporary luxurious televisual value inclinations: *The Sopranos, Suits,* and *Billions*

Contemporary luxurious televisual value inclinations are distinct from all other value inclinations we have studied concerning luxury and its theorization. They vary in levels of generalization and specificity, in ordering principle and in constancy, over time and space. *The X-Files*'s twentieth-century luxurious

televisual value inclinations can be compared with the contemporary luxurious televisual value inclinations of *The Sopranos*, the American crime television series, which revolves around New Jersey-based Italian American mobster "Tony Soprano" (James Gandolfini), and which aired on HBO between 1999 and 2007, on these criteria (Chase 2001). Firstly, *The X-Files* tends to refer to specific luxurious televisual value configurations and cultural forms; therefore, Scully's values incorporate a predilection that she ought not be a believer like Mulder, regarded as distrusting of governments and large institutions and that she ought to be regarded as skeptical of conspiracy theories and be encouraged to participate in her and Mulder's cases with a sort of luxurious detachment. In contrast, contemporary luxurious televisual value inclinations have no specific value inclinations bar at the most general level, for example, "Christopher Moltisanti's" (Michael Imperioli) general conviction, as Tony's protégé and member of the Dimeo crime family, that, as associate and eventual underboss, he ought to be able to be what he wants to be: a boss in the crime business (Figure 7.2). In this sense, Christopher's contemporary luxurious televisual value inclinations are less inclinations and more of a flowing volatile ordering or narcissistic modeling system whose only cultural rules are that he should form and order his impulsive luxurious televisual values, frustrated value inclinations, and attitudes toward his perceived lack of progress for himself. Whereas *The X-Files*'s Scully requires subscription to an essential collection of medical values arranged around some "objective" standards such as "I ought to supply scientific explanations," contemporary luxurious televisual values, as manifested by Christopher's disdain for authority, denote no essential values—no standards— and set *his* independence or self-invention as its *only* rule, inclusive of hijacking trucks and shooting a baker's clerk in the foot for ignoring him.

Scully is required to possess essential values and not simply let core explanatory principles such as offering scientific alternatives to Mulder's deductions slip. Contemporary luxurious televisual selves like Christopher, on the other hand, are eager that violent individuals like him and groups like crime families will continue to explore murder and rearrange their fractious luxurious televisual value configurations, permitting a larger diversity of aggressive incidents, assorted clashes, and individual modeling based on the cultural desire for promotion with little fear of deserting twentieth-century luxurious televisual principles and forms (Tony tells Christopher that he will lead the Soprano family into the twenty-first century.) The same is true for luxurious televisual value configurations and cultural forms over time. While Scully requires that she keeps her scientific values for life, be it scientific knowledge, faith in

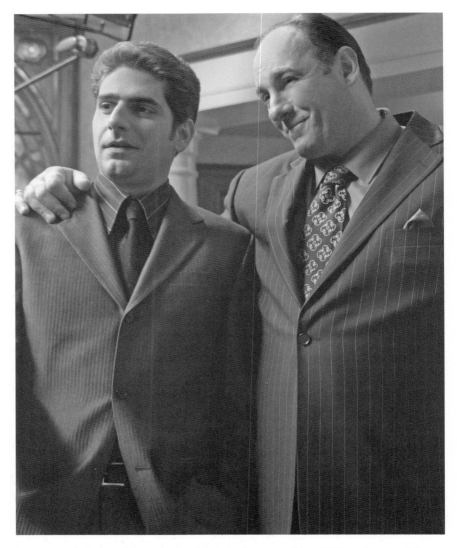

Figure 7.2 "Christopher Moltisanti" (Michael Imperioli) and "Tony Soprano" (James Gandolfini) in *The Sopranos*, 2005.

Photo credit: HBO/Kobal/Shutterstock.

technology, or the human species, contemporary luxurious televisual selves like Christopher instead imagine that loyalty to the "family," marriage, and making films (he tries to become a Hollywood screenwriter) are incessant processes, and he frequently reorganizes his values. Lastly, other value dimensions can be of universalistic application to other elements of the world of luxury and television. Contemporary luxurious televisual values such as those of Christopher I consider to be of universal application as visual representations, but I also consider that de facto every luxurious televisual culture, luxurious televisual group, and luxurious televisual individual will build their own and ever-shifting luxurious televisual value inclination.

My theory of contemporary luxurious televisual value change, therefore, is distinctive in content and cultural form. I not only create a new luxurious televisual value dimension, conjecturing a shift from twentieth-century to contemporary luxurious televisual value inclinations, but also consider this to mean a movement from luxurious televisual value inclinations that are specific, united, and unchanging in order over time and space (e.g., *The X-Files'* Scully), to a new luxurious televisual value inclination where none of these apply (e.g., *The Sopranos's* Christopher). By a contemporary luxurious televisual value inclination, I mean an inclination that, like Christopher's, struggles with drug and alcohol addictions, and is only barely modeled culturally by formal regular attendance anywhere. It is an unspecific ordering principle that permits someone like Christopher any amount of specific values (loyalty, success, etc.), in any drug-fueled variety or violent arrangement, for a diversity of groups, such as the Soprano crime family, to order and disorder, keep or change, extend to New York City or keep in New Jersey as they wish. By using the example of "Luxury Lounge" (2006), the seventh episode of *The Sopranos's* sixth season, in which Christopher flies to Los Angeles on a casting trip to enlist actor Ben Kingsley (playing himself) for Christopher's movie project "*Cleaver*," we might say that contemporary luxurious televisual values demand only that luxurious televisual selves correspond to a minimal set of urban procedures (flying to Los Angeles, checking in to a hotel) and that what they do with their ability to "lounge"— how it is used to schedule meetings with Kingsley, urbanized, and expanded to the world of casting agents—is an issue for the luxurious televisual selves and not the suppliers of the "luxury lounge" (a room set up with free luxury-branded gifts handed out to celebrities). Christopher's contemporary luxurious televisual value inclinations are held together with an ordering system more like an aptitude for lying around than an aptitude for liveliness.

Contemporary luxurious televisual selves such as Christopher combine their drinking and drugs values as they combine everything else in their lives on the working principle of a voluptuous cultural imagery that is nothing like the picturesque "Italianicity" Barthes (1977a: 48) discusses concerning an advertisement that portrays a mesh shopping bag containing a packet of pasta and fresh vegetables. For Christopher not only accepts, combines, and applies the values of sex as a mere service industry that best expresses what he apparently feels best suits his comprehension of himself and his female escort in "Luxury Lounge" but also connotes a televisual image of out-of-control Italianicity by relaying familiar and, by now, "consensual" (if not to many Italian Americans) messages of what being an "Italian" mobster means. Christopher's contemporary luxurious televisual value inclination, then, is, as we saw in Chapter 6, rather like a contemporary luxurious televisual pleasure dysphoria (the meeting with Kingsley does not go well), prudently and decisively shaped to reflect the luxurious idea of self Christopher invokes, but one that remains unimpressive and uninteresting to film stars like Kingsley. Christopher's luxurious televisual values cannot, therefore, be mixed together with Kingsley's or Lauren Bacall's inclinations (playing herself, she is in town to be a presenter at a film awards show), because Christopher's, Kingsley's, and Bacall's attitudes, especially toward the gifts associated with presenting, are concerned with the construction of two very different luxury lifestyles.

What characteristics do Christopher's contemporary luxurious televisual value inclinations display in "Luxury Lounge"? They are a kind of self-fashioned dysphoric fascination with the great quantity of free expensive luxury items offered to a casual-acting Kingsley, combined from Kingsley turning down the role in "*Cleaver*," Christopher's alcoholism, and his awe at Kingsley having access to the luxury lounge. They are dreams of lavishness, mingling old celebrity and new obscenity in luxuriously patterned cultural configurations, and they are individualized (Kingsley says he gives almost all his presents away to charity) and personalized since each award presenter receives free luxury goods worth around $30,000, values and inclinations that are shared by a celebrity group that does not include Christopher.

Combining means Christopher choosing his own form of lavishness from obtainable celebrity resources, as when, before leaving Los Angeles, outside the awards show, a masked Christopher mugs Bacall, punching her and stealing her luxury gift bag. A contemporary luxurious televisual self, Christopher chooses a compendium of values that would be thought aberrant or wicked by twentieth-century luxurious televisual selves such as *Stoney Burke*'s Sutton Meade. Thus,

Christopher combines his value of male self-determination with an urban cosmopolitan value to increasingly have dealings with celebrities like Kingsley, with a value that his stolen luxury goods are the epitome of desired liberty and that he can offer Tony some of them. No twentieth-century luxurious televisual self moral belief system could begin to comprehend, let alone know how to assess, Christopher's inclination.

Dreams of lavishness mean that Christopher's luxurious televisual self and the rest of his "crew" aspire to set their often-feuding values in the dream world of those others such as Kingsley and Bacall who live beyond the ailing "family." Whereas in twentieth-century luxurious televisual belief systems identity was shaped by membership of large collectivities, such as *Dallas*'s Ewing family that dreamed of distancing themselves from other large collectivities, such as *Dallas*'s Barnes family, the increasingly violent rationality of Christopher's contemporary luxurious televisual affiliation is the shaping of his own hostile identity as a reaction to other brutal individuals such as Tony and crews to which he has luxurious immediacy. Christopher's identity, then, such as his aggressive reasoning, is an amalgam of a multifaceted system of different Italian American mobster sign systems (e.g., fashionable suits, antagonism to "outsiders," ruthless egoism, the lingua franca of the crew. Christopher: "Louis Brazi sleeps with the fishes") that anchor and communicate a series of luxurious messages and meanings from which we, as visual consumers, extract the fundamental "meaning" of being near Christopher (Lavery 2006). Yet, in the era of the contemporary luxurious televisual self, selves such as Christopher are more liable to experience a permanent feeling of unease and dissatisfaction through pleasure dysphoria, of not being in the same kind of body as a celebrity such as Kingsley, rather than the absolute or general dysphoria of not being in the same kind of body as Tony, the head of a "family" hierarchy that has descended into a leaderless crew.

Individualizing or personalizing denotes the visual representations wherein contemporary luxurious selves accept and change values to match their subjective needs. A good illustration is the case of "Harvey Specter" (Gabriel Macht) in *Suits*, the American legal drama television series which premiered in 2011 on USA Network, the American pay television channel (Figure 7.3). For Harvey, a newly promoted senior partner at the prestigious New York law firm Pearson Hardman, while still supporting the official values of the law and the values pronounced by the other senior partners, feels able to shorten, adapt, and alter these to allow for such illegal decisions as hiring an associate attorney, "Mike Ross" (Patrick J. Adams), a talented college dropout who has never attended

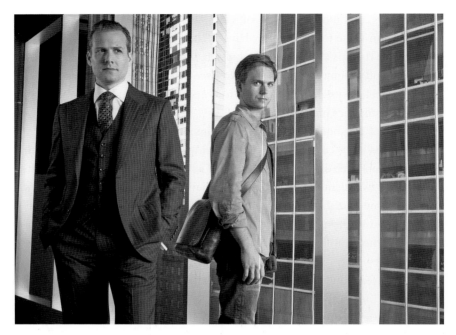

Figure 7.3 "Harvey Specter" (Gabriel Macht) and "Mike Ross" (Patrick J. Adams) at the New York law firm "Pearson Hardman" in *Suits*, 2011.
Photo credit: Frank Ockenfels/Dutch Oven/Kobal/Shutterstock.

law school, and such quasi-legal decisions as conspiring with Mike to pretend that he is, in fact, a Harvard Law School graduate. Harvey's personalizing in this popular show is evident not only in his choice of Tom Ford and Canali, Brioni, and Hugo Boss suits, accessorized with cuff links, an immaculate Windsor tie knot, and cutaway shirt collars, but also in his choice of luxury car, which is in-show product placement by Lexus, whose own brand awareness has been boosted by 22 percent by Harvey in *Suits* (Baysinger 2015: 1). Harvey's personal choice of a Lexus is, then, a visual and cultural phenomenon wherein this luxurious televisual self changes a mass-produced luxury car into something identifiable as his own. Consequently, a luxury car such as Harvey's Lexus can adjust the content of the program to communicate Harvey's character, and the value system of the program's fans who are asked by Lexus to submit their own photos on Facebook and Instagram using the hashtag #SuitsInspiration. The personalized value system of *Suits* fans, therefore, is one in which their versions of a television program is adapted by a value inclination for photos of luxury cars on public social media platforms rather than private individual television viewing.

Yet one of the dissimilarities between the contemporary luxurious televisual selves in *Suits* and other value inclinations is their individuality. Of course, most value systems are individual in part since they do not require full devotion to all group values by all its members all the time. But Harvey's devotion to a contemporary luxurious televisual value inclination means that he mingles his constant requests for promotion to junior partner and matches that value with an endless set of desires to win his cases at all costs. Not only this, but he mingles unorthodox methods, including coercive persuasion, and matches that with old-style bluffing, and the calling in of favors, and new individualized values, as when he ignores his bosses' instructions, openly challenges their decisions, and does as he wants. Not only are Harvey's risky methods and values mingled with the placing of his own interests above those of his colleagues, but his luxurious televisual inclination envelops his job performance and the high value he places on his reputation.

Harvey's risk-taking, selfish, and status-seeking characteristics would be thought flaws by twentieth-century luxurious televisual selves and their value inclinations. This is because such characteristics are calculated to disregard the interests of Harvey's work colleagues while fostering his own highly individualized luxurious inclinations within Pearson Hardman concerning his present occupational performativity and future standing. Harvey's alternative is to perceive his very characteristics of emotional detachment, high octane performativity, and cold professionalism as strengths which allow for his extensive and profound feelings of loyalty for those who have been loyal to him. Contemporary luxurious televisual selves such as Harvey want to feel at home with emotional distance and comfortable with their "uncaring" values (caring makes Harvey appear "weak") and luxury lifestyle. Indeed, what Harvey wants is a mixture of unfeeling self and trampled other, subjective invulnerability and objective luxury car, the noble morality of the sports enthusiast and the freedom to purchase an expensive collection of signed basketballs for his office that, he thinks, while sipping his luxury-branded Macallan single malt Scotch, is in fact achievable not only in the movies like *Top Gun* (1986), the American romantic military action drama film directed by Tony Scott, that he constantly quotes, but also in his own future as absolute top dog.

At the heart of Harvey's approach to his own luxurious televisual self, therefore, is the idea that the meaning of the other, such as Mike Ross, is produced through a seemingly subjective system of signs (the other is evoked in the language of Harvey's phrases such as "I don't pave the way for people . . . people pave the way for me," in objectified images, and in sounds which are far

removed from that of the purr of a luxury car) that are "noble" yet always flexible and "moral" yet culturally specific to Pearson Hardman. Harvey's process of signification, of his composing of his "message" to Ross and to others through amalgamations of sports signifiers, also entails the manufacture of a message of "freedom" with at least two levels of meaning: the denotated, obvious, or intended meaning of luxurious objects and the contextual meaning of signed basketballs that are socioculturally inflected for the benefit of anybody who enters Harvey's well-appointed office and connoted or culturally implanted within the domain of luxury branding (Barthes 1983). Harvey's goal, then, is to create a sort of discursive norm about himself (and *only* about himself) necessitating luxury cars and sports, or a self-defined and self-generated one-man "consensus" about what the experience of "freedom" is for him and why it matters to have costly items, and this forms the touchstone by which Harvey's luxurious world gauges conformity to the "right" signs (not basketballs but *signed* basketballs) and divergence from the actual sport of basketball. Harvey's office thus offers us a comprehensive instance of a signifying system as a luxury-branded system, which, for Harvey, through Macallan single malt Scotch and continuous quotation from *Top Gun*, constructs a systematic and complex realm of American idealistic meaning, action, and drama that curiously defines his future as lying in the past (twenty-five-year-old Scotch, the thirty-plus-year-old *Top Gun*), fashionable power dressing, explicit dress codes (Tom Ford suits), and a barely legal language (Harvey: "A good lawyer knows the law. A great lawyer knows the judge").

Within luxurious televisual value inclinations are numerous constituents, incorporating first-order values, or direct imperatives such as sociocultural moral rules like the law; some luxurious televisual value inclinations, like the general value that luxurious televisual selves, such as "Charles 'Chuck' Rhoades Jr." (Paul Giamatti) in *Billions*, the American television drama series that premiered on Showtime in 2016, ought to encourage prosecution of financial crimes; and some second-order rules and principles. The second-order luxurious televisual values in *Billions* denote the contextual systematizing principle that directs first-order rules and inclinations, such as the principles of crusading federal prosecutors like Chuck and, as US Attorney for the Southern District of New York, the freedom to pursue legal battles. Chuck's contemporary luxurious televisual value inclination varies from twentieth-century luxurious televisual value inclinations by the increasing *imbalance* and association between these constituents and those of rogue hedge fund managers, such as "Bobby 'Axe' Axelrod" (Damien Lewis) of Axe Capital. Contemporary luxurious televisual selves such as Bobby have few

first-order categorical imperatives or rules, so enlarging the sphere for freedom to use insider trading or additional "values" like bribery and the "rights" and capacity for the illegal growth of his firm's enormous wealth. Bobby limits even value inclinations concerning his charitable acts of generosity to a minimum for the same reasons, while acceding that some of these will be essential if his illegal actions are to appear to have a moral normative structure. This increasing imbalance brings about Bobby's real and possible further instability regarding his contemporary luxurious televisual value inclination, as if, given that he is under constant investigation by Chuck, he has a hedge fund manager's "code" systematized on information about illegal insider trading rather than information upon rules of legal "outsider" trading. Bobby's signifying hedge fund manager's code, consequently, is his personal set of culturally *unrecognized* rules that guide how other business organizations may be "read" by this career criminal. In fact, Bobby's code determines not only the legal and illegal data from which important insider trading deals can be "selected" without any acknowledgment of the law of the land but also the way "selected" legitimate trading deals can be meaningfully conjoined with illegitimate ones (see, for example, Barthes 1977a: 32–51). Bobby acknowledges the demand then for some contemporary luxurious televisual values (to keep public favor with him), to have some but only a few rudimentary second-order value principles, such as friendship and cooperation, or the principles of a contemporary luxurious televisual self founded on "fixes" and framing others, wrongdoing, and, above all, investment in oneself and the things that such investment can buy, such as Bobby's luxurious oceanfront house and his yacht named "*The Good Life*."

Clearly, Christopher Moltisanti, Harvey Specter, and Bobby Axelrod, among many other contemporary selves in US television, share certain luxurious televisual value inclinations. My theoretical research corroborates my premise that we can observe a noteworthy and rising proportion of contemporary luxurious televisual selves with these inclinations. While obvious in US television, the development is also marked in European television, particularly France and the United Kingdom. Contemporary representations of seventeenth-century kings (e.g., *Versailles*) and twentieth-century-into-twenty-first-cent ury queens (e.g., *The Crown*) are, I argue below, the most obviously luxurious televisual selves, with the amount increasing the further contemporary luxurious televisual selves ascend to a throne. Access to privileged circumstances correlates with contemporary luxurious televisual selves, it being marked among those selves who have access to riches. Yet, those such as the poor brothel keeper

(e.g., *Harlots*), who, crucially, have an entrée to the rich, are also inclined toward contemporary luxurious televisual selfhood.

Overall, I propose that contemporary luxurious value inclinations are on the increase on US and European television. And, I argue, such inclinations are contingent on structural influences. For contemporary luxurious televisual value inclinations are most widespread in the most luxurious televisual landscapes, and within each televisual landscape, the value inclinations are most widespread among contemporary luxurious televisual selves either *with* high quantities of cultural and economic capital or with *access to* those with high amounts of cultural and economic capital.

Contemporary televisual values and voluptuous behavior: *Harlots* and *Versailles*

How do contemporary values connect to voluptuous behavior on European television? Contemporary American luxurious televisual selves like Bobby Axelrod, I emphasized, are those who try to communicate their own group of values and inclinations and to do so in their own ways. I argue that contemporary voluptuous televisual selves are visually represented in some ways that are dissimilar to twentieth-century luxurious televisual selves, particularly in preferring more voluptuousness in television series such as *Versailles*, which is set throughout the building of the palace of Versailles during the reign of Louis XIV, and which premiered in 2015 on Canal+ in France, directed if at all through television series such as *Harlots*, the British period drama that debuted in 2017 on ITV Encore and which focuses on "Margaret Wells" (Samantha Morton), who runs a brothel in eighteenth-century England, rather than through conventional biographical drama television series, such as *The Crown*, which premiered in 2016 on Netflix and which is a narrative concerning the reign of Queen Elizabeth II of the United Kingdom. While still being visually represented in conventional luxuriousness, contemporary voluptuous televisual selves comprehend this in a more indulgent and sensuous way than twentieth-century luxurious televisual selves and mix and strengthen this with a variety of alternative visual representations.

In twentieth-century television, luxurious behavior was routinized into a series of mass visual representations I call conventional luxurious visual representations. Visual representation of conventional luxuriousness took on several patterned cultural configurations, which can be communicated in a

adjusted to the cause of her mother Margaret's financial conflict with Lydia Quigley, for whom Margaret had previously worked as a prostitute. I rather argue that such visual representations are culturally adjusted to female sociocultural "operators" (who are, structurally, *forced* to accomplish their purposes by devious means) and driven by an appreciation of high- and low-class events in brothels. Above all, such visual representations help us to question the circumstances under which voluptuous televisual selves create meaning. Integral to this is the role of the visual language of female sociocultural "operators" in creating meanings which structure the manifold ways in which voluptuous televisual selves confronted with *structural violence*, with sociocultural structures and institutions that damage them by precluding them from meeting their basic needs through ageism and classism, elitism, ethnocentrism, racism, and sexism, can be read. Following Barthes (1977a), I argue that the voluptuous televisual selves in *Harlots* are not *given* but can be *revealed otherwise* in the act of viewing women compelled to achieve their intentions by "devious" methods. In interrogating the seemingly fixed character of voluptuous televisual selves in *Harlots*, we can begin to investigate the ever-changing, volatile, and questioning aspects of comprehending and negotiating cultural events and forms such as the behavior of high and low-classes within the setting of a brothel. Moreover, contemporary voluptuous televisual selves such as Charlotte in *Harlots* surprise us with their ability to traverse a wide range of class and occupational, gender, and ethnic backgrounds, places, and spaces. Whether in Covent Garden or Soho, Charlotte's golden rule is to stop at nothing as she serves rich and highly influential people in the judiciary and the police. Yet, despite her struggles with such people, some of whom, like Lydia Quigley, are blackmailing religious reformers into opposing her mother, Charlotte repeatedly prostitutes herself in dirty doorways, takes lovers in cramped whorehouses, and sleeps with the wealthy in sumptuous four-poster beds and tastefully decorated Soho parlors. For Charlotte, these people and irreligious places are the buildings and mansions, run-down hovels, and perhaps only voluptuous spaces that can activate her progressively amoral responses to extraordinary interior decoration and the spectacle of Georgian sex work.

On the issues agenda, the range of *Harlots* concentrates principally on issues concerning social class and sexuality, sociocultural improvement, money, power, and the aristocracy. Yet the agenda is not set for either the lower or the upper echelons of Georgian society; indeed, it is recurrently experiencing female reorganization and sexual reordering. I regard the representation of sociocultural improvement, of paths to a better life, to be of secondary

importance, but the experience of the prostitute to be of primary importance in *Harlots*. A new feminist agenda of issues concerned with prostitution as a trade involving one's neighbors and openly sadomasochistic (flagellation) specialties and activities has supplanted the issue agenda of men as women's protectors and lovers. Indeed a new issue, namely, that of women's sexual freedom, of women as *something other* than men's slaves, has been introduced. The male coalitions that might once have been thought a characteristic of contemporary voluptuosity (men sampling prostitutes together etc.) I understand as having been supplanted by female coalitions between mothers, daughters, and wives.

In terms of the voluptuous behavior in the mansions and streets of Georgian London, there is in *Harlots* an insecure and ever-altering, frequently precarious, agenda at work in Greek Street and Covent Garden. The voluptuous televisual selves who inhabit the taverns and brothels are outstanding at adjusting to circumstances, particularly when rival high-class brothel owner Lydia Quigley procures religious crusaders and police constables to storm Margaret Wells's brothel. In episode 1 of *Harlots*, for example, we are shown how Margaret reacts to the imposition of a £100 fine and her subsequent inability to make the final payment on her new brothel in Greek Street by auctioning off the virginity of her youngest daughter, "Lucy" (Eloise Smyth), to the highest bidder and then building an unlikely association, in episode 2, with one of Lydia's girls, "Mary Cooper" (Amy Dawson), who is dying of French pox, but who shares Margaret's agenda and is eager to play her part in Margaret's revenge against Lydia. Charlotte Wells, meanwhile, toys with her refusal to sign Sir George Howard's contract to become her "keeper" while concomitantly affirming her growing friendship with a would-be male gigolo and, in episode 3, coming to an agreement with Sir George's wife, "Lady Caroline Howard" (Eleanor Yates), that Sir George's extramarital liaisons can be used to their mutual advantage. Margaret Wells's old lover, plantation and slave owner "Nathanial Lennox" (Con O'Neill), not only arrives as a new agent in the voluptuous agenda, with new "American" values, a new wife, children, and a new collection of issues concerning his preparedness to invest in Margaret's new brothel, but his circumstances are unconventional in that his activities include a bogus marriage to his ex-slave wife "Harriet" (Pippa Bennett-Warner), her "freedom" to be a lie, and leaving his bastard children enchained and unprovided for upon his death in episode 2. Briefly, the agents, values, issues, and variety of activities we are seeing in contemporary voluptuous televisual selves disrupt the somewhat rigid limits established by twentieth-century luxurious televisual selves.

Contemporary voluptuous television becomes portrayals and visual representations of selves seeking pleasurable sensation who have elevated levels of personal self-assurance in being effectual in voluptuous situations. While disbelieving the conventional behaviors of religious crusaders, police constables, and judges, the women in *Harlots* will exploit and function within a sphere wherein "Justice Cunliffe" (Richard McCabe) can casually ask Lydia Quigley to illegally procure an untouched girl for a secret group of high-born men—"the Spartans"—to rape, but they are more inclined toward their own unconventional activities, such as Margaret Wells selling Lucy's virginity three times over. For example, contemporary voluptuous televisual selves such as Lydia Quigley may be discovered in illegal sexual spheres, but she is equally liable to seek effectual satisfaction through activities such as appointing others to do her bidding and in outfoxing Margaret, to be a purveyor of irritation to others, and to see voluptuousness as suitable also in her self-important attitude and in her ability to grant favors.

At the structural level, and as an analyst of the new voluptuousness on television, I identify the new sites for the portrayal of voluptuousness in *Harlots*. But my argument regarding the rise of television series such as *Harlots* is that I see *Harlots* as only *one* important site, with others, such as *Versailles*, discussed below, offering a multitude of representations of lifestyles.

Reinterpreting television series such as *Harlots*, therefore, is an act of voluptuous televisual cultural criticism, aimed at examining such significant sites and uncovering the voluptuous aspects of everyday representations of lifestyles in contemporary visual culture. Questioning the "obviousness" of voluptuousness, we can dispute the supposition that such cultural manifestations are "natural" in everyday life and that they should be accepted without question (Barthes 1972a). Thus, we can probe the seeming innocence of television series. Evaluating cultural productions, phenomena, and popular cultural forms like *Harlots*, we can not only analyze them but also imbue them with an openly voluptuous and historical aspect. This questioning and original approach toward representations of luxury lifestyles, I argue, must be a cornerstone of any cultural and contemporary critical appreciation of voluptuous expressions in everyday life.

Let us look at four representations of voluptuous lifestyles across the televisual landscape of *Versailles* to see how values mediated through representations of the lifestyle of a young French king in 1667, "Louis XIV" (George Blagden), influence voluptuous behavior and attitudes to power (Figure 7.5).

Filmed inside the most famed palace in the world and costing over US$2 million per episode, *Versailles*'s stories from the age of the Sun King, much like

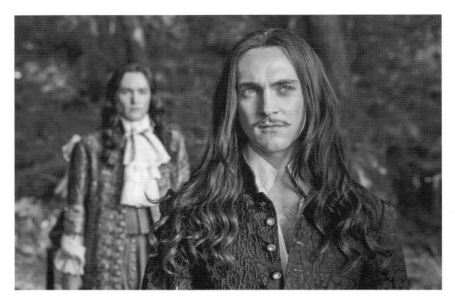

Figure 7.5 "Monsieur Philippe d'Orléans" (Alexander Vlahos) and "Louis XIV" (George Blagden) consider the ambiguities of power in *Versailles*, 2015.
Photo credit: FILM COMPANY CANAL+/AF archive/Alamy Stock Photo.

the film *Farewell, My Queen*, discussed in Chapter 6, center on voluptuousness and unbending codes of conduct, on the constraints of court protocol, and the opulent theatricality that is regal sovereignty. Brave dukes, plotting marquises, and the reverberations of the Thirty Years' War (1618–48) are the background to *Versailles's* portrait of the life and times of the fearful and troubled Louis XIV, who decides he must keep all his irritable nobles under one roof to counteract spiteful jealousies, insurgencies, scheming, and sexual chaos. Add "Monsieur Philippe d'Orléans'" (Alexander Vlahos), Louis's younger brother into the fray, who was overtly gay, given to transvestism, and a formidable battlefield leader, and the historical stage is set for a cultural narrative about sexual politics and royal conspiracy, comradeship, sibling rivalry, disobedient noblemen and women or, in other words, voluptuous televisual selves.

Employing Louis XIV's traumatization by the Fronde (the revolt of nobility during Louis XIII's reign) as a starting point, we can locate various interests—in the sense of the advantages or benefits that might be obtained by certain people and groupings—that the conspiratorial nobles and Louis XIV combine into diverse representations of their voluptuous lifestyles: interests in establishing the seat of power out of Paris, in Versailles, in the transformation of a hunting lodge into a castle, in the king becoming the state, in the king being the husband of

the queen, father to the first royal baby, and in being counseled by his advisors to go to war to impose his power. If we look initially at the structure of the representations of voluptuous lifestyles in *Versailles*, we can see, through, for instance, Louis XIV's brother Philippe's dreams of glory on the fields of future battles, how fragmented in terms of meaning they become as Louis XIV successfully persuades the nobility to live at his side in Versailles. We can also perceive that in this premodern culture of kings, queens, noblemen, and noblewomen, there are but a small number of people who can be represented as living voluptuous lifestyles (because most of the population are peasants), whereas in our contemporary culture of elected presidents, first ladies, and various nominated political elites, there are many people who can be represented as living voluptuously diverse lifestyles because most of the population are no longer peasants.

We thus discover narrow diversity in representations of voluptuous lifestyles in the televisual landscape of *Versailles*, with the king having the most meaningful, textured, and structured representations concentrated on explaining his "unnatural" if voluptuous lifestyle of privilege. Usually, the nobler the origin, the more cultured and luxurious the representation of lifestyles, except in the instance of "Montcourt" (Anatole Taubman), who is a noble but branded suspect because he cannot prove his noble rank. Among individual voluptuous televisual selves, such as Montcourt, the highly connected have more coded and structured representations of their voluptuous lifestyles than the less connected. In *Versailles*, then, cultural capital as signified by level of personal connection is the main signifier of a premodern and entangled voluptuous lifestyle.

Consequently, we can explore how voluptuousness interrelates with other interests within different representations of voluptuous lifestyles in *Versailles*. Let us focus upon representations of lifestyle that merge voluptuousness with power or the king's humanity or both (using power as a signifier of high levels of cultural political capital and the king as a husband and father as a signifier of high levels of cultural yet highly gendered capital). Here we find that contemporary televisual selves with the most entangled representations of voluptuous lifestyles—televisual selves such as the king merging voluptuousness with power and humanity—use the widest range of voluptuous practices. The difference between voluptuous power and voluptuous humanity in the representation of lifestyle matters for the king's choice of voluptuous activities. His interest in being a good husband and father is a more everyday human worry, and it attracts activities directed to pleasurable sensation directly, whereas the more elite concern of power attracts a wider and more varied range of activities. The

king as husband and father pulls at our emotions directly and through his wife, god-daughter, brother, and mistresses, whereas power groupings use a broader range of urges and influences, including the visual representation of slaughter and suspicion, arrest, and murder. In brief, those contemporary televisual selves in *Versailles* that display a voluptuous humanity and lifestyle are more inclined to locate themselves within the sphere of the court and those that display a voluptuous power and lifestyle to place themselves more within the spheres of lawbreaking and heroism, action, and the fields of battle.

The form and content of the representations of voluptuous lifestyles in *Versailles* as examined here have apparently little influence upon trust in human pleasurable sensation. This is unsurprising as all representations of voluptuous lifestyles seem to need the bowing and curtseying to kings and queens that a royal household and a subservient noble retinue delivers for the monarch's enjoyment of others' punishment and his feeling of owning a vast estate complete with the palace of Versailles. With the rising fragmentation, opposition to prospective solidification, and divergence of representations of voluptuous lifestyles in *Versailles*, particularly the alternative variants, such as banditry, the delights of royalty and the sense of aristocratic conspiracy against the king become ever more attractive to the competitors for power, sooner than seeking to chase and win lovers at court. *Versailles's* contemporary broad-mindedness and even celebration of the varied if paranoiac pursuit of endless targets together with an optimistic view of escape and the quest for identity is, ostensibly, the only rational strategy in a regal sphere where the joy of covering oneself in glory and the relentless consciousness of the threat of war generate a culture that exemplifies numerous frequently incommensurable representations of voluptuous lifestyles, and which wants to produce support and acceptability for the taking of mistresses, the doing of dirty deals, and the open use of brute force, and all in the name of the game of thrones.

While *Stoney Burke* and *Dallas, Miami Vice, The X-Files, The Sopranos, Suits*, and *Billions* all have their own luxurious televisual values and inclinations, it is the contemporary televisual values and behavior of the voluptuous selves in *Harlots, Versailles*, and elsewhere that are a phenomenon of the present period in the television landscape. They present a sometimes more loathsome, distasteful, or erotic configuration of pleasurable sensation than, say, *The Crown*. But, as I have argued in this chapter, their actual meaning and importance does not lie in what they have achieved in the portrayal of breathlessness and sweet kisses, or in their broadening of access to the enjoyable feelings of luxuriousness to new individuals and groups of visual consumers, but in their *distinctively recognizable*

visual patterns and representational configurations of voluptuousness, a visual mark-making and representation of cultural patterns that welcomes sexualized modes of life or conduct and voluptuousness. By sexualized modes of life or conduct is denoted a collection of visual, representational, and rhetorical practices that foster open dialogue about stylishness, deliberations concerning vanity, opposition over the meaning of consumption, and the portrayal not only of ill-gotten treasures but also of noncompliant lifestyles. By voluptuousness is denoted the visual representations by which images and voices may bring hitherto unseen and unheard, often barred, subjects, such as the impact of the images and voices of "irresponsibility," revelry, and the merits or otherwise of an "unthinking" or "irrational" course of life into the production of *jouissance* and thus the body of the voluptuous (Barthes 1977a: 188). Both reflect the important observations that as the character, function, and agenda of voluptuousness are established in discourses of softness and repose, so the important technique of voluptuous visual representation is the imaging and voicing of voluptuous televisual selves' visual and spoken viewpoints on their golden visions of voluptuousness and getting them seen and heard. Voluptuousness as visually represented by contemporary televisual selves is acknowledged to be built in golden visions of voluptuousness; indeed, voluptuousness *is* a golden vision.

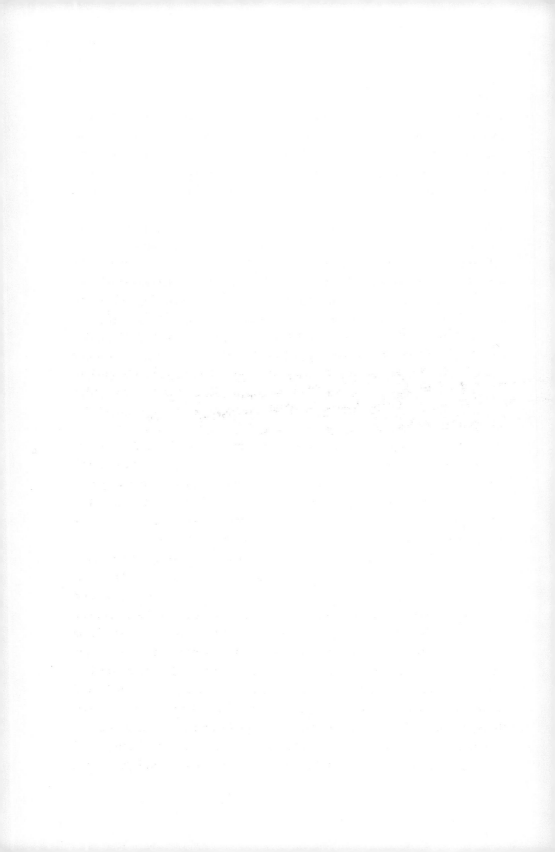

Luxury and social media

Contemporary luxurious visual representations are one of the most important components changing the global character of the "physical" luxury fashion house (i.e., the bricks-and-mortar luxury-branded flagship or department store). In this chapter and taking Louis Vuitton as my primary example of the physical luxury fashion house, I will investigate these luxurious visual representations and their consequences for Louis Vuitton and its label, the "LV" logo. I argue that the old luxurious order surrounding Louis Vuitton is disappearing and that the restructuring of luxurious visual representations is in large part responsible for the creation of a diversity of new interweaving and overlapping "luxury authorities," such as paid "social influencers" on social media, who shape luxury visual consumers through marketing (Hinton and Hjorth 2013; Fuchs 2017). I particularly examine the appearance of the "digital luxury authority" and what I call the "new digital luxury fashion house" founded on luxury new and social media's highly visual websites and applications ("apps") that allow visual consumers as users to generate and share lavish representations and to participate in luxurious social networking (Armitage and Roberts 2014).

The new digital luxury fashion house is a response to contemporary cultural shifts and a reaction to the external processes of increasingly globalized luxurious visual representations. Lush visuals, discourses of plush representation, and sumptuous pictorial practices congeal over time into perhaps banal graphic structures such as loving couples clinking champagne glasses. Yet, it would be a mistake to discuss these abstract luxurious visual representations as if they had concrete or material existence or as unchanging. Rather, these opulent visualities change or restructure (as do luxurious photographic, cinematic, and televisual selves) and network with each other and with luxury fashion houses through time. Visual structures that do not adapt themselves to pressures might go out of existence, while those that do adapt modify their representational configuration, structure, logic, and legitimacy. Louis Vuitton is an instance of a

centralized nineteenth- and twentieth-century corporate structure experiencing radical internal and external visual and other pressures, which are compelling various representational restructurings in response. Dana Thomas (2007) explains this in terms of the new corporate need to satisfy shareholder profit margins and market share producing the pressure and the new "deluxe" fashion house that has "lost its luster" being the response. I share numerous ideas on corporate restructuring with Thomas, and her imaginative approach to the changing shareholder architecture of the profit-seeking luxury fashion house, its financialized and marketized structures, its fashion tycoons, and its future. I deviate from Thomas's analysis and assessments in an important respect: being centrally concerned with luxury and visual culture, I am less involved with corporate shareholder profit margins and market share as contemporary pressures than I am with what I identify as "reluxe" or with how the new digital luxury fashion house has not lost but transformed the very idea of luster today. To be clear from the outset, "luster" is a term I use in this chapter to denote the unique quality or condition of shining by a sort of reflected light of a physical or digital luxury fashion house's goods and services and the mystical value attached by visual consumers to its sheen through its association with heritage and use (see also Beauloye 2016). Nonetheless, I have found Thomas's theoretical model and its implications a source of inspiration.

Physical and digital luxury

One of the most profound features of contemporary luxury, I argued in Chapter 2, is the interrelatedness of luxury and visual culture. Not only are luxurious selves, luxurious occasions, luxurious structures, and luxurious influences more interrelated, but there is also an interpenetration from one luxury sector to the other. I shall differentiate between physical and digital luxury fashion house visual representations. The physical is where luxury fashion houses, in the form of bricks-and-mortar luxury-branded flagship and department stores, and their visual representations, interrelate. Interrelatedness happens in a variety of ways, and external luxury fashion house actions have consequences inside luxury fashion houses whether they plan and accept this or not. The digital is not only where luxury fashion house social media stores and their visual representations interact but also, increasingly, where *other* new luxury authorities also interrelate—whether luxury fashion houses like it or not. The digital is where luxurious visual difficulties and representational matters are increasingly shared

by luxury fashion houses *and* new luxury authorities. Social influencers on social media within different luxury visual consumer social media forums and networks, such as Facebook, YouTube, WeChat, Instagram, Tumblr, Twitter, Snapchat, and Pinterest, for instance, claim to make luxury more "accessible" through an appeal to everyday luxury visual consumers. And, of course, now luxury visual consumers are not obliged to enter a luxury-branded flagship or department store even to browse, such developments mean that readers, viewers, and consumers as users can interact with and experience luxury on an entirely new level that cuts *horizontally* through the leading luxury fashion houses.

With the growing reality of an expanding world of luxury and diminishing environmental resources, of the growing difficulty of luxurious visual setbacks and the luxurious costs of their representational solutions, physical luxury fashion houses face a number of significant challenges. Physical luxury fashion houses have grown to meet these challenges in a diversity of ways, but few have proved to be of permanent importance. Confronted with visual hindrances on a world scale—world creative talent shortages, environmental accountabilities, and responsible corporate partnerships and sponsorships—physical luxury fashion houses such as Louis Vuitton cooperate through such national organizations as the Comité Colbert, which was founded in 1954 to gather French luxury houses to promote French *art de vivre* at the international level, and the Walpole, which is an alliance of the United Kingdom's luxury brands that promotes, protects, and develops the qualities of British luxury, both of which are much praised but handicapped by the very rationality and operation of the contemporary luxury fashion house. Physical luxury fashion houses are still a pertinent and defensible idea and reality, inclusive of their visual representations, but by themselves they increasingly do not meet the needs of contemporary luxury culture because of the difficulties of interrelatedness, interpenetration, and digital luxury.

The physical luxury fashion house results from the need for luxury brands such as Louis Vuitton not only to cooperate but also to compete with other physical luxury fashion houses, such as Hermès and Burberry, in an assortment of spheres where visual intricacy and cost of representations necessitate this, as in the need for Louis Vuitton to launch a new physical luxury-branded flagship store or a new physical department store such as the Louis Vuitton Island Maison at Marina Bay Sands in Singapore (Figure 8.1). Usually, these physical luxury-branded flagship and department store structures, which are established to ease such undertakings (for Louis Vuitton in this instance), have proved effectual and fared well with visual consumers all over the world, but Thomas's viewpoint that their success would weaken and challenge the acceptability and luster of the

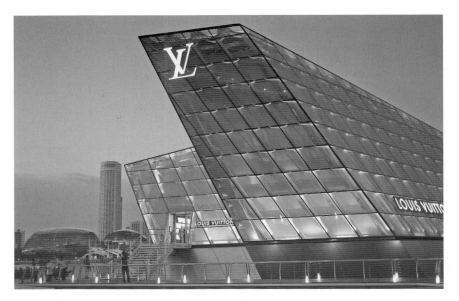

Figure 8.1 Louis Vuitton Store, Marina Bay Sands, Singapore, 2013.
Photo credit: How Hwee Young/Epa/Shutterstock.

physical luxury fashion house remains unproven. Indeed, unlike Thomas, I do not see the success of physical luxury-branded flagship and department stores as having entirely negative consequences, since the increasingly "mass" luxury fashion houses of digital visual culture, such as Louis Vuitton, introduce a new visual, immaterializing, yet global visual consumer dimension, an argument connected in this chapter with their digital weakening of and challenge to the acceptability and luster of the physical luxury fashion house. For it appears that whatever physical luxury fashion houses such as Louis Vuitton say and do, visual consumers the world over trust in them to the point of obsession at the level of the luxury label. We might theorize the continued global movement to more and more physical luxury-branded fashion house flagship and department stores. But I theorize that practical interrelatedness will increasingly function not without the need for such global and unilinear suppositions as with the "*hybrid*" need for physical luxury-branded fashion house flagship and department stores *and* new digital luxury fashion house social media stores as well as, crucially, *other* new digital luxury authorities operating within social media forums and networks such as social influencers. For example, interrelatedness is currently propelled in part not by physical luxury-branded fashion house flagship and department stores but by new digital luxury fashion house approved "mid-

tier" or even "micro" social influencers whose new digital luxury authority concerning questions of "authenticity" holds appeal for active and engaged luxury communities of followers who value "the grain of the voice" (Barthes 1985b) of the influencer and trust their judgments on luxury products and services.

Multinational corporations such as Facebook and Google's YouTube are the fundamental models of digital penetration into physical luxury fashion houses compelling interrelatedness, though other examples might prove to be of longer term importance for them. Such instances are the growth of digital communications and new media systems, particularly China's WeChat; the "Rich Kids of Instagram"; the interest in digital luxury demonstrated on Twitter and Snapchat; digital luxury on Pinterest; and the growing significance of digital visual cultures of luxury from user-generated content and text posts and comments to the globalization of digital photos or videos concerning luxury. Practically global, these digital visual cultures of luxury data generated through online interactions on social media are coming to have a disrupting influence upon numerous physical luxury fashion houses (Okonkwo 2010).

The physical luxury label (Louis Vuitton, Chanel, Gucci, etc.) is also a visible phenomenon once more. While most visibly developing in Europe today, these physical luxury labels have also had an influence upon physical luxury growth in contemporary Asia, and particularly so in China/Hong Kong (Kapferer and Bastien 2012: 114). Yet physical luxury labels and physical luxury growth are increasingly joined by new digital luxury labels and by new digital luxury social influencers. Frequently setting up groundbreaking on-screen connections with new digital luxury labels, with other social influencers, and with visual consumers across the world in an instant, today's digital luxury social influencers thus not only provide news about new product and service launches, content promotions, and distribution outlets but, importantly, also demonstrate a commitment to socio-technological innovation that is lacking at many contemporary physical luxury fashion house labels.

The appearance of the new world order of luxury indicates the restructuring of the physical luxury fashion house and the physical order—particularly physical luxury-branded fashion house flagship or department store visual representations like those of Louis Vuitton—as well as the finding of solutions to disagreements over the operation and development of its 3,700 stores worldwide (Belloni 2016). Most physical luxury fashion houses now think they act for themselves in other countries without the need for direct international holding

company (i.e., Louis Vuitton Moet Hennessy or LVMH) interference into the look of their stores. We are seeing the growth of the intra-physical luxury fashion house and digital structures and solutions. The triggering issues are numerous, including the recognition of physical luxury fashion house governance and organizational excess, overwork, and ineffectiveness in numerous business spheres, and increasing cost of physical luxury fashion house research and development of brand solutions. But the main issues are the growth of physical luxury shopping malls in the heartlands of global capitalism; the growth of new stand-alone and built-in social media services and interactive Web 2.0 internet-based apps; the understanding that numerous physical luxury fashion house performance problems must be confronted globally *and* locally; the growth of global luxury social media users creating service-specific communication profiles for websites or apps that are replete with luxury *as* visual culture; and the loosening of national, luxurious, and even local visual cultures and philosophical attachments to the domination of French and Italian physical luxury goods in favor of luxury service experiences delivered by "born global" but local, small, and medium sized but, crucially, digital enterprises.

Today it is almost a commonplace to speak of luxurious, visual, and cultural interdependence. Interdependence is also supplemented by a new technological openness of structures to the external world of luxury. But global interdependence and the world luxury system are also supplemented by the enfeebling of physical luxury fashion houses such as Louis Vuitton and the old lustrous systems of physical luxury-branded flagship or department store visual representations, by a recognized and deteriorating ability of physical luxury fashion houses to solve visual problems by waging war on social media web-based technologies of representation, desktop computers, and mobile technologies (e.g., smartphones and tablet computers), and the loss of their once gleaming domination, both real and visual-cultural, all of which produce volatility in the physical luxury-branded flagship or department store. The results of crosscutting digital issues have also corroded the unity of physical luxury fashion houses and their capacity to solve their lack of openness to technology at the levels of luxury production, luxury sociocultural investment, and luxury visual consumption, producing volatility. Into the reckoning have come new and frequently less foreseeable visual consumers and structures, which undermine matters further. Consequently, I consider the new world order of luxury to be in such rapid change that the old world order of luxury is in decline and no new world order of luxury but the hybridity of physical and digital luxury appears plausible.

The luster of the physical luxury fashion house

My objective in this section is to demonstrate why and how the physical luxury fashion house as it has been is now experiencing such a shift that its identity may not allow recognition in several decades' time. I argue that financialization and multinationalization of formerly national activities and visual representations, related to globalization and interlinking of corporate decision-making in relation to "millennial"—young people born in the early 1980s—and postmillennial generational and geographical complexities (i.e., their increased use and familiarity with global communications, media, and digital technologies and a liberal approach to politics and economics) is corroding the luster of the contemporary physical luxury fashion house. The results are not identical across existing physical luxury fashion houses, though. And, as anybody who has ever visited one will tell us, physical luxury fashion houses still retain immense luster as surface sheen and are by no means about to surrender decision-making concerning millennial and postmillennial generational and geographical complexities to other or different forms of lustrous gloss. In brief, ritualistic assertions of luster are still asserted and are in existence alongside a slow corrosion of "authentic" luster.

Luster involves the possession and control of a kind of total luminosity and unconditional brilliancy within a given physical luxury fashion house. The specific physical luxury fashion house that has come to place luster in the contemporary world of luxury is the physical luxury-branded fashion house's flagship or department stores. For me, the physical luxury fashion house is a historical construct, a historical "Maison" built partly from the fragments of other luxury structures, partly from new luxury materials and structures. For instance, we can compare the history of the typical Louis Vuitton flagship store with the newness of the Fondation Louis Vuitton in Paris (Figure 8.2). With its brightly lit Frank Gehry architecture inspired by the shining glass of Paris's Grand Palais and the luminous splendor of the Palmarium, which was built for the Jardin d'Acclimation in 1893, the Fondation builds on the history of Louis Vuitton and on the history of Paris while offering a futuristic vision to its newest physical and digital "inhabitants," such as Michael Burke, Chairman and Chief Executive Officer (CEO) of Louis Vuitton, Nicolas Ghesquière, Louis Vuitton Creative Director, and Louis Vuitton's millions of visual consumers. But, the physical luxury fashion house Louis Vuitton of today became the luxurious habitus of the contemporary visual consumer only after a long period of disagreement

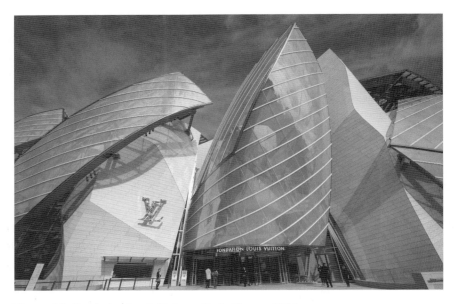

Figure 8.2 Fondation Louis Vuitton, Paris, France, 2014.
Photo credit: ROMUALD MEIGNEUX/SIPA/Shutterstock.

over the company's direction, adjustment by its more than 121,000 employees to its governance structures, acquaintance with the organization of Louis Vuitton internal business groupings, adaptation by luxury trunk and shoe, watch, and jewelry makers, and contemporary corporate performance principles.

The emerging common characteristics of this new physical habitus are encapsulated in the idea of luster. CEOs such as Louis Vuitton's Michel Burke attain dominion over a physical luxury fashion house by, as Kapferer and Bastien (2012: 143–44; my emphasis) put it, fulfilling various ontological functions and by means of creating sociocultural space or distance and that distance necessarily being known beyond its real clientele (as we saw with the example of the film *Pain & Gain* in Chapter 6): the physical luxury fashion house "must *radiate* as a symbol of superior taste, in the literal and figurative sense." The physical luxury fashion house is thus a sociocultural indicator and architect of taste hierarchies, of luxurious meanings, and of lustrous representational display. Centralized brand legitimacy at Louis Vuitton occurred after lengthy periods of disagreement over talent, environmental challenges, and competitions over particularly attractive luxury partnerships, almost always supplemented by resort to the invention of sociocultural aloofness, space, distance, and detachment. This physical luxury fashion house of Louis Vuitton represented by luxury flagship and department

stores has come to have one CEO or executive committee or board of directors, one set of legitimate and legitimating CEO rules (corporate profitability on behalf of shareholders), and a centralized bureaucracy, all to rule over and/or serve a carefully defined people called employees and visual consumers. These processes, as well as their visual representations, are not identical and are still unfinished in numerous parts of the world, notwithstanding successful attempts to export them from their home in France. Thomas's *New York Times* bestselling narrative of "deluxe" through the corporate consolidation of small, family-run enterprises into luxury goods and services holding companies disregards a massive amount of difference and necessity in corporate trajectories, sponsorship calendars, and the contents of contemporary initiatives in major luxury business groupings.

Conflicts over business insights, disparities between business groups (sunglasses vs. books, for example), illogicalities concerning leather goods or men's ready-to-wear, and challenges within physical luxury fashion houses such as Louis Vuitton have been met with various degrees of success by maintenance activities, visual adaptation, and representational change. Luxury has been about handling visual maintenance and representational change within and between physical luxury fashion houses. But for me the challenges to Louis Vuitton and to other physical luxury fashion houses have expanded and altered, externally and internally, to a point where the structure and the inter-structural system are under extreme stress.

There are five *external* and six *internal* changes that are revealing of the challenge confronted by physical luxury fashion houses such as Louis Vuitton. Externally we can begin with:

(1) *Retaining the physical luster of the physical luxury fashion house in times of great uncertainty.* No physical luxury fashion house can now expect to maintain its physical luster for visual consumers successfully within the global context of geopolitical, economic, technological, and monetary turmoil beyond its corporate borders or within its own internal tough growth conditions. Again, changes in social media are forcing physical luxury fashion houses to obsess over the function of physical luxury-branded flagship and department stores to such a point where few if any physical luxury fashion houses can assert complete autonomy from such unpredictable situations or the many challenges associated with preserving their physical luster.

(2) *Constant adaptation to fluctuating market circumstances that undermine physical luster.* As argued above, the world luxury market is being so

relentlessly restructured that no physical luxury fashion house can now adapt and fully maintain itself in the market within the context of these global market conditions and forces of change. Digital interpenetration is dividing the physical luster of luxury fashion houses while the physical luxury fashion house structures managing fluctuation are solidifying interdependence. Physical luxury fashion houses can no longer perform independently even the basic tasks of corporate technological innovation between their organizations and their visual consumers' new expectations, and between luxury production and visual consumer demands for openness, and efficiency is reduced. The luxury shopping malls of global capitalism, such as the Ion Orchard mall in Singapore (Figure 8.3), are again transforming themselves from a modern to a contemporary basis where the luxury-branded flagship and department stores of high-end retailers—from Louis Vuitton and Fendi to Tom Ford and Versace— and their luxurious visual representations dominate, where the serial reproductive rationality of gourmet restaurants, art galleries, and office space replaces that of luxury production, and where contemporary understandings of global luxury visual consumers' latest requirements in retail districts reigns.

Figure 8.3 Louis Vuitton Store, Ion Orchard Mall, Singapore, 2016.
Photo credit: Wallace Woon/Epa/Shutterstock.

(3) *Physical and digital or hybrid organizational rapidity, effectiveness, and the targeted implementation of corporate initiatives.* These plans have developed and succeeded in numerous spheres. Effectiveness has solidified countless luxury organizations, and legitimacy is now ensuing to such a point that fast-changing and crosscutting visual consumer allegiances are fragmenting physical luxury fashion house legitimacy. Hybrid physical and digital luxury is new and is restructuring the expectations of visual consumers, allowing for new hybrid ideas of luxurious identity. Likewise, the sphere of luxury now involves the targeting of digital markets, the completion of new structures, and luxury market segmentation.

(4) *Decision-making in relation to millennial and postmillennial generational and geographical complexities.* Particularly given today's tough and unknown challenges, decision-making relating to millennial and postmillennial generational and geographical complexities is now hybridized by luxury fashion houses. Difficulties concerning the physical speed of logistics and delivery, challenges of digital transformation, and the accelerating demands of millennials and postmillennials are affecting physical luxury fashion houses' markets, while their visual consumers can only be understood as hybridized (operating across physical *and* digital luxury) and as thus generating hybridized solutions. These problems dismay millennial and postmillennial or more "open" younger luxury visual consumers, particularly in major capitals like Paris and New York, dissolving their loyalties to the physical luxury fashion house and sending them elsewhere.

(5) *Digital and global luxurious visual cultures.* Such luxurious visual cultures as that of Singapore and Hong Kong are redirecting global attitudes concerning what count as "prestigious places" (Sharr 2016; Paris 2018) in terms of activities, systems of values, and urban transformation, loyalties regarding physical luxury fashion houses, and the visual and cultural inclinations of visual consumers, who meet both in person and online, thus spawning new global trends thanks to face-to-face encounters and social media. Once, for example, a natural national community was made up of the visual consumers of a French national physical luxury fashion house called Louis Vuitton (Pasols 2012; Mason 2015). Today, especially with the global growth in luxury travel and travel to buy luxury goods and services, both key profit sources for physical luxury fashion houses, these communities of visual consumers know of *no physical national limits nor no digital global borders.* When positioned

beside (1)–(4), we can speak of numerous challenges to the legitimacy of the physical luxury fashion house.

Internal changes and challenges begin with:

(1) *The potential overload of physical luxury fashion houses' portfolios of lavish products and services.* Contemporary physical luxury fashion houses have few shared functions, but one shared characteristic has been the propensity to undertake increasing portfolios of prestigious products and services—associated with trunks and leather goods, shoes, and watches in the case of Louis Vuitton—to the point where potential overload may increasingly create corporate role inefficiency and functional failure in the value structure and the spirit of entrepreneurship in its systems. Most contemporary physical luxury fashion houses are abandoning centralized organizational responsibilities, but with variable consequences and reactions by employees and visual consumers (Belloni 2016). The collapse of the border between the physical luxury fashion house and its visual consumers is captured in the following process.

(2) *Digital interpenetration.* This term designates the process by which the physical luxury fashion houses' employees and visual consumers, creative structures, interests in excellence, and spheres of execution become digitally interpenetrated to such a degree that the capacity of the physical luxury fashion house to remain independent yet agile regarding digital change is challenged.

(3) *Openness to technological innovation.* In the same arena, we have new stresses over openness to technological innovation. Though hands-on corporate and cultural practices have never had widespread application to all contemporary physical luxury fashion houses, it does appear that corporate cultural practices and their configurations have altered and that the physical luxury fashion houses' ability to successfully technologically innovate through, for example, openness to "open source"—where luxury customers would be able to legitimately modify luxury goods and share luxury services because their luxury designs would be publicly accessible—is reduced. Despite ostensible corporate cultural and technological innovation being a strong contemporary trend in physical luxury fashion houses such as Louis Vuitton, therefore, what we might call "open source luxury" is a technological innovation far too radical for physical luxury fashion houses to contemplate in the present period. External luxurious selves have landed, and inside physical luxury fashion houses visual consumer and

visual consumer-inclined digital luxury "authorities," such as new luxury label social influencers, have appeared as significant players regarding the research and development of new luxury goods, services, and visual-cultural practices. Italian millennial luxury authority and social influencer Chiara Ferragni of "Blonde Salad," for example, is one of the new stars of social media advertising (Figure 8.4). Beauty vlogger, cult celebrity, world traveler, and all-round fashionista, Ferragni's golden luxury lifestyle is powered by her sharing her photographs with her *9.6 million* followers on Instagram, making Ferragni one of *the* micro celebrities of the social media domain. Ferragni has thus found fame and fortune solely by publishing photographs, mainly of herself, wearing a mixture of luxury-branded outfits including Louis Vuitton in various beautiful settings. I argue that today visual consumer and communication cleavages concerning digital social media have more influence upon visual consumer behavior than physical ones. Visual consumer cultural needs, expectations, and the desire for openly innovative luxury goods and services and new luxury-branded flagship and department store *experiences* (a key term in the world of contemporary luxury) are increasing, altering, and crosscutting with new hopes and marketized innovative digital systems. The "touch points" of contact with physical luxury fashion houses are now beyond the previous consensus relating to physical luxury in a luxurious world of fluctuating digital desires. Visual consumers are proving harder to please and sales harder to maintain as new luxury label social influencers online such as Ferragni become better informed about their own and other luxury visual consumers' interests. Indeed, visual consumers are constantly redirecting their accelerating and fragmenting attention toward ever more "authentic" goods, while millennials and postmillennials seeking sales and service excellence enter new digitized social configurations and offline relationships with the physical luxury fashion house. Millennial and postmillennial loyalties to physical luxury fashion houses' brand values fluctuate quicker with realignments and increased instability concerning the scope and quality of physical luxury fashion houses' brand values, such as their sociocultural commitments to the environment. Physical luxury fashion houses such as Louis Vuitton must innovate in association with the new digital technologies that have emerged as a concomitant to the new, ultra-connected millennial and postmillennial generations who are influencing important aspects of the economy and visual culture (Belloni 2016). We can address these changes while examining the subsequent associated transformations.

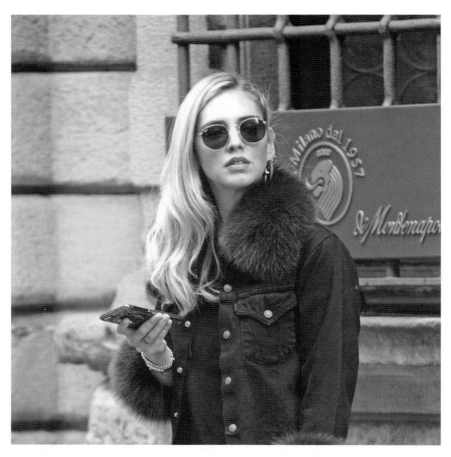

Figure 8.4 Chiara Ferragni, Milan, Italy, 2017.
Photo credit: Mimmo Carriero/IPA/Shutterstock.

(4) *Physical changes.* Physical luxury-branded flagship and department stores are increasingly seen as exhausted as the leading way of establishing, systematizing, and arranging physical luxury fashion houses' visual and other activities, as, in an altered world of luxury, visual consumers find that their physical disadvantages overshadow their advantages. Confronted with a restructuring economic, informational, luxurious, and sociocultural global world, large, fixed, and bureaucratic physical luxury-branded flagship and department stores appear weary if not worn out, and they are being restructured along lines signified by ideas of decentralized sharing of visual consumer opinions online, devolved new luxury label social influencers such as Ferragni with her own line of branded shoes ($500 per pair) on-screen, in effect deregulated social networks, self-managed omni-channel luxury shopping, and the widespread use of privatized mobile phone and tablet computer devices. The centralized and "unaccountable-to-the-visual consumer" structures of the physical luxury fashion house are in transition if not in decline.

(5) *Cultural plurality and fragmenting luxury visual consumer needs.* For many reasons, the luxury-branded and cultural ties between physical luxury fashion houses such as Louis Vuitton and the luxury visual consumer are untying and being substituted by ties of a new, more numerous, diverse, and less permanent kind that favor purchasing *anywhere, anytime,* using *any* social media channel. Incidentally, the changing role of the notion of *time* should not be undervalued in the sense that physical luxury fashion houses must tackle the digital needs and technological openness of specific (most likely younger millennial and postmillennial) subgroups of luxury visual consumers and the specific (most likely older premillennial and postmillennial) physical needs of those luxury visual consumers that do not feel the same belonging to digital tools and digital cultural values as digital savvy luxury visual consumer groups.

(6) *The drives and subjective inclinations of "the extended luxury visual consumer."* Personal luxurious lifeworlds and the proximate luxury visual consumer habitus of an increasingly personalized body and fully Wi-Fi-ed home are at the heart of the new near-seamless life and luxury visual consumer experience of self or what I call "the extended luxury visual consumer." Physically distant from old-style corporate luxury strategies, physical luxury-branded flagship and department stores, the authorized, physical, and digitally extended luxury visual consumer appears to pursue gratification at the level of digital luxury lifestyle, eco-aware luxury

consumption, and a privatized "always already there" style of luxury, instead of in public physical luxury-branded fashion house flagship and department store and luxury visual consumer experiences inclined to the unified physical luxury fashion house (Belloni 2016).

In short, the contemporary physical luxury fashion houses' designs and products, central supply chain structures and standards, solidified over generations, are, much like the glaciers following the catastrophe of human CO_2 emissions all around the globe, thawing if not yet disappearing. New digital luxury authorities such as Ferragni, environmentally deficient fashion configurations, sometimes ineffective administrative sites and stores, and digital structures are emergent. But, to date, few have begun to solidify or transform into the much-needed long-term implementation of physical luxury fashion house business models that combine performance, ongoing openness to technological innovation, and environmental responsibility. We must now examine the new digital luxury fashion house structures that are developing as candidates for reorganization.

The new digital luxury fashion house

Any new digital luxury fashion house such as a future Louis Vuitton must be able to act cost-effectively to accommodate the shifts in its external and internal systems and luxury retail company worlds. It must evolve contemporary corporate structures to produce this and to imaginatively protect and develop its label and, in our case study, the LV logo as a digital product space and its crucial role as a *signifier* for extended luxurious visual consumers within the new luxurious configurations that LV coats and trunks, leather shoes, watches, sunglasses, and books and the like can take.

As with Barthes's (1977a: 52–68) method of explaining the "filmic" component of Eisenstein's film stills, it is a matter of differentiating various levels of meaning within the LV logo. The informational level of the LV logo involves what it immediately communicates—"LV" or "Louis Vuitton." However, the symbolic level of meaning, of "LV" as an increasingly digital signifier that represents hierarchical cultural values, entails extended luxurious visual consumers reading, viewing, and using the Louis Vuitton website in the more complex cultural symbolisms involved in its logo. In the incarnation of the LV logo seen in Figure 8.5, for instance, the LV coat detail is overwhelmed with lustrous silver and pink, gray, and blue for the visual consumption of extended luxurious visual

Figure 8.5 Louis Vuitton show, model backstage, coat detail, Spring Summer 2019, Paris Fashion Week, France, 2018.
Photo credit: WWD/Shutterstock.

consumers. The symbolic level of the LV logo coat detail involves a seemingly simple yet multifaceted collection of symbolic coding functioning within contemporary luxury culture: the glossy spectacle of silver as a sign of the well-off Louis Vuitton coat wearer, of the insider's knowledge of Louis Vuitton trunks or leather shoes, of the cultural cachet of owning a Louis Vuitton watch and the subsequent "knowing" visual exchange between extended luxurious visual consumers in the boulevards of Paris or Milan while wearing Louis Vuitton out and about town. These symbolic levels of the meaning of Louis Vuitton products from coats and sunglasses to books are the connotative meanings of the LV logo, and they can all be identified and deliberated through the semiotic method of reading expounded by Barthes that was discussed in Chapter 3. Furthermore, like Barthes, we might not want to end our reading of the LV logo coat detail at this level of symbolic meaning. We may try to move beyond the "obvious" symbolic meaning and juxtapose it to what Barthes (1977a: 56–65) names the "obtuse meaning." With the LV logo coat detail, for example, we might note that,

for some extended luxurious visual consumers, there may be characteristics here which strike them without seemingly "adding up" to an identifiable symbol or second-order connotation: some extended luxurious visual consumers could—possibly even unintentionally—focus on the lavish viscosity of the twin letters "L" and "V," on the softness of the digital rendering on their mobile phone screen, on its digital luster on their iPad, or the gracefulness of the entire polished image on their desktop computer. These signs, which the extended luxurious visual consumer possibly will not "know" how to read as a viewer or user, indicate Barthes's (1977a: 55) "obtuse" or "third meaning." Barthes proposes that such traits cause our readings of the obvious meaning to "slip" or, as he puts it, "the third meaning . . . seems to me . . . to open the field of meaning totally, that is infinitely" (1977a: 55). The identification of this third meaning is important for students of luxury and visual culture because it changes the LV logo coat detail from a "mere" logo of only two letters into a *text of luxurious pleasure* and even of *visual and cultural bliss*. It permits a reading that *escapes* both the preferred narrative and chronology of Louis Vuitton and, more significantly, any structure which a narrowly semiotic reading would discover within the LV logo coat detail. Such an open, infinite meaning endures only on the level of the signifier—there is no signified to "terminate" or "complete" this meaning. The third meaning of the LV logo coat detail, therefore, is some "thing" which we can "find" theoretically but not fully explain. In other words, the third meaning of the LV logo coat detail appears to us as a *transition*—literally—from the "language" of the twin letters of L and V to a logo coat detail that is a *sign for luxuriousness itself* (Barthes 1977a: 65).

To permit these increasingly digital meanings and logos, products, and spaces to become further entrenched in Louis Vuitton, they must be even more effective and endure for some period within one of the world's leading international luxury fashion houses. Internal and external issues concerning digital luxury services and physical luxury products are going to be joined together in a manner that will oblige the luxury fashion house to reconsider its physical role and its digital structures—from its physical luxury-branded flagship stores and stand-alone boutiques to department stores and lease departments in high-end department stores such as Harrods in London, and, importantly today, through the digital commerce conducted through its website (Rocamora 2016).

The luxury fashion house is wavering between the rising effectiveness and legitimacy of physical and digital luxury structures and brand values and the breaking of old physical and reproduction of numerous new digital structures and values inside the physical luxury fashion house. Luxury fashion houses

such as Louis Vuitton must restructure to meet these strains and conflicts and to meet the ever-shifting needs of extended luxurious visual consumers and new configurations of technological openness that can generate future revenue in the billions of dollars. Growth in company digital complexity, flexibility in operating in more than fifty countries, a capability to read and accommodate extended luxurious visual consumers' wants and demands as extended luxurious visual consumers in several thousand physical luxury-branded flagship and department stores worldwide, intertwining Louis Vuitton and extended luxurious visual consumer worlds driven by luxury labels, re-visioning the heritage of Louis Vuitton (founded in 1854 on Rue des Capucines in Paris) and further commodifying Louis Vuitton digital services, and especially being equipped to remain a profitable global-capitalist luxury retailer and a successful supplier of extended luxurious visual consumer worlds of luggage consumption, luxury Louis Vuitton lifestyles, and designs will be strategic priorities.

Possible company disintegration and degeneration of the "look" of Louis Vuitton; diversity of patterns and the conceivable incommensurability of Louis Vuitton's famous beige and brown motif with other luxury companies' innovative decorations; incoherence between physical stores and social media and incompatibility between cities and luxury shopping malls; "homages," imitations, and counterfeiting of the Louis Vuitton "look"; randomness of future extended luxurious visual consumer pattern preferences; globalization and perhaps the overabundance of the LV logo internationally; zero tolerance for registered trademark infringements and failures within the company's management; prioritization of the extended luxury millennial and postmillennial visual consumer but the maintenance of the company as a global corporation— these are only some of the corporate worries, product disparities, and urban challenges confronting the new digital luxury fashion house. Though unlikely to fail as rapidly or steeply as recent global luxury fashion houses, such as Jaeger or Colette, luxury fashion houses such as Louis Vuitton in France and elsewhere must transform themselves digitally to survive. But the ideal type of the new digital luxury fashion house described here will not be global because it is not founded upon the growing superfluity of the LV logo worldwide or other characteristics found in historical models of the physical luxury fashion house; it will be a continually reflexive digital company, anticipating and reacting to new and old extended luxurious visual consumers, openness to new patents, graphic symbols, visual structures, and representations beyond the quatrefoils and flowers of the LV logo, which, when originally used in 1896, were based on the Victorian trend of using Japanese *mon* designs. A global digital luxury

fashion house structure is unlikely to arise from the restructuring process and its visual representations explained above; diversity of counterfeiting and contrast of countries, cities, and luxury goods and services are liable to rule. Again, as with contemporary luxury culture, I see the new digital luxury fashion house such as Louis Vuitton as containing traditional and contemporary features.

To help establish my argument, I will employ the model of openness to technological innovation taken from the analysis in the previous section concerning internal changes and challenges to physical luxury fashion houses such as Louis Vuitton. In this, the physical luxury fashion house technologically innovates for its extended luxurious visual consumers and for its own organization. On the extended luxurious visual consumer side, the purchase of travel goods in Louis Vuitton flagship and department stores, for example, must feature wider customer openness globally and temporally, and, on the organizational side, digital openness within and between stores worldwide develops even further. Moreover, the retailing of Louis Vuitton's Keepall, Noé, and Speedy bags, for instance, and which are believed by the physical luxury fashion house to be one of its chief *raisons d'être*, will be joined by an acceptance of the incorporation of new technologically enhanced materials rather than merely leather into most of its products, together with tendencies to broaden its lines beyond small purses, wallets, and luggage.

How will the new organization and extended luxurious visual consumer characteristics develop in the future? First, *organization*. The new digital luxury fashion house can now be described as having to innovate regarding organizational and extended luxurious visual consumer demands for openness digitally and physically.

(1) Organizational openness is liable to continue governed by the pro-logo requirements of the luxury shopping malls of global capitalism, and in this sense the new digital luxury fashion house will remain structured by the physical luxury fashion house purchase of luxury purses, shopping for bags, cruising for wallets, and the Louis Vuitton Papillion cylindrical bags that generate millions of dollars in annual revenues.

(2) The new digital luxury fashion house, confronted with the new internal and external luxury digital economy of websites and physical stores, will give precedence to the need to innovate in all locations and at all levels, and especially regarding the South Asian digital spheres (Belloni 2016).

(3) Innovation concerning extended luxurious visual consumer and organizational openness will arise as the main rationale and role of

the new digital luxury fashion house, with extended luxurious visual consumers as the market for everything from the Louis Vuitton Cup yacht race in the United States to the Epi and Taiga leather lines in South Korea, China, and Russia.

(4) Interpenetration and the continued globalization of luxurious visual representations internal and external to physical luxury-branded flagship and department stores will necessitate that neither withdrawal from nor control of the worldwide luxury market is possible for one luxury brand.

(5) Faced with the reality of a more multifaceted, varied, digital luxury economy that now regularly includes social media conscious writers, artists, and filmmakers, the new digital luxury fashion house will play an even more difficult role than earlier, being ready to introduce or withdraw, for instance, prêt-à-porter lines of clothing, de-or re-commission LV scrapbooks or the Louis Vuitton City Guide series.

(6) The new digital luxury fashion house will arise as a twenty-first-century decentralized business venture as its digital luster rather than its physical luster spreads globally from the Middle East (Dubai) to Africa (Nigeria) and South America (Brazil).

(7) To accommodate this role, the new digital luxury fashion house must provide the aesthetic structure to support the new and globally informed wider level artistic patterning of luxury goods—such as the Jeff Koons Louis Vuitton luxury bags discussed in Chapter 4—to be sold in the physical and the digital spheres.

(8) Physical distance from extended luxurious visual consumers will become an even more appealing option to new digital luxury fashion houses as they cope with growing overload difficulties, and particularly the demands of ever more extended luxurious and voluptuous visual consumers hoping to secure a place on a Louis Vuitton VIP client list.

Second, *extended luxurious visual consumers*. One likely characteristic of luxurious future visual culture and luxury lifestyles beyond Louis Vuitton bejeweled charm bracelets and so on will be the further growth of the extended luxurious visual consumer.

(1) The new extended luxurious visual consumer of the new digital luxury fashion house will demand that the new digital luxury fashion house provide ever more retail environments appropriate for the continuous purchase and pleasing visual consumption of everything from watches to handbags. The most marked characteristic will be that extended

luxurious visual consumers will focus their interests on the openness of extended luxury customer matters sooner than on, say, the contemporary architectural concerns of the structure of physical luxury fashion house buildings, such as the Louis Vuitton flagship store discussed above in Singapore's Marina Bay.

(2) The new extended luxurious visual consumers will focus their concerns on several luxury brand levels and demand trouble-free digital transmission and communications between them—from Christmas window scenography on a mobile phone to artistic collaborations on Facebook. The luxurious body, multicolored on a YouTube channel, WeChats about bags, LV logos on Instagram, Tumblr blogs in lavish white, black, and gold, entire Twitter accounts smitten by artists creating new magnificent accessories, Snapchat users trading Japanese artist Takashi Murakami smiling cartoon faces, the lush Pinterest world of pinks, yellow, and fresh cut flowers—these luxurious visual representations become of more marked importance to the extended luxurious visual consumer.

(3) The new extended luxurious visual consumer will provide the patterns and the forms that the new digital luxury fashion house must adopt—and most likely in a limited number of pieces. In the old physical luxury fashion houses of the 1990s, the luxury production battle was about which runs of luxury bags had the luster most apt to permit further consumption without too many hazards. The development of digital luxury services and especially those areas focused on luxurious experiences (e.g., tickets to attend the Louis Vuitton Cup yacht race) at the expense of physical luxury goods signifies the real diffusion of this shift in European, North American, and Asian luxury economies (Husband and Chadha 2015).

(4) The new digital luxury fashion house must then provide the conditions for luxurious lifestyle gratifications for numerous varied and increasingly individualized extended luxurious visual consumers. Of greatest significance is that the new digital luxury fashion house acknowledges that different extended luxurious visual consumers not only have different degrees of openness beyond the physical luxury-branded flagship and department store but that different extended luxurious visual consumers also have different global city locations. Therefore, the new digital luxury fashion house must put additional efforts into ensuring that extended luxurious visual consumers without physical luxury-branded flagship and department stores are given the same global options as extended luxurious visual consumers in New York City or Johannesburg with physical

luxury-branded flagship and department stores in terms of capital spend on digital and cultural investment in web design and the deployment of local stars and celebrities.

(5) Digital interpenetration and the appearance of ever more luxury goods and services will ensure that the new digital luxury fashion house is further pulled into the digital markets for everything from art and jewelry to tinted lenses.

(6) As extended luxurious visual consumers' desires for Louis Vuitton Damier Graphite canvas bags, need for new patterns and color combinations, and largely urban interests are so unstable and precarious concerning look and feel, the new digital luxury fashion house must become even more receptive to shifts in, for example, celebrity status.

(7) In the developing extended luxurious visual consumer and luxury lifestyle fashion and style sphere, the invention and manifestation of difference—in design, in tailoring, in art—is supreme, compelling the disintegration of old and the invention of new differences, which will be more incomplete or disconnected in terms of corporate digital aesthetic direction, momentary in digital product lines, and fluctuating concerning digital advertising, tougher to interpret and to react to. New digital luxury fashion house directors will occupy a luxurious but extremely competitive digital market where digital advertising for luxury resorts (e.g., Ferrari World, Abu Dhabi) rather than merely other digital luxury fashion houses are brand competitors, and they will need to react like luxury brand entrepreneurs. The new digital luxury fashion house will then need to further marketize its brand and its fashion services to survive (counterfeiting, among other things) and to thus further modify its digital signifiers, such as the LV logo, as status symbols and further commodify its global signature, while its products and services will refresh themselves employing the digital and visual language of de-commodified "creativity" and "authenticity," "communication," and "collaboration" (Kastner 2013).

(8) To date, much of physical luxury fashion house custom has been focused on signifiers such as the LV logo and typically within the context of, for instance, Louis Vuitton products widely sold in its own and others' physical department stores (e.g., Neiman Marcus and Saks Fifth Avenue New York). This arrangement, and with it the emergent *hybrid* (physical *and* digital) luxury fashion house, will continue to encounter pressures and restructurings, such as Amazon.com's increasing desire to retail Louis Vuitton products, which are today primarily available only at authentic

Louis Vuitton boutiques, with a small number of exceptions. If the luster of
the LV logo is to survive, it must reorganize along several lines to meet the
needs of the new extended luxurious visual consumer and the new luxury
economy—wherein Louis Vuitton boutiques within physical department
stores continue to operate independently from the department store and
continue to have their own Louis Vuitton managers and employees—but
without overlooking those who primarily inhabit the role of digitally
extended luxurious visual consumer: the millennials and postmillennials,
for example, who prefer *online only* authorized Louis Vuitton website
channels to purchase their products and services. Difficulties such as
Louis Vuitton's attempt to have the "LV.com" domain name compulsorily
transferred to the new digital luxury fashion house from its American
proprietor, that action's failure in 2006, and the domain being subsequently
acquired by "LV=" (an English friendly society and insurance company),
are now crosscut with those introduced by the more personal agendas
of extended luxurious visual consumer desires for product and wants
concerning handmade trunks featuring contemporary fashion design,
creative craftsmanship, individualized patterns, and the luster of having
only one private key for all of one's luggage. If it cannot react by learning
from, collaborating, and competing with the luster of other luxury logos,
the LV logo will become increasingly irrelevant, or perhaps be outshone by
new competitor digital luxury fashion houses such as Hermès. Hybridity
will therefore be a lot more complex than the wooden frames of a Louis
Vuitton trunk.

(9) In these processes, extended luxurious visual consumer relationships and
extended luxurious visual consumer culture will increasingly open up the
previously closed physical luxury fashion house and become a sphere for
new configurations of luxury founded not only on physical things such as
Louis Vuitton suitcases, iconic bags, brown Damier and monogram canvas
materials, both of which were originally introduced in the nineteenth
century, but also on the digitization of the company's products and services
inclusive of the eponymous LV logo.

Difficult relationships between extended luxurious visual consumers and the
new digital luxury fashion houses' organization, and the need to uphold and
improve company organization, market, and product legitimacy, will continue
but in different configurations. Problems at the level of the luxury-branded
flagship or department store, location, controls over product quality and pricing

may continue to be prevented but never be fully surmounted, and then only if the new digital luxury fashion house can allow individualized extended luxurious visual consumers to fulfill their goals to purchase luxury products and to act in their accomplishment through its distribution channels and, crucially today, the new digital luxury fashion houses' own website such as Louis Vuitton. com. The new digital luxury fashion house must ensure the "right" mixture of organization and, more and more, advertising and other visual consumption outcomes in cultural, luxurious, and economic yet cultivated terms; it must, and against the counsel of Kapferer and Bastien (2012: 77) to "Keep stars out of your advertising," generate the "right" celebrity rich environment if it is to maintain visual and cultural legitimacy—using famous models, musicians, and actors as it already has, such as Gisele Bündchen, Madonna, and Angelina Jolie. The new digital luxury fashion house will have little place or time for being narrow-minded or inactive and must come to terms with the need to be open to innovation through technological means.

Characteristics of the new digital luxury fashion house

We may now conclude through a comparison of the new digital luxury fashion house and the old physical luxury fashion house of bricks-and-mortar luxury-branded flagship and department stores using the descriptions above. This comparison will help us to appreciate contemporary luxurious visual representations and to pinpoint the important shifts underway at Louis Vuitton and at other luxury fashion houses.

In short, the new digital luxury fashion house will increasingly come to "share" luxurious visual representations with other new digital luxury authorities and social influencers on social media, such as Chiara Ferragni (and there are many others), who affect extended luxury customers through their selective promotions. It will, then, "share" luxury new and social media, websites, apps, users, extravagant representations, and social networking with others. Contemporary digital changes in luxury culture are the chief mediums and structures for transmitting the extended luxurious visual consumer, her fashionable lifestyle, and interpenetrated public reactions and private luxurious values to the new digital luxury fashion house and the suitable mediums for the new digital luxury fashion house to engage itself with in the new corporate luxury system. Rich visual representations and the new digital luxury fashion house will present new brilliant spaces for private and public practices. The

new digital luxury fashion house is necessitated by the new luxury system and acts as a spur to the operation and accelerated dematerialization caused by new pictorial values, luxurious attitudes, and individualized inclinations. Luxury is moving out of visual spheres previously understood as fixed in time, such as Louis Vuitton's graphic symbolization of quatrefoils, flowers, and the LV logo, and moving into others, such as new digital visual structures and representational configurations, meaning that the logic and legitimacy of the marketized corporate structure is now integral to luxury and visual culture. Yet, such corporate structures are also more and more obliged to "share" public digital spaces with new groupings, such as social influencers, not all of whom are paid by luxury corporations or will refrain from disapproving of certain corporate visual and cultural values.

Distinct from Thomas's explanation of profit and market share seeking luxury corporations giving rise to the new deluxe fashion house that has lost its luster, my own interpretation in this chapter has concentrated upon the issue of the new "reluxed" digital fashion house that is presently transforming the entire idea of luster, along with its extended luxurious visual consumers and their marketized, if fashionable, luxury lifestyles. With the analog customer being substituted by the digital customer, the old corporate luxury and its visual culture will progressively become outdated. Old loyalties to physical luster and notions such as the unique will disappear and new ones will develop. Old issues will disappear, and new ones concentrated on digitized conceptions of sheen will appear, producing new physical opportunities besides digital restraints and the inevitable glitches with the production, distribution, and consumption of luxury fashion houses' goods and services. The new digital luxury fashion house and its administration must adapt to and legitimate the newly digitized spiritual values of extended luxurious visual consumers. It will then have to negotiate adjustments associated with its own luster and with its own heritage on a digital *and* physical basis, acquiring the capability for a truly *hybrid* luxury.

Conclusion

Throughout this book I have concentrated on one significant question: *what appears as luxury in contemporary visual culture?* But, as we have seen, the concept of luxury within this context cannot be taken up, let alone analyzed, without initially understanding what we mean by the idea of contemporary visual culture and by notions of contemporary fashion and art, photography, cinema, television, and social media. It was for this reason that I began in Chapter 1 with an overview and definition of what contemporary visual culture is or could be for a variety of visual culture theorists.

I suggested that contemporary visual culture must be understood in relation to art history and in relation to art in the present period with all that that implies concerning the rise of the increasingly interrelated socially mediated forces of luxury fashion, the activities of contemporary artists in relation to luxury brands, luxurious photographic systems, and the relationships between luxury and cinema and luxury and television. Accordingly, the new knowledge of luxury and original analyses of visual culture contained in *Luxury and Visual Culture* contribute to a wider discourse of pictorial representation through their exploration of the visual sphere of luxury and their performance of visual and cultural research. I examined the relationship between what we know and think about luxury and how we can express that relationship through the lens of visual culture.

It was for this reason that I began not with an analysis of luxury but with an analysis of contemporary visual culture. For this book has not presented an examination of luxury but an engagement with the relationship between twentieth-century and contemporary conceptions of luxury and visual culture. But there has also been the question of the relation between what these concepts represent. One of the original contributions of *Luxury and Visual Culture*, therefore, is its consideration of the relation *between* luxury and visual culture.

Commencing with an investigation of the discourses of contemporary visual culture allowed me to present the reader with my chosen perspective on the

discourses. In Chapter 1, I defined two categories regarding contemporary visual culture: radicals and moderates. The former constructs the world of art history as unavoidably moving toward its final downfall. Radicals support withdrawal from art history and deconstruction of the rules of art and history. Moderates like myself, I argued, accept contemporary and visual cultures, their discursive behaviors, practices, institutions, and processes, including old as well as newly contemporaneous visual forms. Moderate visual culture theorists consider the whole range of extant visual and cultural subjects and not just a narrow range of aspirant radical alternatives. Radical visual culture theorists might argue that, as there is no "correct" method for researching art history, we must assume a deconstructive method, while moderate visual culture theorists argue that we must assume a reconstructive method, the idea that numerous art historical and contemporary methodologies need to be mixed together to deliver the best method for researching contemporary questions. We should welcome this— together with honesty and reflexivity—and refuse all demands that research and researchers bow to any one research strategy. This adds up to more than a discursive approach to contemporary visual forms. I argue that reconstruction better encapsulates the moderate visual culture theorists' approach to visual and cultural methodology.

Probing the discourses of contemporary visual culture and offering the reader my preferred reconstructed standpoint on the discourses was a precondition to the move in Chapter 2 to the exploration of luxury in contemporary visual culture. But, as I established, luxury and the ways people use it cannot be understood without placing it within larger contexts and everyday practices, behaviors, and circumstances. For, as we have ascertained throughout *Luxury and Visual Culture*, while luxury does consist of a particular domain—the abundant—with its own logic, it is also linked to, in our case, the domains of fashion and art, photography, cinema, television, and social media. Equally, such luxurious realms not only form the contexts of the conception of contemporary visual culture used in this book but, as we also observed, perform specific roles for people in everyday life, which I understood through placing, contextualizing, and considering them through people's actions, reactions, and luxurious choices in the configuration that is their everyday life.

It was for these reasons that, prior to the chapters on luxury and art, luxury and photography, luxury and cinema, luxury and television, and luxury and social media, it was important to present and summarize the broad methodological approach adopted in *Luxury and Visual Culture* toward contemporary visual

culture. Consequently, in Chapter 2, I appraised the chief visual representations in contemporary visual culture and introduced a second original contribution to contemporary visual culture studies: the idea of cultured people neither as simply viewers nor as spectators but as *visual consumers*, as cultured people who scrutinize contemporary visual representations such as advertising billboards as a concerned viewer or spectator *and* as a likely or sure consumer. Such cultured people, I argued, engage with what might be called the "dual character" of the visual representations under discussion in this book as part of their everyday lives. They comprehend the context within which the contemporary visual culture of luxury functions, how contemporary visual culture and luxury are intertwined with their own everyday life practices, and they regularly contemplate the traditional frontiers between the luxurious and the necessary. Given such understandings, it was necessary to explain in Chapter 2 that concepts such as cultural studies and visual representations were and are not so much inadequate but inadequate insofar as the aims of *Luxury and Visual Culture* are concerned. For much of the literature on cultural studies does not incorporate the visual and much of the literature on visual representations does not incorporate luxury or luxury brands. Thus, I adopted a contemporary visual culture studies approach in this book. But I also felt it was essential to pioneer a third original contribution to contemporary visual culture studies, which I call *luxury-branded visual representations*. And I did so because, while there are discussions of advertising within contemporary visual culture studies, there are virtually no discussions of luxury, luxury brands, or luxury-branded visual representations. It is as if luxurious and luxury-branded visual representations do not exist when, in fact, as I have been arguing throughout *Luxury and Visual Culture*, they not only do exist but are, I have suggested, becoming ever more important as middle-class incomes in particular continue to rise in countries as different as the United Kingdom and the United States, Nigeria, China, Dubai, Russia, and Indonesia (Deloitte 2017). Naturally, if there are almost no discussions of luxury or luxury-branded visual representations within contemporary visual culture studies, it is hardly surprising that there are no discussions either of the fourth original contribution to contemporary visual culture studies contained within *Luxury and Visual Culture*: the concept of *luxurious photographic, cinematic, and televisual selves*. For me, these selves are not to be dismissed as mere advertising imagery and written textual copy produced by luxury brands and designed to sell luxury-branded goods and services. They are visual representations of *luxurious* selves. Furthermore, while certain luxurious photographs are branded, not all luxurious visual representations of selves are. Besides, as I established in the many

examples of luxurious cinematic and televisual selves in Chapters 6 and 7, such visual-cultural representations exist and (often inadvertently) raise profound issues concerning, for example, shifts in income distribution around the globe (Piketty 2014), as well as what it does and might mean to be a luxurious self in an unstable world where the answer to the question "who am I?" is forever deferred.

The role of luxury fashion in contemporary visual culture was investigated in Chapter 3 along with a deeper consideration of the idea of the visual consumer. However, the majority of Chapter 3 took its stimulus from the work of Barthes on the contemporary visual culture of luxury fashion. Drawing on Barthes's visual and cultural criticism, inclusive of his conception of semiotics, the chapter surveyed his theoretical studies of visual representations and signs, language, meaning, and communication. Barthes's writings on visual representations, everyday life, and popular cultural narrative structures did not so much provide the methodological basis as the methodological inspiration of *Luxury and Visual Culture*. This was for two reasons. First, his work on luxury fashion covers an enormous variety of visual topics and representational subjects from visual consumption and visual codes to the nature of reading and the constitution and configuration of visual texts. Moreover, his writings throw down the gauntlet to us as visual consumers to reassess the countless myths of luxury fashion. For Barthes, luxurious contemporary visual culture and spectacular luxury fashion are not just types of ideology but an entire sociocultural order whose visual representations, conceptions, and discourses of pleasure, often manifested as luxury-branded visual representations, will eventually appropriate the written word. Second, any fair appraisal of Barthes's theory and its legacy concerning his influence on contemporary research on luxury fashion must acknowledge that, while his work includes a vast assortment of visual questions and representational ideas, it remains problematic because, despite the high structuralism (and near unreadability) of his over-organized *The Fashion System* (Barthes 1983), it is unsystematic overall (Calvet 1994: 264–67). Barthes's theoretical gifts and advances fall within the arena of a literary attitude to visual codes, to reading, and to the constitution and configuration of visual texts. His writings thus contribute enormously to the semiotics of visual consumption, to the textual study of myth, to the visual language of luxury, and to the sociocultural interpretation of fashion. However, his main contribution was not to a systematic theory of luxury but to a particular way of seeing contemporary visual culture: for Barthes's is an *instinctive* and perceptive attitude to the display of luxury fashion. Yet, on the optimistic side, it was this attitude that taught me and lots of other readers of

Barthes to consider the ideology and sociocultural order of representations as *signs*: Barthes made me conscious that many of my previous conceptions were not so much wrongheaded discourses as discourses that needed to be turned into questions concerning, for instance, the meaning of pleasure. By focusing on luxury-branded representations, I have not sought to dispute Barthes's explanations of the fate of the written word as offer an important *supplement* to his work that involves the elucidation of luxury-branded discourses with a view to altering the way we see these visual representations. Like Barthes, I have tried to show the reader what a visual culture discloses about itself through the signs of luxury it creates.

Some of the things that a visual culture discloses about itself through the signs of luxury it creates I discussed in Chapter 4, which centered on the relationship between luxury and contemporary art. Considering the role of luxury-branded visual representations produced by contemporary artists, such as Jeff Koons, that chapter analyzed contemporary visual culture's signs and the production of art for luxury brands in everyday life besides querying Zaniol's assertion (2016) that luxury-branded contemporary art is misrepresenting and deforming the contemporary art world.

In Chapter 5, by contrast, I looked at the relationship between twentieth-century and contemporary luxury and photography and to the luxurious photographic selves produced by, for instance, Richard Avedon and Tim Walker. Focusing on a fifth original contribution to contemporary visual culture studies, on visual representations of *voluptuousness* in contemporary luxury fashion photography, Chapter 5 concluded with a comparative discussion of Barthes's (1972a: 56–57) "The Face of Garbo" and the contemporary face of Teddy Quinlivan, the American transgendered supermodel.

Chapter 6 discussed twentieth-century and contemporary luxury and cinema and the luxurious cinematic selves found in, for example, *The Blue Bird* and *Blue Jasmine*. Considering questions of lavish choice, that chapter concentrated on the fragmentation of meaning and the transformation of luxury lifestyles in contemporary cinematic cultures. Importantly, it was also when debating coping and not coping with lavish choice, the field of luxury lifestyles, and the role of voluptuousness in contemporary cinematic cultures that, of necessity, I deviated from the work of Barthes on visual culture and introduced the writings of Pierre Bourdieu (1984) on social space and Michel de Certeau (2009) on strategies and tactics. Such a deviation was necessary not to elaborate Bourdieu's conception of cultural capital accumulation but to expound his idea of social space, a concept that I found useful to apply when considering the

luxurious cinematic selves on display in films such as *Spring Breakers* and *The Bling Ring*. Similarly, de Certeau's persuasive distinction between strategies and tactics proved valuable when, for instance, deliberating those luxurious cinematic selves with power over their own lives, such as *Pain & Gain*'s Victor Kershaw, who uses strategies and plans, and those luxurious cinematic selves with no power over their own lives, and who cannot use or make their, often misguided, tactical efforts at "strategies" function, such as *Pain & Gain*'s Danny Lugo. Deviating from the work of Barthes signaled less a critique of his conception of visual culture on my part and more of an attempt to supplement it. Indeed, both Bourdieu (1984: 69) and de Certeau (2009: xxi) acknowledge the importance of Barthes's writings to their own work. In the same way, it would be false to imply that Barthes had little interest in the social, given that his essay on the structural anthropology of Claude Lévi-Strauss, for example, contained in Barthes's *The Semiotic Challenge*, is entitled "Sociology and Socio-Logic" (Barthes 1988: 160–72; see also, for example, Barthes, Stafford, and Carter 2006: 3–19, 31–34). Nevertheless, although Barthes is concerned with society and particularly with its structuring of reality, his own structural analyses were less concerned with Bourdieu's and de Certeau's questions of social space and strategies, tactics, and cultural capital accumulation than with issues of social mediation and systems of signification. Issues concerning social space and strategies, tactics, and cultural capital accumulation are not wholly absent from Barthes's writings but, unlike his ideas about, for instance, narrative and signification, they remain underdeveloped and under-applied. In any consideration of luxurious cinematic selves, therefore, I argue that it is important to take into account their narratives and their representations of the world of luxury, their meanings, and their systems, but also the meanings they attach to their strategies and tactics, to their understanding of systems of power, and to their lives seemingly without coherent narratives. While Barthes is thus correct to stress that the meaning of all narratives is mediated, it is also correct to stress that a full understanding of mediation must also entail grappling with the meanings of strategies and plans, of narratives of power, of biography, of struggle, and, crucially, of widespread social confusion.

Questions of extravagant choice and the transformation of the relationships between luxury, twentieth-century and contemporary television culture figured prominently in Chapter 7. Thinking through what I termed luxurious televisual values, that chapter examined how various luxurious televisual selves position themselves toward what they consider the better and withdraw from what they consider the worse. Functioning within the context of the unavoidable

necessity of the constant reevaluation of meaning, I argued that the luxurious televisual selves of *Stoney Burke*, for example, not only *experience* a variety of dubious values (immorality, racketeering, depravity, etc.) but also increasingly *employ* them in their everyday lives. Additionally, these luxurious televisual selves do so to such a degree that their suspect values can only be understood as a function of what is this book's sixth original contribution to contemporary visual culture studies, which, necessarily deviating from Barthes's analyses once more, and with the help of Kant (2002, 2015), I described as luxurious televisual selves' mental *inclinations*. Shunning conventional concepts of morality and duty, contemporary luxurious televisual selves in *The Sopranos*, *Suits*, and *Billions*, for instance, increasingly ground themselves in the world of *sensual behavior*. Their inclinations toward ever newer pleasures and riches form their subjective experiences and their material wants, their many and varied desires, their subjective cravings, their sometimes-unintelligible aspirations, their imperfect and unfinished status as expressive yet frequently dependent luxurious televisual selves in thrall to the faculty of sensation, all of which means that they are driven by, and only respond to, *need*. Such animal inclinations on show in *Harlots*, for example, do not respond well to the conservative notions of duty and morality portrayed in *The Crown*. Unlike the women in *The Crown*, the women in *Harlots* prefer to draw stimulation from their volatile cross-class environment, from their Nietzschean (2017) "will to power" and from their own actions and others' reactions governed by luxurious goods and services rather than by any law. Hostile to the traditional morality of *The Crown*, the inclinations of the luxurious televisual selves in *Harlots* function beyond the realms of duty.

Finally, Chapter 8 considered contemporary ideas concerning luxury and social media: what, that chapter asked, is happening to physical luxury, to luxury-branded flagship and department stores, and how might their relationships with digital luxury, with Facebook and YouTube, WhatsApp, WeChat, Instagram, Twitter, Snapchat, and Pinterest, be defined and understood? Chapter 8 also offered a discussion of the luster, of the reflected light and sheen, of what I called "the physical luxury fashion house"—from the Fondation Louis Vuitton in Paris to Louis Vuitton stores in Singapore. The reason for combining an exploration of luster with an account of Louis Vuitton and social influencers, such as Chiara Ferragni, is related to *Luxury and Visual Culture*'s seventh original contribution to contemporary visual culture studies, which is characterized by the drives and subjective inclinations of what I called *extended luxury visual consumers*. For, although, in many respects, such subjects retain separate—and sometimes

antagonistic—lustrous identities and luxury-branded affiliations, they are nevertheless increasingly *symbiotic*. For instance, to explain contemporary social influencers without reference to the extended luxurious lifeworlds of today's visual consumers or to discuss the impact of social media without reference to the new and now near-seamless offline-online life and luxury visual consumer experience of self is to intentionally or otherwise misrepresent the socioculturally extended and luxurious, visual, consumer, mediated, and experiential context within which these developments are being played out. Moreover, in the case study of Louis Vuitton presented in Chapter 8, both the physical luxury fashion house and what I called "the new digital luxury fashion house" share the well-known label that is the LV logo. These interdependencies, I argued, underline the extent to which, even in the digital product space, the LV logo plays a crucial role as a signifier for extended luxury visual consumers. Lastly, these interdependencies were made even more resonant because many of them arise from Barthes's (1977a: 52–68) insights into visual representations: insights that I associated with various levels of meaning within the LV logo that did not so much "explain" it as identify it as one of *the* signs of contemporary luxuriousness.

Yet, as I stated in the Introduction to this book, I have made a *theoretical* and an *experiential* argument supporting the use of the concept of contemporary visual culture. In fact, I have argued that contemporary advanced cultures can be studied as contemporary *visual* cultures, as cultures wherein art and history are not so much usurped as joined by an ever-growing number of visible, identifiable, signs and their qualities or effects. These cultures are, as I have shown throughout *Luxury and Visual Culture*, and to a large degree, increasingly affected by a growing assortment of new signs, of luxury-branded visual representations that, I have sought to emphasize, can only be considered and explicated as *forces*. Signs have thus been considered as forces, and by signs as forces I have been referring to visual phenomena, cultural things, contemporary organisms, luxurious forms of consciousness, and the spirit of luxury brands, or, in other words, luxury-branded visual representations as indications of various aesthetic drives, photographic dynamisms, cinematic and televisual passions. The varied luxury-branded visual representations produced by contemporary artists and the production of more and more luxurious photographic, cinematic, and televisual selves, as I have demonstrated, are therefore to be appreciated less in terms of the necessary, the unchanging, and the eternal philosophy of being and more in terms of the changing philosophy of becoming, representations and selves that, while increasingly noteworthy, are constantly changing, along

with the processes and flux of contemporary capitalist cultures. In *Luxury and Visual Culture*, I have thus explored the contradictions of becoming increasingly complex and the logics of luxuriousness, branded sensations, visual moments in which representations and selves occasionally become greater than they were and occasionally lesser than they were or will become. Suggesting any new definition of luxury and its visual cultures consequently entails thinking becoming and a readiness to enter new representational and subjective zones that are unclear, that exist *between* luxury and its visual culture, and exceed their superficially "natural" separation into the luxurious, the visual, and the cultural. Engrossed in a becoming that is profounder than the luxurious and loftier than any lived experience of the visual, this is a cultural zone that is shadowy and often *obstructs* becoming (we think of the perpetually thwarted Danny Lugo in *Pain & Gain*) yet often also discharges a whole sequence of multilayered effects wherein becoming communicates itself in contemporary scenes of disordered complexity (we think of the disordered complexity of the life of "Alien" in *Spring Breakers*). Such luxurious selves accordingly explore cultural zones of disequilibrium within the context of habitually unequal yet simultaneously "liberating" sociocultural systems where the importance of "becoming luxurious" (Armitage 2019: 25–46) is overriding.

Nonetheless, and however varied luxurious selves are, the creation of ever more cultural zones of disequilibrium takes place within the context of systems dictated by *jetztzeit*, by Benjamin's (1970: 263) present or now time. What is more, it is here wherein the concept of what Paul Virilio (2011) calls "the futurism of the instant" constantly threatens the concept of history and the idea of the *moment* constantly threatens the idea of the time of the "*longue durée*," of the time of events that happen almost indiscernibly over a long period of time, only gradually altering the relationships between people and the world (Lee 2013). Yet we do not have to engage with high-level German philosophy or with the complex concepts of critical theory to be able to translate *jetztzeit* into experiential everyday meaning. Think, for example, of the latest "philosophy" of the luxury fashion brand Burberry: "see now, buy now." This is a *visual* (*see* now) form of immediate *consumption* (*buy* now) that, under the sign of "modernization" (with frequent collections rather than just two a year), introduces now time into the visual culture of luxury fashion in a way that Barthes would surely question. With progressively less time to linger over the signs that are luxury-branded visual representations, we are left to wonder what will become of cultural and narrative structures and the language of luxury fashion in years to come. What are the benefits of "see now, buy now" for luxury

fashion labels such as Burberry? One thing is certain: without an ability to identify the codes of luxury fashion within contemporary capitalist cultures, even young, mobile phone brandishing extended luxurious visual consumers will struggle to read, let alone configure, the luxury-branded visual texts that are today's catwalk shows where clothes are obtainable to buy instantly rather than months later. Complex, luxurious, branded, visually and culturally directed by the philosophy of the instant, voices are lost, meaning is further disjointed, and the written word is further arrogated by the time of contemporary luxury, the experimentation of brands, the visual appeal of luxury goods and novel representations of everything from the sumptuous silk fabric of a Hermès scarf to the hand-stitched handbags of Mulberry.

However, as I argued when discussing luxury and contemporary art, today's emergent philosophy of the instant does not entail a complete severance from yesterday's increasingly obsolescent philosophy of the *longue durée*. The luxury-branded visual representations produced for Louis Vuitton by the contemporary artist Jeff Koons, for example, draw on the "Masters" of modern visual culture such as Vincent Van Gogh. Koons's Louis Vuitton bags printed with Van Gogh's *Wheatfield with Cypresses* (1889), together with other bags printed with the works of, for instance, painters as distinct and historically distant as Leonardo da Vinci, Peter Paul Rubens, and Jean-Honoré Fragonard thus *employ* art history, traditional, and modern artists to produce contemporary bags with luxurious golden, if logo laden, visual and cultural physiognomies. Yet, simultaneously, the variety of luxury-branded visual representations, the speed at which they are being produced, and the quantity of them, I have suggested, is now contributing to the structure of our everyday lives in ways that are historically unprecedented. Also, many of these luxury-branded visual representations are not produced by world-renowned contemporary artists, such as Koons, but produced by visual consumers themselves accepting and employing the technological forces of social media and, in particular, YouTube. In addition, it is here that I deviated somewhat from the concept of modern visual culture and the idea of cultural studies. For, if we take a phenomenon I described as the "semiotics of the bedroom," of (unauthorized) luxury-branded visual representations of "unboxing" "reveals" produced by visual consumers on YouTube as an example, we are contending with a contemporary rather than a modern aspect of visual culture. Yet, such a phenomenon is currently beyond the purview of many adherents of cultural studies. This, I think, is because some visual consumers have effectively become amateur video or performance artists of luxury goods, such as Chanel purses. But it is precisely for this and other reasons that, for me at

least, this form of unboxing and revelation is best discussed under the banner of contemporary visual culture studies. Moreover, the technological forces of social media propelling the production of luxury-branded visual representations *on* YouTube by contemporary visual consumers are not simply an influence upon everyday life; for some visual consumers, they *are* everyday life. And it is up to any future contemporary visual culture studies to account for the new ways in which visually literate amateurs and cultures of video, technologically driven performance art, and the forces of visual consumption develop their diverse roles and their contemporary public and private objectives in their respective aesthetic worlds.

But, in arguing that the techno-structural transformations wrought by social media such as YouTube are creating progressively immaterial cultural circumstances for new forms of visual production and consumption, everyday life, and art, I did not want to lose sight of other new ways of proceeding and new kinds of consciousness in contemporary visual culture. Twentieth-century and contemporary luxurious photographic selves, I have argued, are increasingly voluptuous selves and are emerging as the increasingly dominant *form* in contemporary luxury fashion photography, as I discussed when considering Miles Aldridge's and Tim Walker's representations of lifestyles satiated by the senses alone through refined and extravagant conduct. Seemingly devoted to the infinite task of reinventing their bodies and their general awareness consistent with the new luxurious cultural forces in their photographic environments, voluptuous selves are ostensibly driven by and self-assured about their ability to act voluptuously for themselves and for the benefit of visual consumers, to navigate contemporary forms of luxury, and to resolve their own difficulties within the context of the landscape of desire that is contemporary luxury fashion photography. Voluptuous selves conform less to Barthes's (1972a: 56–57) feminine face of Garbo and more to Teddy Quinlivan's transgendered face of the supermodel.

Then again, in extreme forms of luxury lifestyle in contemporary cinema, such as those represented in *Spring Breakers*, luxurious faces like that of "Alien" threaten (through intimidation or acts of violence) the like ability of other luxurious individuals and groups to even *raise* their own questions let alone create their own solutions to the problems of lavish choice. Whether the further fragmentation of meaning and transformation of luxury lifestyles in contemporary cinematic cultures will be realized is a question for future researchers. What *is* evident in the present period, though, is that the ability to cope or not cope with lavish choice is obvious in movies such as *The Bling*

Ring and has already multiplied as an important theme among groups and individual luxurious cinematic selves, such as those in *Pain & Gain* and *A Five Star Life*, who, I have argued, increasingly constitute a field of luxury lifestyles in contemporary cinematic cultures. Still, we do not have to consider luxurious lifestyles in contemporary cinematic cultures for very long before, as I discussed in relation to *Farewell, My Queen*, multilayered interactions between disoriented individuals and groups, such as Marie Antoinette and her courtiers at Versailles on the eve of the French Revolution, withdraw into the delirium of voluptuousness in the face of rapidly changing and overwhelming politico-structural forces. By the same token, in *Blue Jasmine* and *Madame Bovary*, Jasmine Francis and Emma Bovary gravitate into ever more confused and elated contemporary and historical cinematic cultural lifeworlds where their visions of themselves as representatives of the voluptuous conception of human agency run into the reality of their new everyday lives changed forever by the fast-moving forces of energetic cultural worlds.

Problems of luxurious televisual values continue but are taking new forms as the old luxurious televisual values of *Stoney Burke* and *Dallas*, *Miami Vice*, and *The X-Files* are infused, and new contemporary luxurious televisual inclinations appear. Those luxurious selves situated higher in social space (we think of Harvey Specter in *Suits* and Bobby Axelrod in *Billions*) have advantages over those located lower (we think of Christopher Moltisanti in *The Sopranos*): ownership of economic and cultural capital continues to influence power and luxurious ability. But, in the world of contemporary televisual values, as I argued in the examples of *Harlots* and *Versailles*, even the excluded, the barred, and the rejected *do* have bases and resources for resistance and confrontation, opposition, self-assertion, and voluptuous self-fulfillment. For they are skillful at fashioning new luxury lifestyles, (often cross-class) loyalties, participating in (frequently) same-sex networks with other televisual selves (as prostitutes in *Harlots* or as kings and courtiers in *Versailles*), thus ceaselessly reconstructing and empowering themselves, although within the continually redefined limits of low (*Harlots*) or high (*Versailles*) social space.

Voluptuous representations of sensual pleasures, in which there are no representations of necessity, no foundational standards or prerequisites, except the seeming belief that every luxurious self should be able to configure their appearance as they desire so long as it is roughly attuned with every other luxurious self doing the same is unfolding across contemporary visual culture in new and innovative ways. The individualization of sumptuous pleasures and representations of indulgent lifestyles are increasing to the point where pleasure

may soon be viewed as a restrictive idea. Yet I have argued that, whereas traditional concepts of luxury are lessening (we think of *The Crown* with its biography of the reign of Queen Elizabeth II, Elizabeth's airless and straitlaced marriage to Philip, Duke of Edinburgh, and Elizabeth's Church of England decreed cancelation of her voluptuous sister Princess Margaret's engagement to Peter Townsend), new conceptions of a personalized voluptuousness are increasing. Voluptuous behavior, I contend, is less routinized and conservative than luxurious behavior. I anticipate more voluptuous values and eccentric varieties and kinds of photographic, cinematic, and televisual activity. Customary luxurious values will continue to weaken within contemporary fashion photography, cinematic, and televisual cultures and in terms of importance and will have to alter permanently to uphold the support and inclinations of contemporary visual consumers.

One of the reasons why conventional luxurious values are deteriorating within contemporary fashion photography, cinematic, and televisual cultures is because of the rise in magnitude of the eighth and final original contribution to contemporary visual culture studies in this book, which is *pleasure dysphoria* or pleasure as a malaise, as discomfort, or as something hard to bear. For what are altering are contemporary visual consumers' inclinations toward what they perceive to be the antiquated norms, habits, and practices of luxury. However, a significant issue is that, while old-style luxury is in decay, its loss of power over people's lives and their visual representation as luxurious photographic, cinematic, and televisual selves frequently causes a situation or state marked by feelings of unease and mental distress. It is a condition in which, although visual consumers are progressively willing to take responsibility themselves for their own pleasure-pursuing worlds, when they do so, it leaves them feeling dissatisfied, restless, and suffering, as I argued in the example of *Blue Jasmine*, where Jasmine finds herself in becoming but it is a becoming that is ever more anxious and disgruntled. Jasmine is therefore in the process of becoming *something else* but that something else is appalling, alarming, traumatizing, and unbearable because pleasure has become *jouissance* or bliss as *loss*. Certainly, the dominant characteristic of her once luxurious world is now the visible dispersal of the cultural forces that drove her former assertive self. What Jasmine is experiencing, and for the first time in a very long while, is the difference between luxury and necessity. Jasmine's previous luxurious self has vanished, along with her past luxurious lifestyle, and she must now come to terms with necessity, with low, rather than high, social space. All the while that Jasmine continues to experience low social space as the feeling of being misplaced, disoriented, and confused, however, an experience and a space that is not "hers," Jasmine's

ex-friends continue to live luxurious lives as selves who, unlike her, have no anxieties about the future, secure, shielded, and privileged as they are in their lifeworld of Stoli martinis with a twist of lemon. Material, immaterial, and intellectual resources in the shape of handsome men and gorgeous women with F. Scott Fitzgerald's voices "full of money" (2000: 128) are observed and felt through their oh-so "correct" smooth talk and their readiness to indulge in any amount of "suitable" cultural cosseting, through their exhilarated contemporary sense of the visually luxurious and, of course, through their own refined and well-appointed individualized voluptuousness that always cuts a dash on the streets of Manhattan.

These material, immaterial, and structural changes in everyday life, I have argued, match structural transformations within our historical and contemporary sense of the signifier that is luxury. People and luxurious photographic, cinematic, and televisual selves with voluptuous lifestyles, I have suggested, have always apprehended luxury as a sphere that is unavoidably related to their own personal life. In "Soap-powders and Detergents," for instance, written in the 1950s, Barthes (1972a: 36–38), deliberating Omo detergent, comments that the advertisers declare that it is "foamy," which, Barthes argues, is well-known as a signifier for luxury. For Barthes, therefore, as for me, luxury is not always about some economically remote or impractical thing or a mania for abundance. Rather, it is habitually related to our everyday lives through inexpensive goods as ordinary, dull, and routine as Omo. Needless to say, luxury is concerned with individualized voluptuousness and unconcerned with strict or abstemious perceptions of being. But luxury and its visual culture are also connected to the endless propagation of new values and inclinations and to traditional and contemporary luxurious materials. In some sense, then, "the spirit of luxury" (Armitage and Roberts 2016b), of being luxurious, appears to feel "right" to the great majority of humanity, even if what counts *as* luxury varies enormously around the world, and this is no less true of the contemporary visual consumers and the visual culture of luxurious photographic, cinematic, and televisual selves I have been examining in this book. Luxury's visual consumers and photographic, cinematic, and televisual selves do not so much learn its values as *feel* its energetic components. For the forces of luxury gratify in contemporary visual consumers and their various social media networks that propensity to envisage the physical fabric and material substance of everyday life as something instinctive and lighthearted, carefree, and buoyant, vivacious, spacious, and roomy. However, as I have also argued, contact with the forces of luxury can produce not only new physical and digital luxury products and services from classic Chanel white

jackets and Omo to Louis Vuitton and Hermès websites but also individual and group level transformations in visual culture and beyond, transformations that, while perpetually captivating, are, on occasion, very difficult to deal with.

Finally, in writing *Luxury and Visual Culture*, and in drawing on many diverse sources and numerous varied topics, I have tried to provide a theoretical and experiential narrative that addresses several assorted subjects as an introduction to my attempt to improve the appreciation of luxury and supplement our understanding of its relationship to visual culture. Additionally, and given that this book is meant for scholars and students in critical luxury studies and visual culture, fashion theory, contemporary art, photography, cinema, television, and social media studies, my focus has been centered on the dominant ideas associated with luxury culture and visual representations, signs, lifestyles, values, and the import of, for instance, luster, rather than on an immeasurable number of other possible themes that a book entitled *Luxury and Visual Culture* could have called attention to or concentrated on. As readers will have observed, and as the book's title suggests, the concepts and experiences of luxury and visual culture have been paramount in my analyses of art and photography, cinema, television, and social media and in my explanation of the subtopics at hand. Yet, as I have emphasized throughout this book, and particularly in this Conclusion, I believe that I have made a number of theoretical and experientially specific contributions to the fields of critical luxury studies and visual culture, inclusive of the concepts and experiences of luxury-branded visual representations and luxurious photographic, cinematic, and televisual selves, the idea and experiences of visual consumers, the importance of the notion of voluptuousness, the experience of pleasure dysphoria, the concept of luxurious televisual value inclinations, and the extended luxury visual consumers of the new digital luxury fashion house. Any assessments made of this theoretical and experiential work, together with any appraisals made of its impact, however, are not a matter for this book, for its objective, for its narrative, or even for its author. Rather, such assessments and appraisals are a matter for the book's readers, for other theorists of luxury, for those experienced in visual culture, and for those wishing to make their own impact through different books, different objectives, different narratives, and different authors concerned with luxury and visual culture.

References

Adam, G. (2014), *Big Bucks: The Explosion of the Art Market in the 21st Century*, London: Lund Humphries Publishers.

Aldridge, A. (2009), *The Man with Kaleidoscope Eyes: The Art of Alan Aldridge*, New York: Abrams.

Aldridge, M. (2013), *Miles Aldridge: Other Pictures*, Göttingen: Steidl.

Anderson, B. (2016), *Imagined Communities: Reflections on the Origin and Spread of Nationalism*, London: Verso.

Anderson, C., Dunlop, A., and Smith, P. H., eds. (2014), *The Matter of Art: Materials, Practices, Cultural Logics, c.1250–1750*, Manchester: Manchester University Press.

Ang, I. (1985), *Watching Dallas*, London and New York: Methuen.

Armitage, J. (2012), *Virilio and the Media*, Cambridge: Polity.

Armitage, J. (2018), "Golden Places, Aesthetic Spaces: An Introduction to the Cultural Politics of Luxury," *Cultural Politics*, 14 (1): 51–54.

Armitage, J. (2019), "Becoming Luxurious: On the Rolls Royce Black Badge and Beyond," in J. Roberts and J. Armitage (eds.), *The Third Realm of Luxury: Connecting Real Places and Imaginary Spaces*, London: Bloomsbury, 25–46.

Armitage, J. and Roberts, J. (2014), "Luxury New Media: Euphoria in Unhappiness," *Luxury: History, Culture, Consumption*, 1 (1): 113–32.

Armitage, J. and Roberts, J., eds. (2016a), *Critical Luxury Studies: Art, Design, Media*, Edinburgh: Edinburgh University Press.

Armitage, J. and Roberts, J. (2016b), "The Spirit of Luxury," *Cultural Politics*, 12 (1): 1–22.

Armitage, J., Roberts, J., and Sekhon, Y. (2017), "Luxury Products and Services and the Sustainable Value Chain: Six Management Lessons from Gucci," in M. A. Gardetti (ed.), *Sustainable Management of Luxury*, 259–79, New York: Springer.

Aubenas, S. (2006), *Gustave Le Gray—1820–1884*, Los Angeles: Getty Publishing.

Avedon, R., Squires, C., Aletti, V., Garner, P., and Hartshorn, W. (2009), *Avedon Fashion 1944–2000*, New York: Harry N. Abrams, Inc.

Back, L., Bennett, A., Edles, L. D., Gibson, M., Inglis, D., Jacobs, R., and Woodward, I., eds. (2012), *Cultural Sociology: An Introduction*, Hoboken, NJ: Wiley-Blackwell.

Bailey, D. (2014), *Bailey's Stardust*, London: National Portrait Gallery.

Bal, M. (2003), "Visual Essentialism and the Object of Visual Culture," *Journal of Visual Culture*, 2 (1): 5–32.

Barbe-Gall, F. (2011), *How to Look at a Painting*, London: Frances Lincoln.

Barker, C. (2011), *Cultural Studies: Theory and Practice*, London: Sage.

Barthes, R. (1972a), *Mythologies*, New York: Hill and Wang.

Barthes, R. (1972b), *Critical Essays*, Evanston, IL: Northwestern University Press.

Barthes, R. (1974), *S/Z*, Hoboken, NJ: John Wiley and Sons.

Barthes, R. (1975), *The Pleasure of the Text*, New York: Hill and Wang.

Barthes, R. (1977a), *Image—Music—Text*, London: Fontana.

Barthes, R. (1977b), *Roland Barthes by Roland Barthes*, London: Macmillan.

Barthes, R. (1979), *The Eiffel Tower and Other Mythologies*, New York: Hill and Wang.

Barthes, R. (1980), *New Critical Essays*, New York: Hill and Wang.

Barthes, R. (1981), *Camera Lucida: Reflections on Photography*, New York: Hill and Wang.

Barthes, R. (1982a), *Empire of Signs*, New York: Hill and Wang.

Barthes, R. (1982b), *Barthes: Selected Writings*, ed. Susan Sontag, Oxford: Fontana.

Barthes, R. (1983), *The Fashion System*, New York: Hill and Wang.

Barthes, R. (1984), *Elements of Semiology*, London: Jonathan Cape.

Barthes, R. (1985a), *The Responsibility of Forms: Critical Essays on Music, Art, and Representation*, New York: Hill and Wang.

Barthes, R. (1985b), *The Grain of the Voice: Interviews 1962–1980*, New York: Hill and Wang.

Barthes, R. (1986), *The Rustle of Language*, New York: Hill and Wang.

Barthes, R. (1987), *Criticism and Truth*, London: The Athlone Press.

Barthes, R. (1988), *The Semiotic Challenge*, Oxford: Blackwell.

Barthes, R. (2002), *A Lover's Discourse*, London: Vintage.

Barthes, R., Stafford, A., and Carter, M. (2006), *The Language of Fashion*, London: Bloomsbury.

Baudrillard, J. (1983), *Simulations*, New York: Semiotexte.

Baudrillard, J. (1998), *The Consumer Society: Myths and Structures*, London: Sage.

Bauman, Z. (2000), *The Individualized Society*, Cambridge: Polity.

Baxandall, M. (1988), *Painting and Experience in Fifteenth-Century Italy: A Primer in the Social History of Pictorial Style*, Oxford: Oxford University Press.

Baysinger, T. (2015), "How a Popular Show on USA Has Given Lexus a Big Lift," *Adweek*, August 26. Available at: http://www.adweek.com/brand-marketing/how-popular-show-usa-has-given-lexus-big-lift-166553/.

Beaton, C. and Vickers, H. (2014), *Cecil Beaton: Portraits and Profiles*, London: Frances Lincoln.

Beauloye, F. E. (2016), *Shine: Digital Craftsmanship for Modern Luxury Brands*, Singapore: Florine Eppe Beauloye.

Belloni, A. (2016), "Vigilance, Agility, and Excellent Execution," in *LVMH 2016 Annual Report: Passionate about Creativity*, 15–17, Paris: LVMH.

Belting, H. (1987), *The End of the History of Art?*, Chicago: University of Chicago Press.

Benjamin, W. (1970), "Theses on the Philosophy of History," in H. Arendt (ed.), *Illuminations*, 253–65, New York: Schocken Books.

Berger, J. (2008), *Ways of Seeing*, London: Penguin.

Berry, C. (1994), *The Idea of Luxury: A Conceptual and Historical Investigation*, Cambridge: Cambridge University Press.

Bonham-Carter, C. (2013), *Contemporary Art*, London: Goodman Books.

Bourdieu, P. (1984), *Distinction*, London: Routledge.

Bourdieu, P. (1992), *Language and Symbolic Power*, Cambridge: Polity.

Brettell, A. (1999), *Modern Art, 1851–1929: Capitalism and Representation*, Oxford: Oxford University Press.

Bryson, N. (1985), *Vision and Painting: The Logic of the Gaze*, Basingstoke: Palgrave Macmillan.

Bryson, N., Holly, M. A., and Moxey, K., eds. (1994), *Visual Culture*, Middletown, CT: Wesleyan University Press.

Burger, P. (1984), *Theory of The Avant-Garde*, Minneapolis: University of Minnesota Press.

Calefato, P. (2014), *Luxury: Fashion, Lifestyle and Excess*, London: Bloomsbury.

Calvet, L.-J. (1994), *Roland Barthes: A Biography*, Cambridge: Polity.

Candlin, F. and Guins, R., eds. (2009), *The Object Reader*, London: Routledge.

Cashmore, E. (2014), *Celebrity Culture*, London: Routledge.

Certeau de, M. (2009), *The Practice of Everyday Life*, Los Angeles: University of California Press.

Chaney, D. (1996), *Lifestyles*, London: Routledge.

Chase, D. (2001), *The Sopranos Scriptbook*, London: Channel 4.

Clark, T. J. (1982), *Image of the People: Gustave Courbet and the 1848 Revolution*, London: Thames and Hudson.

Cloutier, D. (2015), *The Vice of Luxury: Economic Excess in a Consumer Age*, Washington, DC: Georgetown University Press.

Cohn, D. (2015), "Un foulard pour Roland Barthes," *Critique*, 11 (822): 880–84.

Comis, G. and Franciolli, M. (2011), *Man Ray*, Milan: Skira Editore.

Crow, D. (2010), *Visible Signs: An Introduction to Semiotics in the Visual Arts*, London: AVA Publishing.

D'Alleva, A. (2005), *Methods and Theories of Art History*, London: Laurence King.

Debord, G. (1967), *Society of the Spectacle*, Detroit: Black and Red.

De Laveleye, E. (2016), "Luxury Is Unjustifiable," with an Introduction by J. Armitage and J. Roberts, *Cultural Politics*, 12 (1): 42–48.

Deloitte (2017), *Global Powers of Luxury Goods: The New Luxury Consumer*. Available at: https://www2.deloitte.com/global/en/pages/consumer-business/articles/gx-cb-global-powers-of-luxury-goods.html [accessed September 6, 2017].

De Ribes, J. and Picardie, J. (2015), *Dior by Avedon*, New York: Rizzoli International Publications.

Dikovitskaya, M. (2006), *Visual Culture: The Study of the Visual after the Cultural Turn*, Cambridge, MA: MIT Press.

Drucker, J. (1999), "Who's Afraid of Visual Culture?" *Art Journal*, 58 (4): 37–47.

Durham, M. G. and Kellner, D. M., eds. (2012), *Media and Cultural Studies: Keyworks*, Hoboken, NJ: John Wiley and Sons.

During, S., ed. (1992), *The Cultural Studies Reader*, London: Routledge.

During, S. (2005), *Cultural Studies, A Critical Introduction*, London: Routledge.

Edwards, S. and Wood, P., eds. (2013), *Art and Visual Culture 1850—2010: Modernity to Globalisation*, London: Tate Publishing.

Elkins, J. (1999), *The Domain of Images*, Ithaca, NY: Cornell University Press.

Evans, J. and Hall, S., eds. (1999), *Visual Culture: The Reader*, Milton Keynes: Open University Press.

Ewing, W. A. and Brandow, T. (2008), *Edward Steichen: In High Fashion: The Condé Nast Years 1923–1937*, London: Thames and Hudson.

Faiers, J. (2016), "Sartorial Connoisseurship, the T-Shirt, and the Interrogation of Luxury," in J. Armitage and J. Roberts (eds.), *Critical Luxury Studies: Art, Design, Media*, 177–98, Edinburgh: Edinburgh University Press.

Featherstone, M. (2007), *Consumer Culture and Postmodernism*, London: Sage.

Featherstone, M. (2016a), "The Object and Art of Luxury Consumption," in J. Armitage and J. Roberts (eds.), *Critical Luxury Studies: Art, Design, Media*, 108–27, Edinburgh: Edinburgh University Press.

Featherstone, M. (2016b), "*Luxus*: A Thanatology of Luxury from Nero to Bataille," *Cultural Politics*, 12 (1): 66–82.

Fernie, J. (1995), *Art History and Its Methods: A Critical Anthology*, London: Phaidon.

Fiske, J. and Hartley, J. (1978), *Reading Television*, London: Routledge.

Fitzgerald, F. Scott (2000), *The Great Gatsby*, London: Penguin.

Flaubert, G. (2003), *Madame Bovary*, London: Penguin.

Foster, H. (2002), *Design and Crime (and Other Diatribes)*, London: Verso.

Foucault, M. (2002), *The Archaeology of Knowledge*, London: Routledge.

Franklin, S. (2016), *The Documentary Impulse*, London: Phaidon Press.

Fry, R. (2017), *Vision and Design*, London: CreateSpace Independent Publishing Platform.

Fuchs, C. (2017), *Social Media: A Critical Introduction*, London: Sage.

Gablik, S. (1985), *Magritte*, London: Thames and Hudson.

Gardetti, M. A. and Muthu, S. S., eds. (2018), *Sustainable Luxury, Entrepreneurship, and Innovation*, Wiesbaden: Springer Gabler.

Giddens, A. (1991), *Modernity and Self-identity: Self and Society in the Late Modern Age*, Stanford, CA: Stanford University Press.

Goldie, P. and Schellekens, E., eds. (2009), *Philosophy and Conceptual Art*, Oxford: Oxford University Press.

Golia, M. (2010), *Photography and Egypt*, London: Reaktion.

Grossberg, L. and Nelson, C., eds. (1992), *Cultural Studies*, London: Routledge.

Hackforth-Jones, J. and Robertson, I., eds. (2016), *Art Business Today: 20 Key Topics*, London: Lund Humphries Publishers Ltd.

Hall, S. and Jefferson, T., eds. (2006), *Resistance Through Rituals: Youth Subcultures in Post-War Britain*, London: Routledge.

Hall, S., Evans, J., and Nixon, S., eds. (2013), *Representation: Cultural Representations and Signifying Practices*, London: Sage.

Harrison, C. (1997), *Modernism*, London: Tate Publishing.

Hatt, M. and Klonk, C. (2006), *Art History: A Critical Introduction to its Methods*, Manchester: Manchester University Press.

Haug, W. (1986), *Critique of Commodity Aesthetics: Appearance, Sexuality and Advertising in Capitalist Society*, Cambridge: Polity.

Hauser, A. (1951), *Social History of Art, Volume 1*, London: Routledge.

Hayward, A. (2004), *Which Side Are You On? Ken Loach and His Films*, London: Bloomsbury.

Hebdige, D. (1979), *Subculture: The Meaning of Style*, London: Routledge.

Held, D. (1989), *Introduction to Critical Theory: Horkheimer to Habermas*, Cambridge: Polity.

Heywood, I. and Sandywell, B., eds. (2017), *The Handbook of Visual Culture*, London: Bloomsbury.

Hinton, S. and Hjorth, L. (2013), *Understanding Social Media*, London: Sage.

Husband, P. and Chadha, R. (2015), *The Cult of the Luxury Brand: Inside Asia's Love Affair with Luxury*, London: Nicholas Brealey International.

Jay, M. (1994), *Downcast Eyes: The Denigration of Vision in Twentieth-Century French Thought*, Los Angeles: University of California Press.

Jenks, C., ed. (1995), *Visual Culture*, London: Routledge.

Jobling, P. (1999), *Fashion Spreads: Word and Image in Fashion Photography Since 1980*, Oxford: Berg.

Johnston, P. (2001), *Real Fantasies: Edward Steichen's Advertising Photography*, Los Angeles: University of California Press.

Kant, I. (2002), *Groundwork for the Metaphysics of Morals*, New Haven, CT: Yale University Press.

Kant, I. (2015), *Kant: Critique of Practical Reason*, Cambridge: Cambridge University Press.

Kapferer, J.-N. and Bastien, V. (2012), *The Luxury Strategy: Break the Rules of Marketing to Build Luxury Brands*, London: Kogan Page.

Kastner, O. (2013), *When Luxury Meets Art: Forms of Collaboration between Luxury Brands and the Arts*, Wiesbaden: Springer Gabler.

Kennedy, A. (2014), *Being Cultured: in Defense of Discrimination*, Exeter: Societas.

Klein, N. (2010), *No Logo*, London: Fourth Estate.

Knowles, C. and Hurwitz, M. (2016), *The Complete X-Files*, London: Titan Books.

Kohn, E. (2016), *Harmony Korine: Interviews*, Jackson: University Press of Mississippi.

Koons, J. (1988 [1989]), "From Full Phantom Five," republished in *Parkett*, No. 19: 45.

Koons, J. and Rosenthal, N. (2014), *Jeff Koons: Conversations with Norman Rosenthal*, London: Thames and Hudson.

Kromm, J. and Bakewell, S., eds. (2010), *A History of Visual Culture: Western Civilization from the 18th to the 21st Century*, Oxford: Berg.

Kuldova, T. (2016), *Luxury Indian Fashion: A Social Critique*, London: Bloomsbury.

Lavery, D., ed. (2006), *Reading The Sopranos: Hit TV from HBO*, London: I.B. Taurus.

Lee, R. (2013), *The Longue Durée and World-Systems Analysis*, Albany, NY: State University of New York Press.

Leibovitz, A. (2008), *Annie Leibovitz at Work*, London: Jonathan Cape.

Leibovitz, A. (2017), *Annie Leibovitz: Portraits 2005–2016*, London: Phaidon Press.

Longhurst, B., Smith, G., Bagnall, G., Crawford, G., and Ogborn, M. (2016), *Introducing Cultural Studies*, London: Routledge.

Lucie-Smith, E. (2001), *Movements in Art Since 1945*, London: Thames and Hudson.

Lury, C. (2004), *Brands: The Logos of the Global Economy*, London: Routledge.

Lury, C. (2011), *Consumer Culture*, Cambridge: Polity.

Marinetti, F. T. (2018), "Against Feminine Luxury," with an Introduction by John Armitage, *Cultural Politics*, 14 (1): 90–94.

Mason, F. (2015), *Vuitton: A Biography of Louis Vuitton*, London: CreateSpace Independent Publishing Platform.

McNeil, P. and Riello, G. (2016), *Luxury: A Rich History*, Oxford: Oxford University Press.

Merleau-Ponty, M. (1964), "Cezanne's Doubt," in M. Merleau-Ponty, *Sense and Non-Sense*, 9–25, Evanston, IL: Northwestern University Press.

Merleau-Ponty, M. (1969), *The Visible and the Invisible*, Evanston, IL: Northwestern University Press.

Mirzoeff, N. (1999), *An Introduction to Visual Culture*, London: Routledge.

Mirzoeff, N., ed. (2012), *The Visual Culture Reader*, London: Routledge.

Mitchell, W. J. (1995), *Picture Theory: Essays on Verbal and Visual Representation*, Chicago: Chicago University Press.

Mitchell, W. J. (1996), *City of Bits: Space, Place, and the Infobahn*, Cambridge, MA: MIT Press.

Moor, A. (2012), *Powell and Pressburger: A Cinema of Magic Spaces*, London: I.B. Tauris.

Nelson, R., ed. (2000), *Visuality Before and Beyond the Renaissance: Seeing as Others Saw*, Cambridge: Cambridge University Press.

Neret, G. (2003), *Balthus Basic Art Album*, Cologne: Taschen.

Newall, D. and Pooke, G. (2007), *Art History: The Basics*, London: Routledge.

Newton, H. (1996), *The Best of Helmut Newton*, New York: Thunder's Mouth Press.

Newton, H. (2009), *Sumo*, Cologne: Taschen.

Nietzsche, F. (2017), *The Will to Power*, London: Penguin.

Nixon, S. (2016), *Hard Sell: Advertising, Affluence and Transatlantic Relations*, Manchester: Manchester University Press.

October Editorial Collective (1996), "Visual Culture Questionnaire," *October*, 77 (Summer): 25–70.

Okonkwo, U. (2010), *Luxury Online: Styles, Systems, Strategies: Styles, Strategies, Systems*, Basingstoke, UK: Palgrave Macmillan.

Paris, M., ed. (2018), *Making Prestigious Places: How Luxury Influences the Transformation of Cities*, Abingdon: Routledge.

Pasols, P.-G. (2012), *Louis Vuitton: The Birth of Modern Luxury*, New York: Abrams.

Piketty, T. (2014), *Capital in the Twenty-First Century*, Cambridge, MA: Harvard University Press.

Pitts, T. and Heiting, M. (2017), *Edward Weston*, Cologne: Taschen.

Pollock, G. (2003), *Vision and Difference: Feminism, Femininity and Histories of Art*, London: Routledge.

Rocamora, A. (2016), "Online Luxury: Geographies of Production and Consumption in the Louis Vuitton Website," in J. Armitage and J. Roberts (eds.), *Critical Luxury Studies: Art, Design, Media*, 199–220, Edinburgh: Edinburgh University Press.

Rojek, C. (2007), *Cultural Studies*, Cambridge: Polity.

Said, E. W. (1994), *Culture and Imperialism*, London: Vintage.

Salgado, S. (2016), *Kuwait, A Desert on Fire*, Cologne: Taschen.

Sandel, M. J. (2006), *Public Philosophy: Essays on Morality in Politics*, Cambridge, MA: Harvard University Press.

Sanders, S. (2010), *Miami Vice*, Detroit: Wayne State University Press.

Sassatelli, R. (2007), *Consumer Culture: History, Theory and Politics*, London: Sage.

de Saussure, F. (2013), *Course in General Linguistics*, London: Bloomsbury.

Schroeder, J. E. (2005), *Visual Consumption*, London: Routledge.

Sekora, J. (1977), *Luxury: The Concept in Western Thought, Eden to Smollett*, Baltimore: Johns Hopkins Press.

Sharr, A. (2016), "Libeskind in Las Vegas: Reflections on Architecture as a Luxury Commodity," in J. Armitage and J. Roberts (eds.), *Critical Luxury Studies: Art, Design, Media*, 151–76, Edinburgh: Edinburgh University Press.

Smith, K. (2012), "Interview with Tim Walker," *The White Review*, December. Available at: http://www.thewhitereview.org/feature/interview-with-tim-walker/.

Smith, M. (2005a), "Visual Culture Studies: Questions of History, Theory, and Practice," in A. Jones (ed.), *A Companion to Contemporary Art since 1945*, 470–89, Oxford: Blackwell.

Smith, M. (2005b), "Visual Studies, or the Ossification of Thought," *Journal of Visual Culture*, 4 (2): 237–56.

Smith, M. (2008), *Visual Culture Studies: Interviews with Key Thinkers*, London: Sage.

Smith, M. and Morra, J., eds. (2006), *Visual Culture: Critical Concepts in Media and Cultural Studies*, 4 volumes, London: Routledge.

Sombart, W. (1967), *Luxury and Capitalism*, Ann Arbor: University of Michigan Press.

Stewart Howe, K. (1994), *Excursions Along the Nile: The Photographic Discovery of Ancient Egypt*, Los Angeles: Santa Barbara Museum of Art.

Storey, J., ed. (1996), *What Is Cultural Studies? A Reader*, London: Bloomsbury.

Sturken, M. and Cartwright, L. (2007), *Practices of Looking: An Introduction to Visual Culture*, Oxford: Oxford University Press.

Sturrock, J. (2003), *Structuralism*, Oxford: Blackwell.

Taroff, K. (2014), "Home Is Where the Self Is: Monodrama, Journey Play Structure, and the Modernist Fairy Tale," *Marvels & Tales: Journal of Fairy-Tale Studies*, 28 (2): 325–45.

Thomas, D. (2007), *Deluxe: How Luxury Lost Its Lustre*, London, Penguin.

Thompson, E. P. (2013), *The Making of the English Working Class*, London: Penguin.

Tilley, C., Keane, W., Kuechler-Fogden, S., Rowlands, M., and Spyer, P., eds. (2013), *Handbook of Material Culture*, London: Sage.

Vasari, G. (2008), *Lives of the Artists*, London: Penguin.

Veblen, T. (2009), *The Theory of the Leisure Class*, Oxford: Oxford University Press.

Virilio, P. (2006), *Speed and Politics: An Essay on Dromology*, New York: Semiotext(e).

Virilio, P. (2007), *The Original Accident*, Cambridge: Polity.

Virilio, P. (2009), *The Aesthetics of Disappearance*, New York: Semiotext(e).

Virilio, P. (2011), *The Futurism of the Instant*, Cambridge: Polity.

Walker, J. A. and Chaplin, S. (1997), *Visual Culture: An Introduction*, Manchester: Manchester University Press.

Walker, T. (2015), *Pictures*, London: teNeues Media GmbH & Co.

Walker, T. and Ansel, R. (2012), *Tim Walker: Story Teller*, London: Thames and Hudson.

Watts, P. (2016), *Barthes' Cinema*, Oxford: Oxford University Press.

White, L. (2009), "Damien Hirst's Diamond Skull and the Capitalist Sublime," in J. Roberts and L. White (eds.), *The Sublime Now*, 155–73, Newcastle upon Tyne: Cambridge Scholars Publishing.

Williams, R. (1980), "Advertising: The Magic System," in R. Williams, *Problems in Materialism and Culture*, 170–95, London: Verso.

Williams, R. (1986), *Culture*, London: Fontana.

Williamson, J. (1978), *Decoding Advertisements: Ideology and Meaning in Advertising*, London and New York: Marion Boyars.

Wood, P. (2004), *Art of the Avant-gardes*, New Haven, CT: Yale University Press.

Zaniol, G. (2016), "Brand Art Sensation: From High Art to Luxury Branding?," *Cultural Politics*, 12 (1): 49–53.

Index